THE
RISKO
BOOK

ollege of Design
brary
ida Street
Calif. 91103

**THE
RISKO
BOOK**

Introduction by Graydon Carter
Interview by Kevin Sessums

THE MONACELLI PRESS

R

theate

Ris

politi

t polo

styl

**THE
RISKO
BOOK**

RISKO: THE ARTIST
Graydon Carter

I don't know what you did as a kid, but when I was young, all I did was read and draw. Reading took me out of my confined, comfy life and brought the outside world, brimming with characters and glamour and adventure, to my doorstep. Drawing did something altogether different for me, as I expect it does for most children. It allowed me to create worlds that only I controlled: worlds that became real just because they were down there on paper. Those fortunate enough to be able to draw or paint for an actual living can retain the ability to create and control their own worlds on paper or canvas. They are doomed to a life of happiness and contentment. For those who can't go on controlling small, imaginary environments professionally, there are always model train sets.

Come into the world of Risko. It's a land of cheery, unfettered celebrity, of lush color and exuberant, swingy lines. In his hand, the art of the airbrush never looked so contemporary or so timeless. At a time when photography has all but replaced illustration as a magazine art form, Risko stalks the earth like a colossus, king of all he surveys. There is nobody better at celebrity caricature right now and he probably knows it—and if he doesn't, he should. Risko's illustrations for *Vanity Fair*, the *New Yorker*, and *Time*, among others, are singular in their ability to limn the character of their subjects, and to entertain with their swirly inventiveness.

Risko's drawings hark back to the early days of caricature, the late 1920s and early 1930s, when Miguel Covarrubias, Will Cotton, and Paolo Garretto ushered in a new era of caricature in the pages of Frank Crowninshield's Jazz Age trumpet *Vanity Fair*. And in a Risko drawing there are elements of all those greats of caricature who went before him. There is in his line, in addition to a bit of Pop, portions of Cotton and Garretto, a heap of Covarrubias, and a dash of Al Hirschfeld.

Even his name has a whizzy, Jazz Age ring to it. Risko! It's like the name of a circus act. Or an old radio-hour sponsor. Only those who are acquainted with him or work with him even know his first name. It's Robert. And it's appropriate that he continues the tradition of peerless caricature in the pages of *Vanity Fair*.

Risko came to New York at nineteen, after a childhood in rural Pennsylvania and a year as a fine-arts major at Kent State. His first published work appeared in *Christopher Street*, a small-circulation magazine that doesn't publish anymore. It was a drawing of Robert De Niro at the time he was playing Irving Thalberg in the 1976 film version of Fitzgerald's *Last Tycoon*.

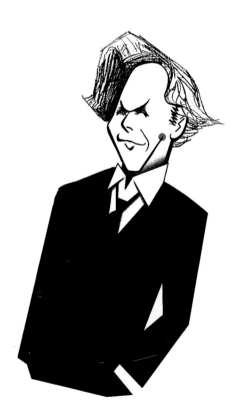

Graydon Carter is the editor of *Vanity Fair*.

(Again, a link with the Jazz Age.) His break came at a magazine
signing, when he slipped Andy Warhol a caricature he had done of
Diana Ross. Warhol liked the drawing and conscripted him to the
pages of *Interview*.

I've worked with Robert Risko for nearly eight years. We use him
when we feel that he can convey something a photograph can't.
Or sometimes when the subject of a story can't be photographed,
or won't be. Risko can be wonderful, reliable, inventive, funny, and
infuriating. He prefers to work from life (a difficulty when dealing
with the well-known). Short of that, he will make use of videos of
the person. If they're not available, he'll settle for photographs.
He'll send in working sketches first. Often they require few adjust-
ments. The nose might not be right. Or the hair is off. Another
sketch will come back the next day. If that's not quite right, he'll
rework it again, usually that afternoon. This is all done by fax.
The final drawing on illustration board is delivered by hand.
A good caricature for Risko can take between a day and a week.

Check out the drawings of Dolly Parton, Ronald Reagan, and
J. Edgar Hoover. In a few simple lines they capture the essence
of each person. Don't be fooled by how easy it looks. Great artists
or illustrators, like great poets, are all about economy. It takes
years to develop a technique, and decades more to simplify it.

The drawing of J. Edgar Hoover is, in my book, one for the ages.
It may in fact be the lasting image of the late head of the Federal
Bureau of Investigation. It ran in *Vanity Fair* in 1993 accompany-
ing an excerpt from investigative journalist Anthony Summers's
biography of the FBI director. Included in the excerpt were details
of Hoover attending an all-male party at the Plaza Hotel in 1958,
in which many of the participants went in drag. Hoover, according
to witnesses, wore a simple black dress. Risko's drawing is
deadly in its glorious, astringent detail: the heavily lidded eyes, the
tufts of chest hair coming up over the bodice, the feather boa, the
thin straps of the dress, the lipstick. In one simple drawing, Risko
created a devastating, indelible image of Hoover, who in his life-
time had destroyed so many lives. This is journalism of a high
standard.

When you pass through this book, imagine Risko in his studio just
a block north of New York's West Village, or in his summer house
in the Springs, an area of the Hamptons that was home to great
postwar American artists such as Jackson Pollock and Willem de
Kooning. There sits a master of a dying art, kerning his line,
hungry always for more work, and when he dreams, thinking
of a career he'd like to have next: that of a blues singer.

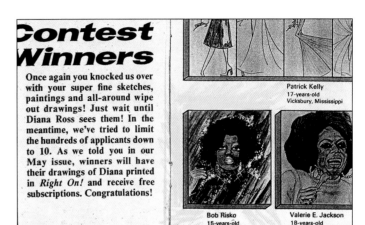

Risko's winning entry, "Draw Diana Ross" contest, *Right On!*
magazine, c. 1970.

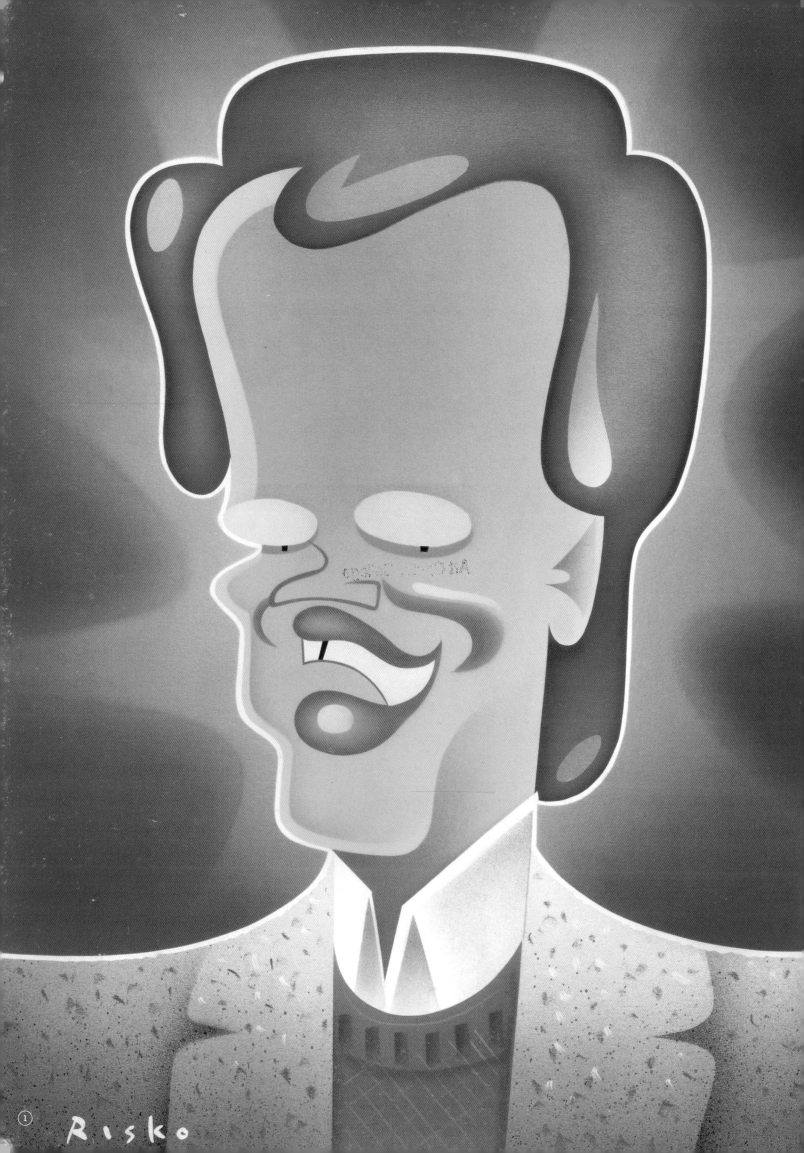

He's got that clown thing happening
where there's the mask and then there's the man.
People identify with both sides,
making him America's perfect late-night court jester.

Art Center College

① David Letterman ⑬ Welcome Back Kotter
② Joan Collins ⑭ Lucille Ball
③ Johnny Carson ⑮ Larry Hagman
④ Roseanne ⑯ Sarah Michelle Gellar
⑤ Calista Flockhart ⑰ Julia Child
⑥ Vanna White ⑱ The Honeymooners
⑦ Will Smith ⑲ Bob Hope
⑧ Bob Newhart ⑳ Bill Cosby
⑨ Seinfeld Gang ㉑ Oprah
⑩ Merv Griffin ㉒ Rosie O'Donnell
⑪ Alistair Cooke ㉓ Wayne's World
⑫ Fran Drescher ㉔ Gilda Radner

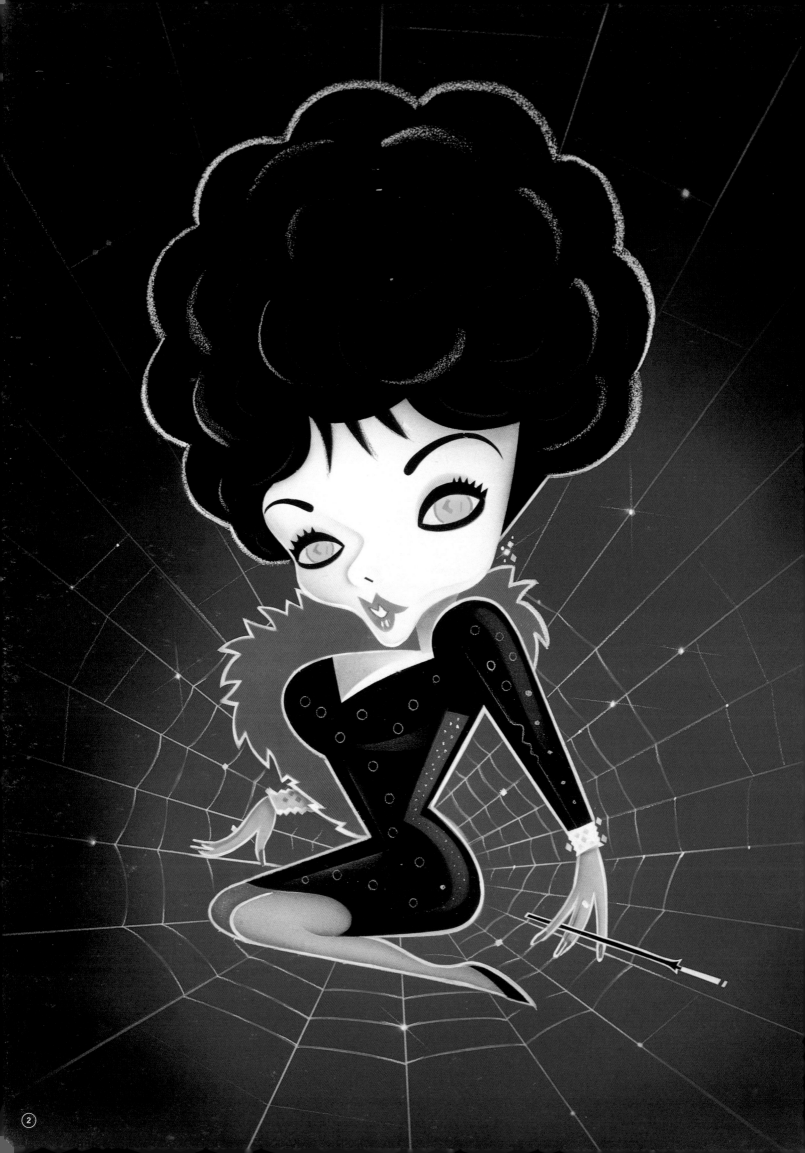

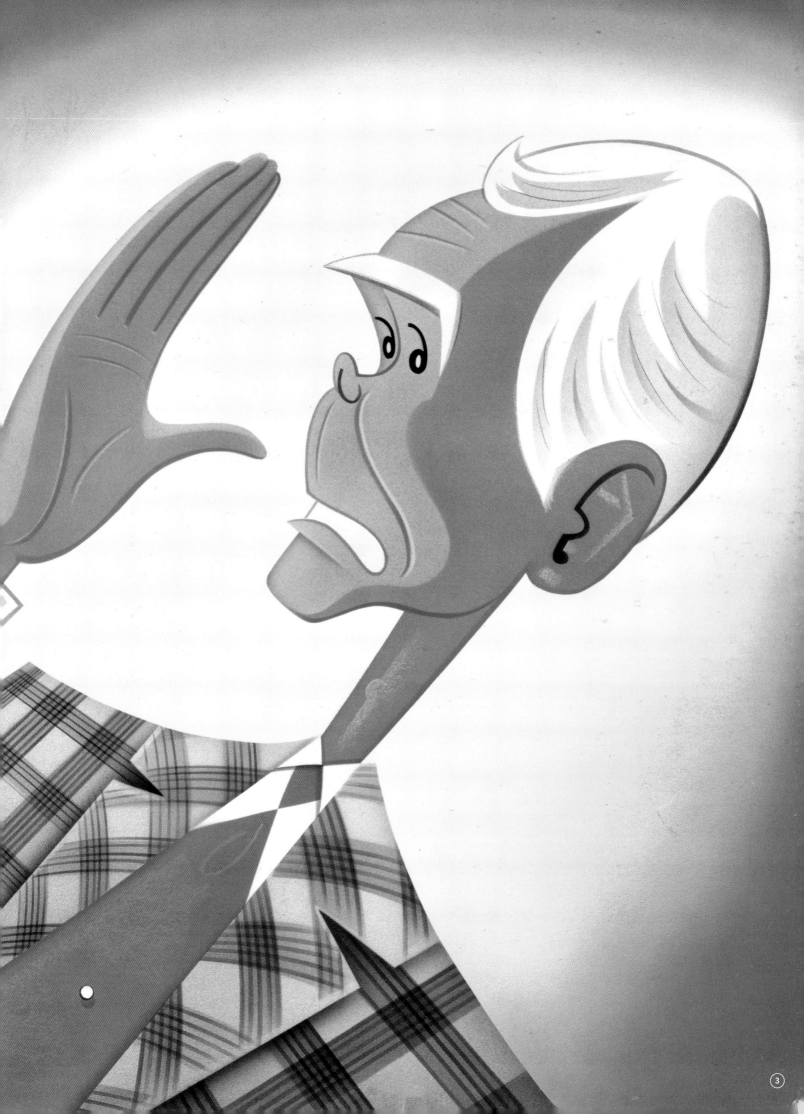

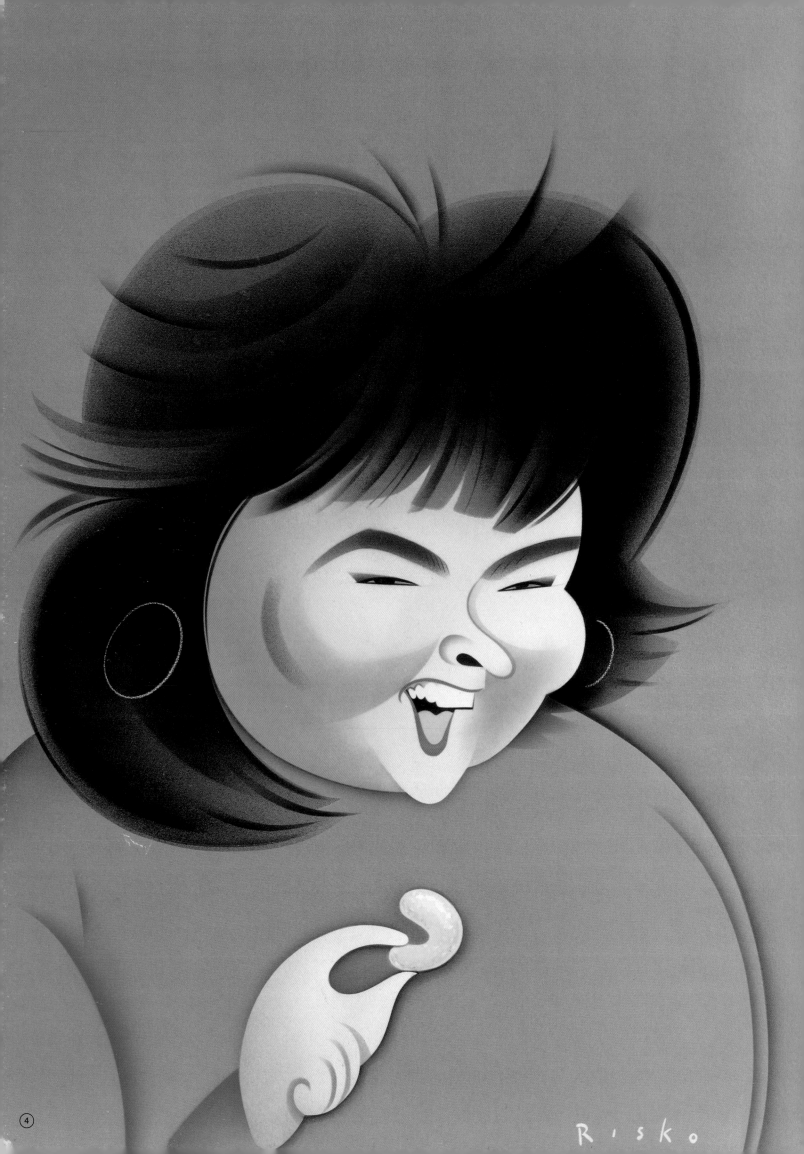

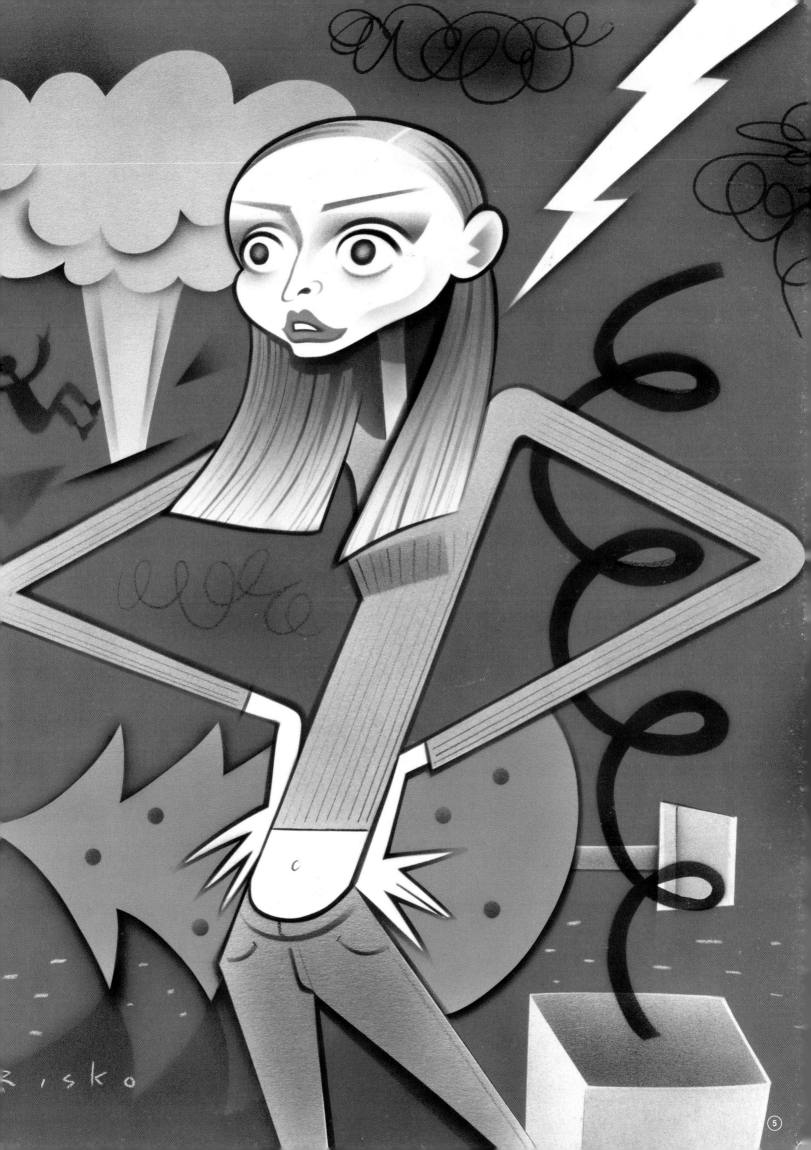

6

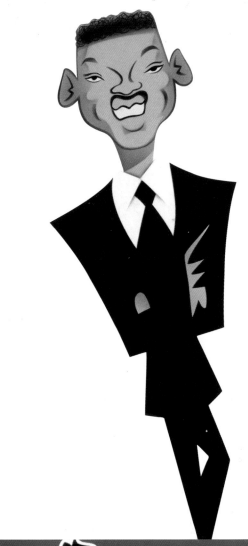

7

8

9

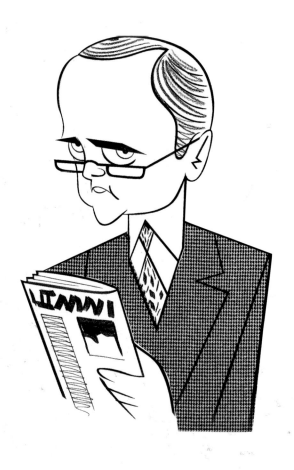

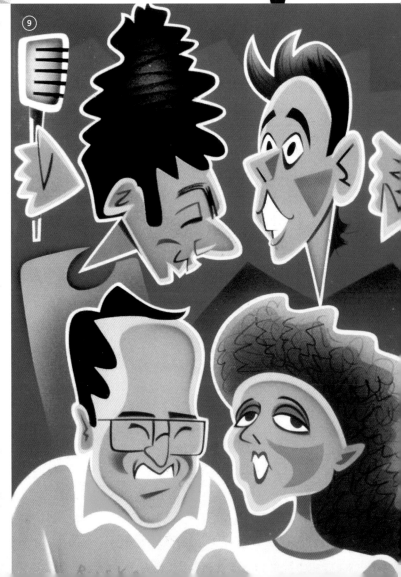

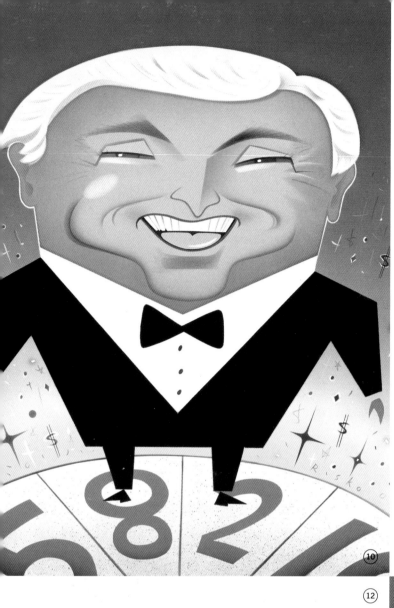

⑩

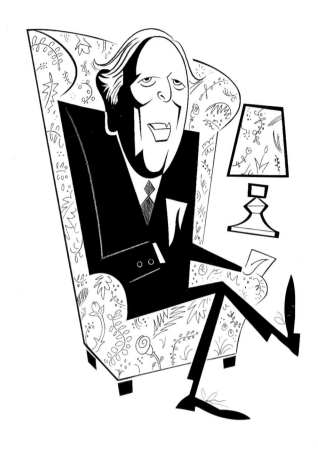

⑪

⑫

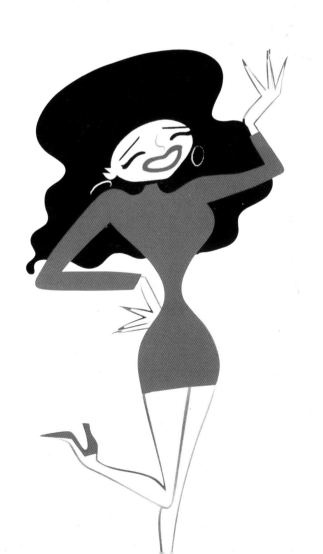

⑬

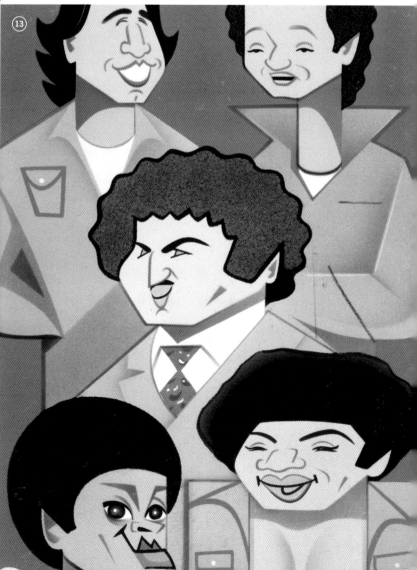

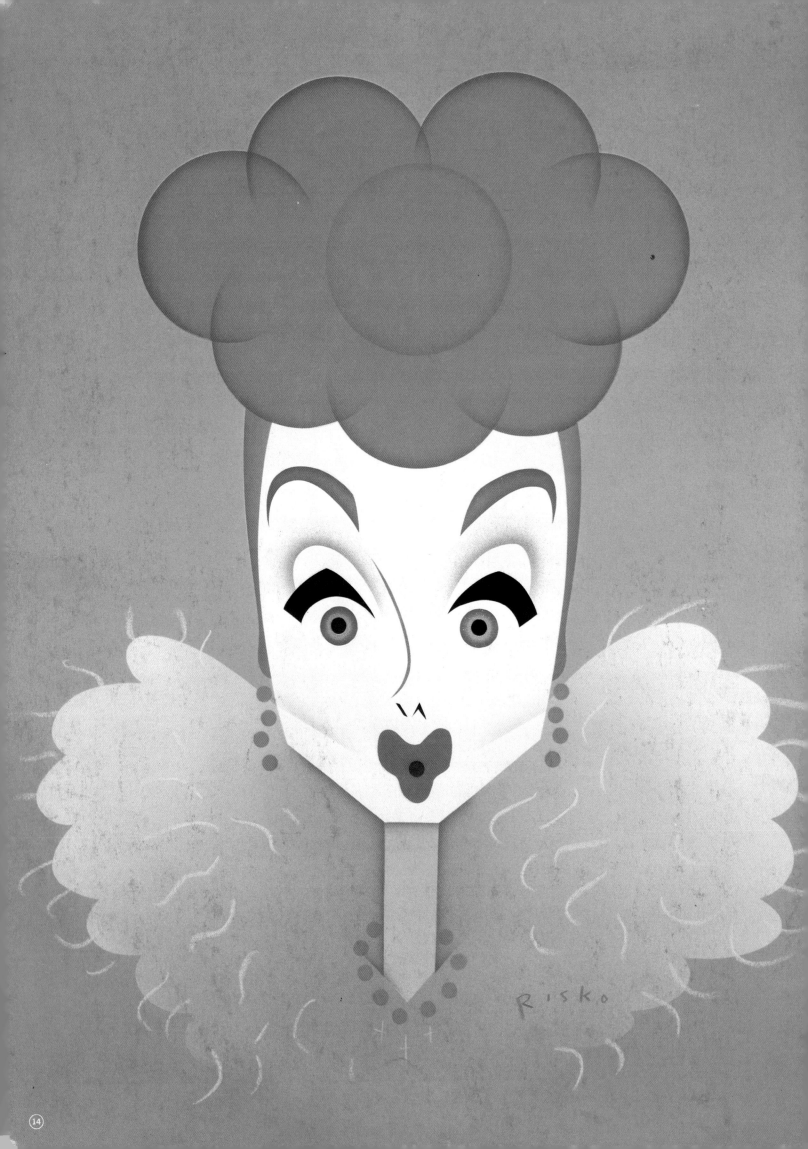

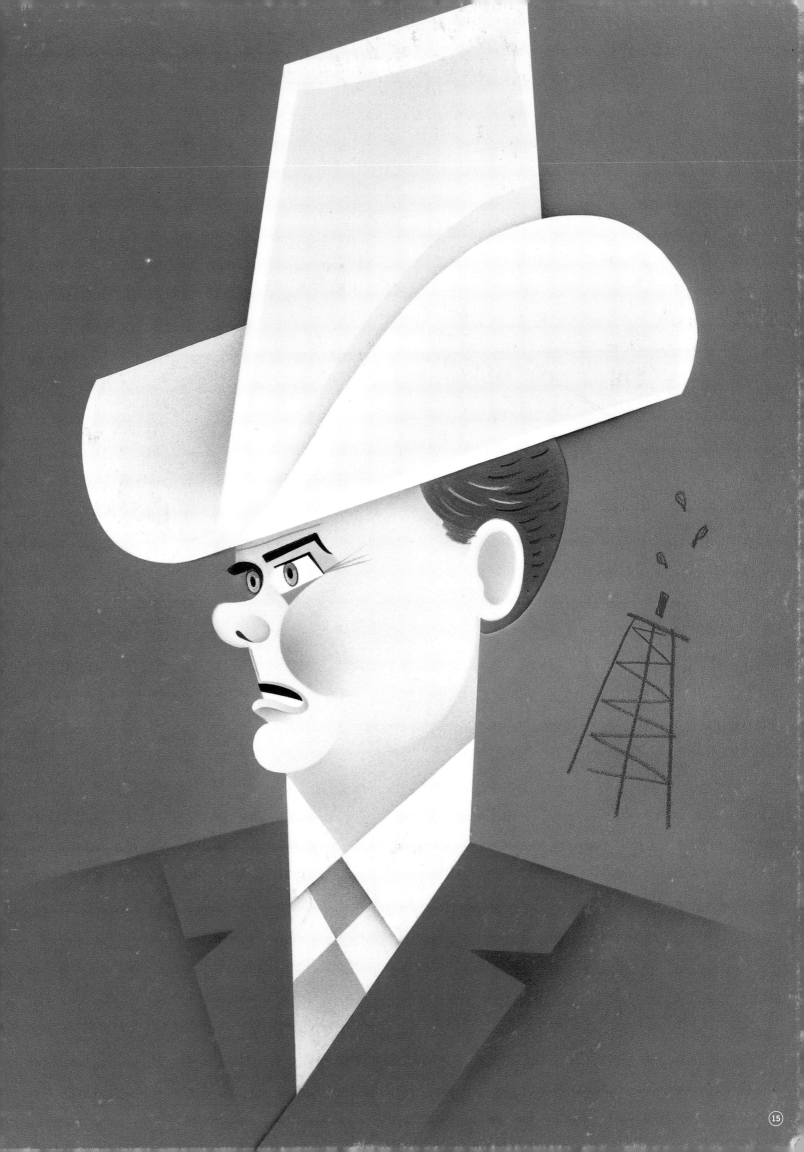

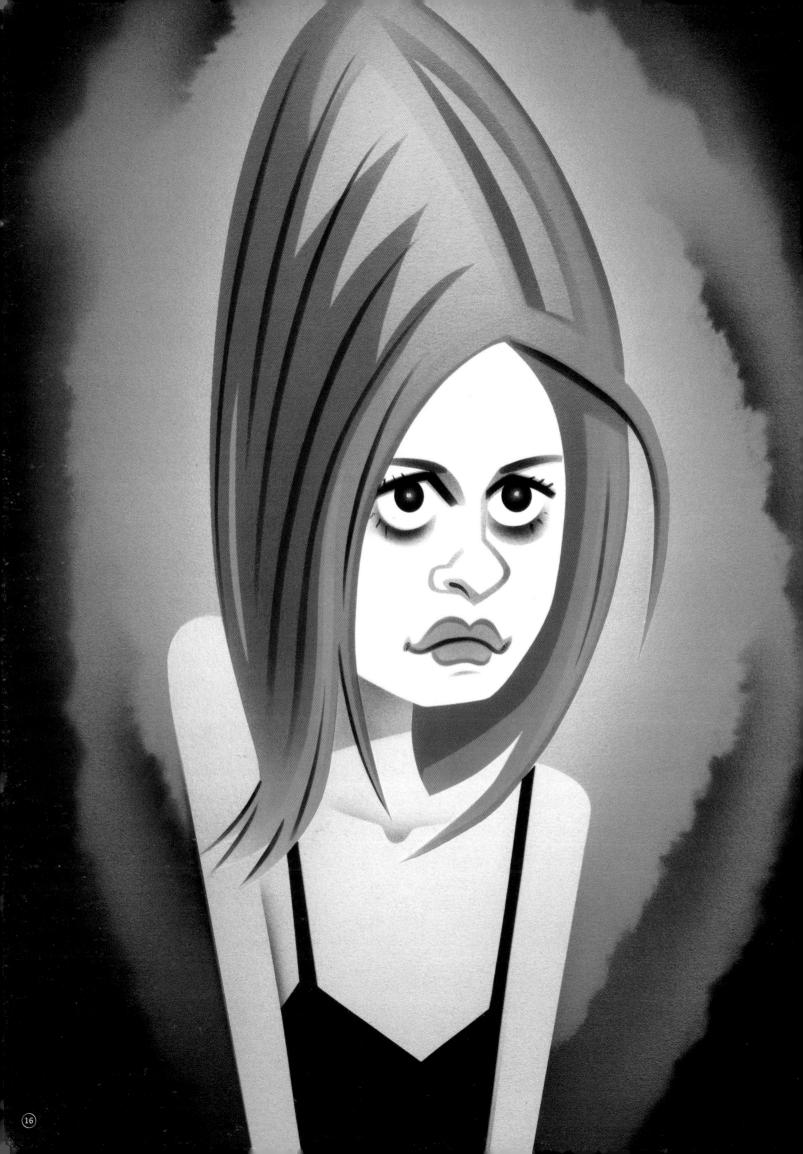

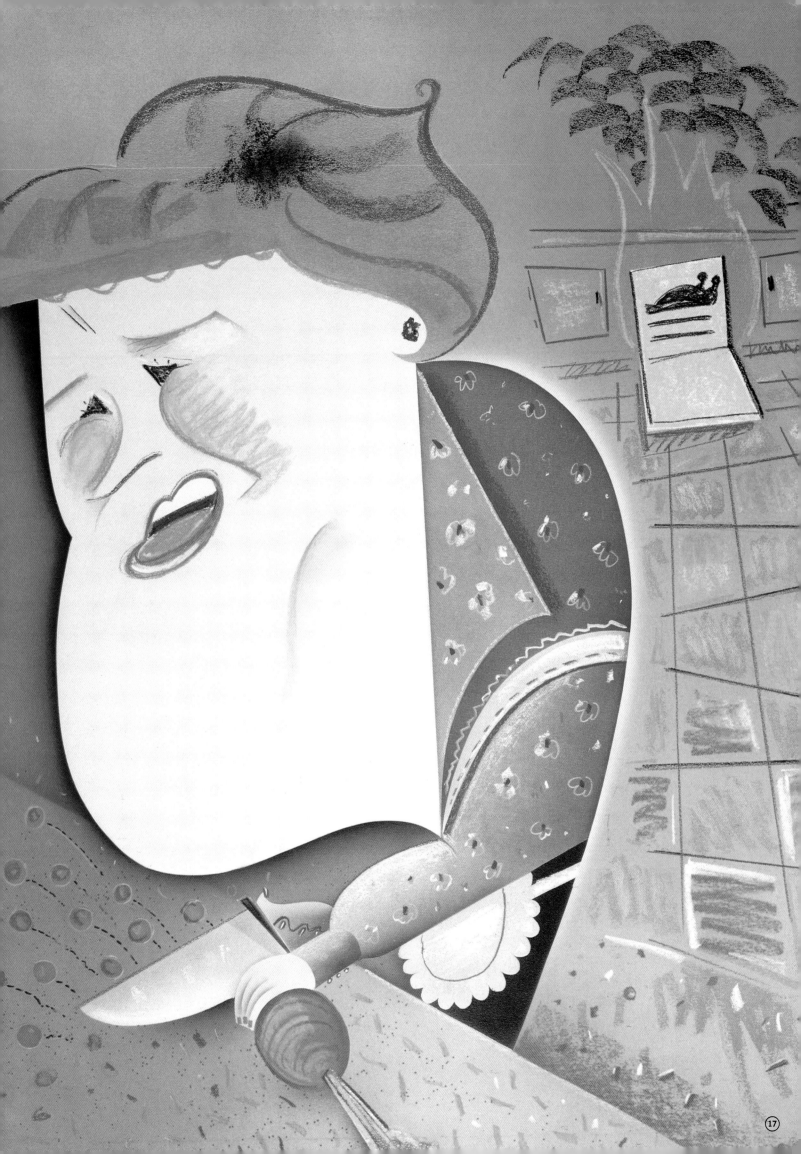

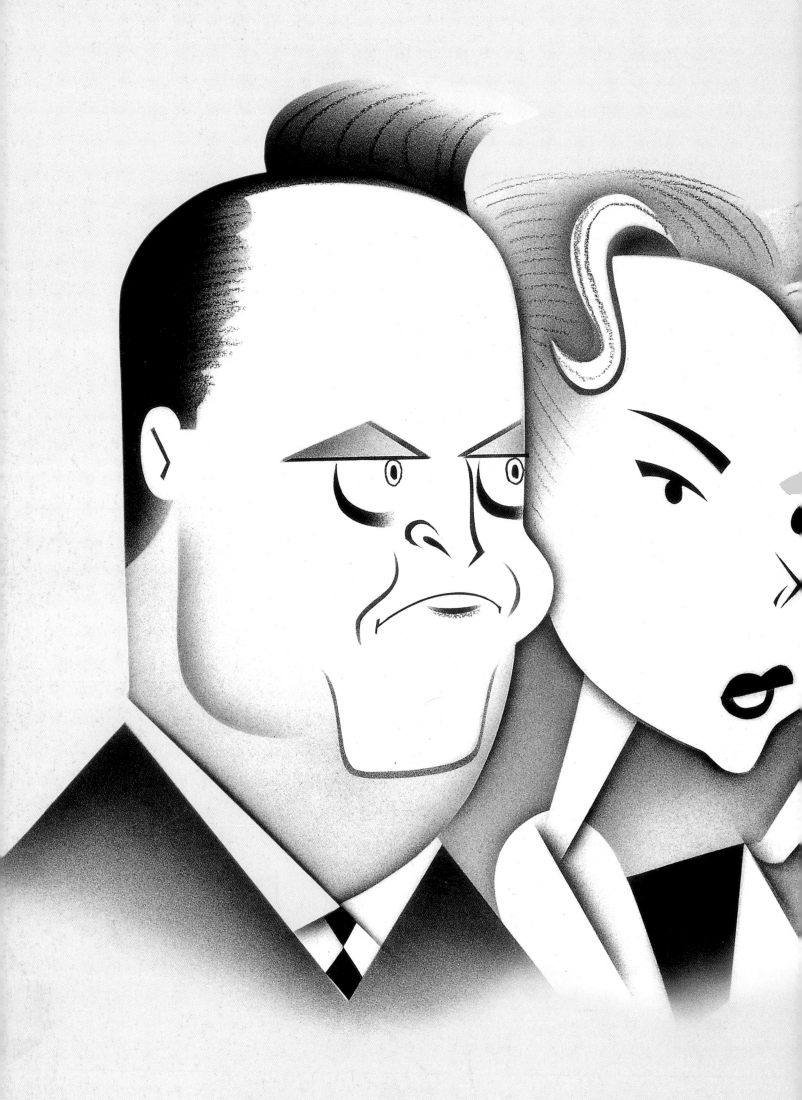

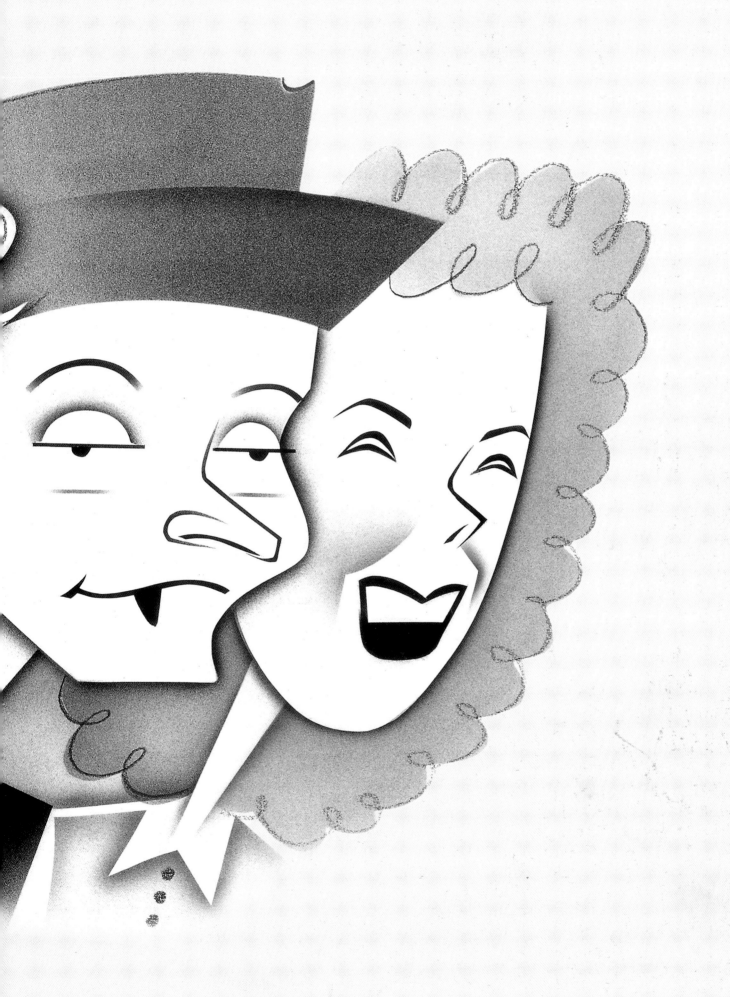

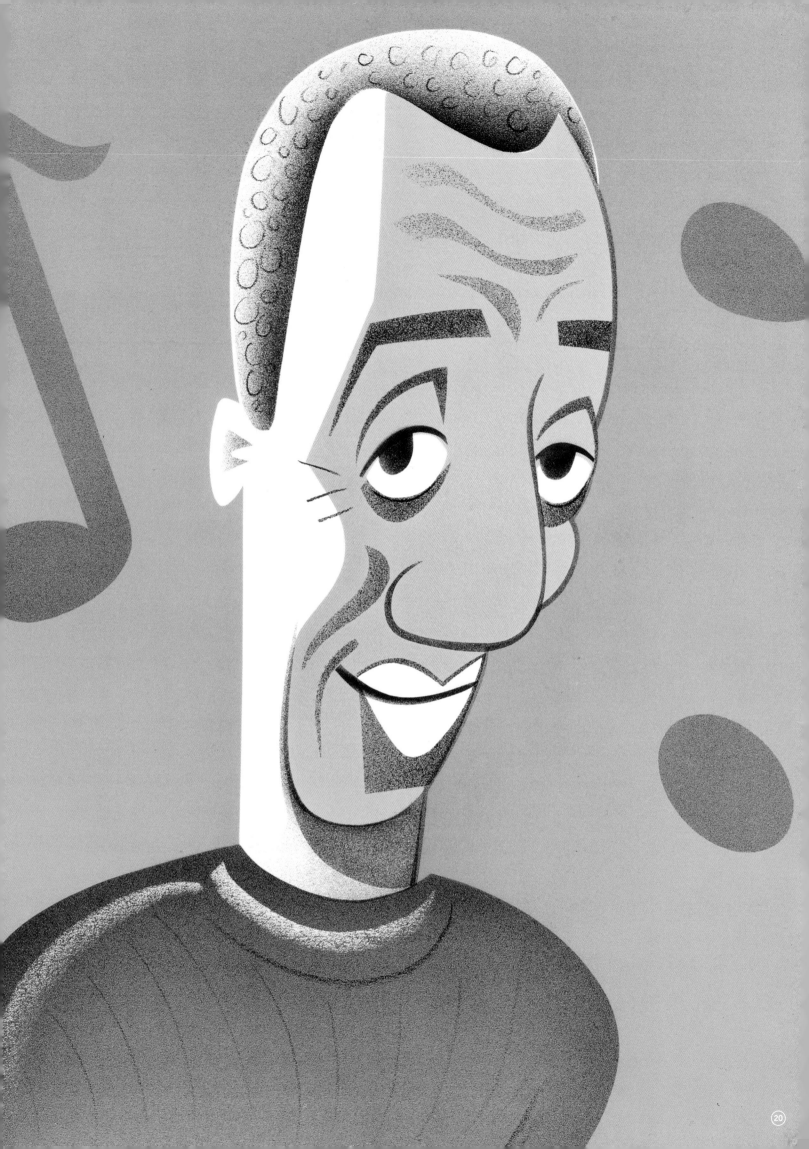

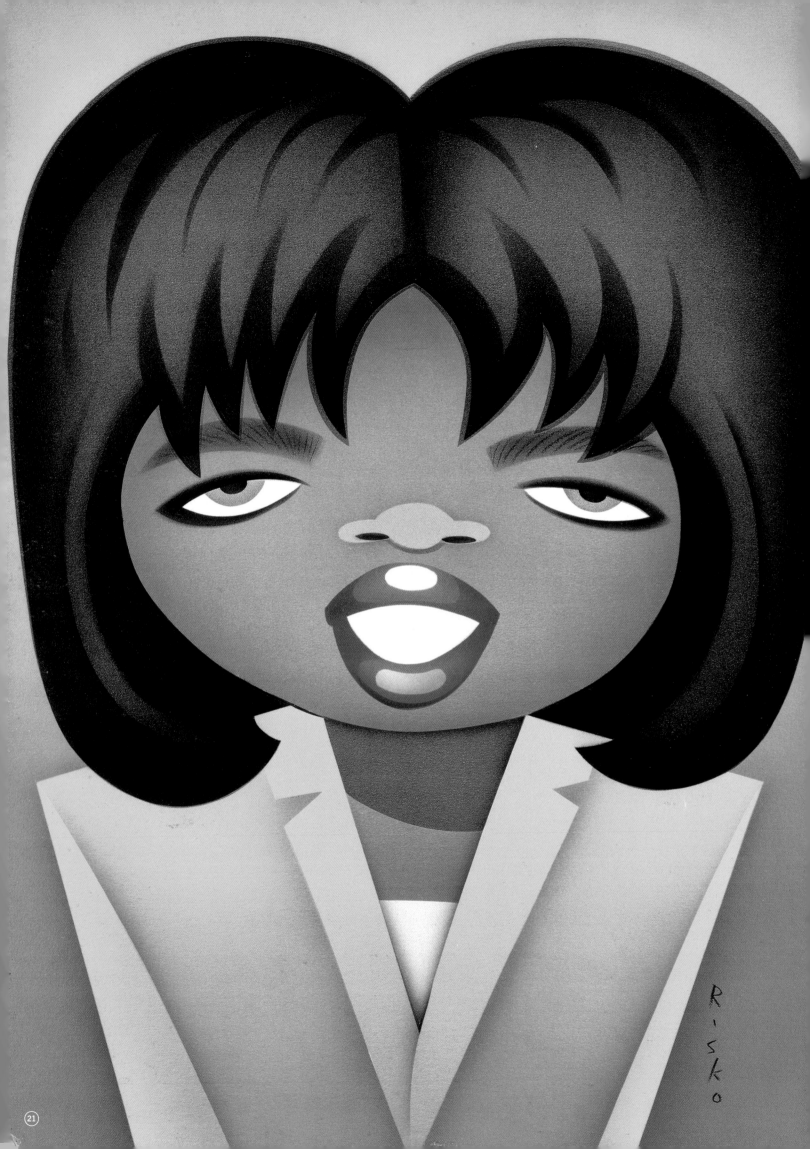

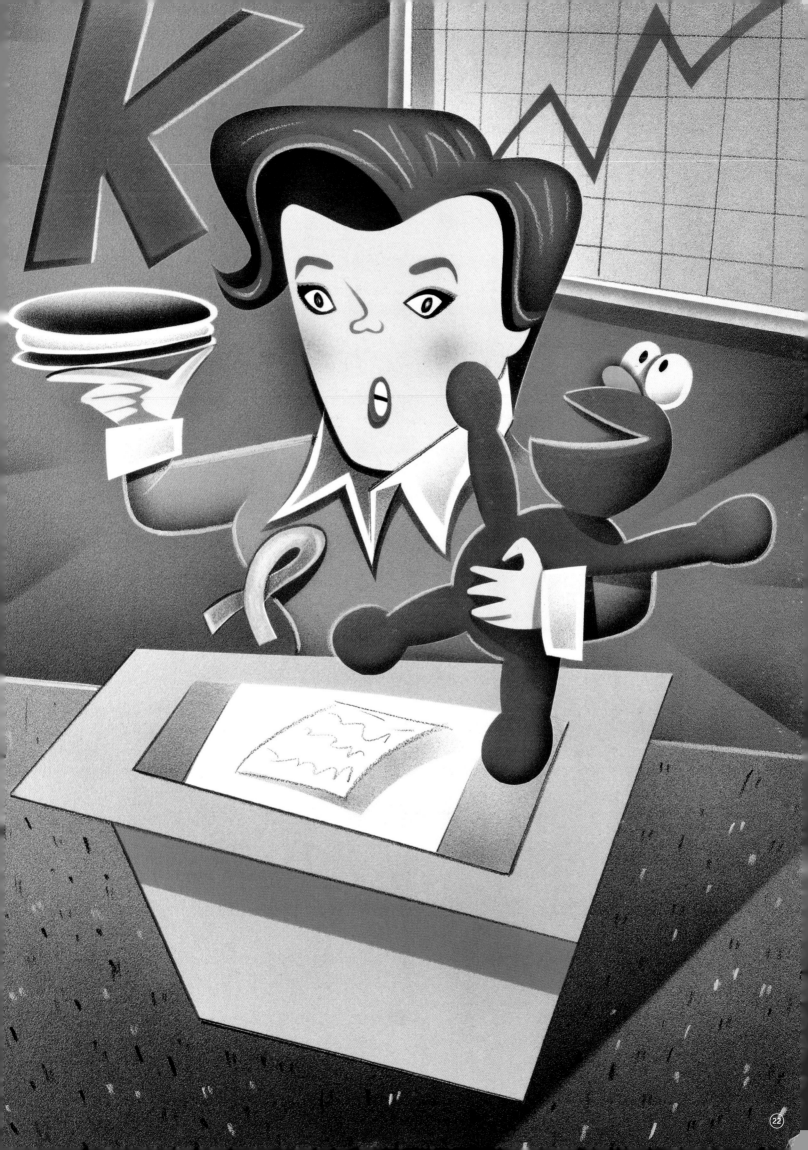

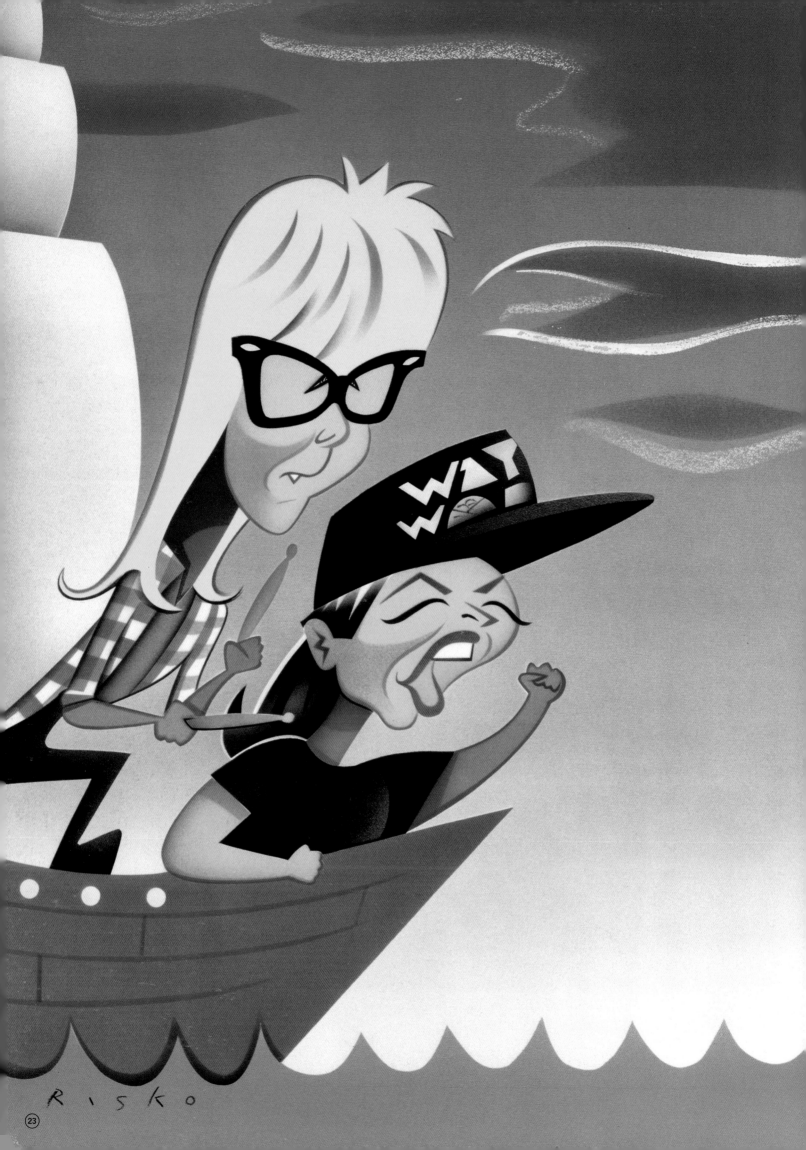

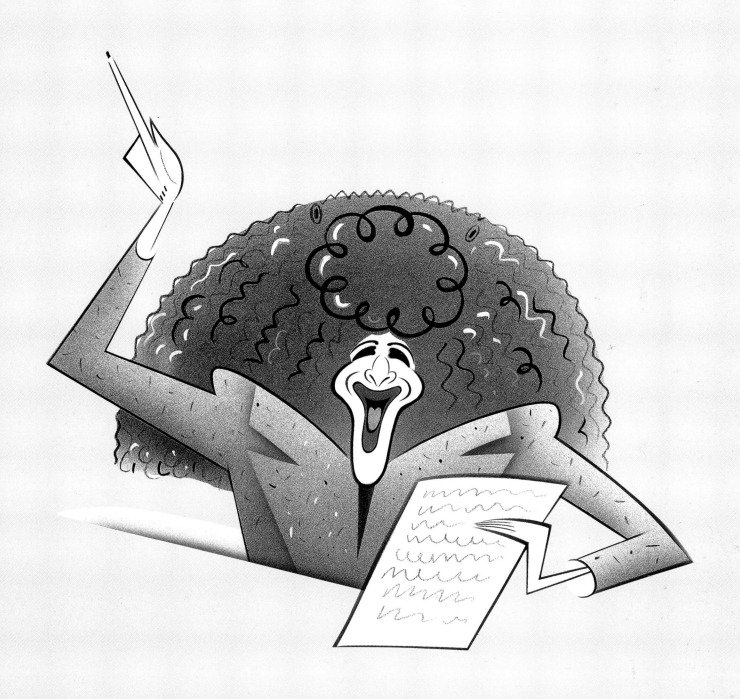

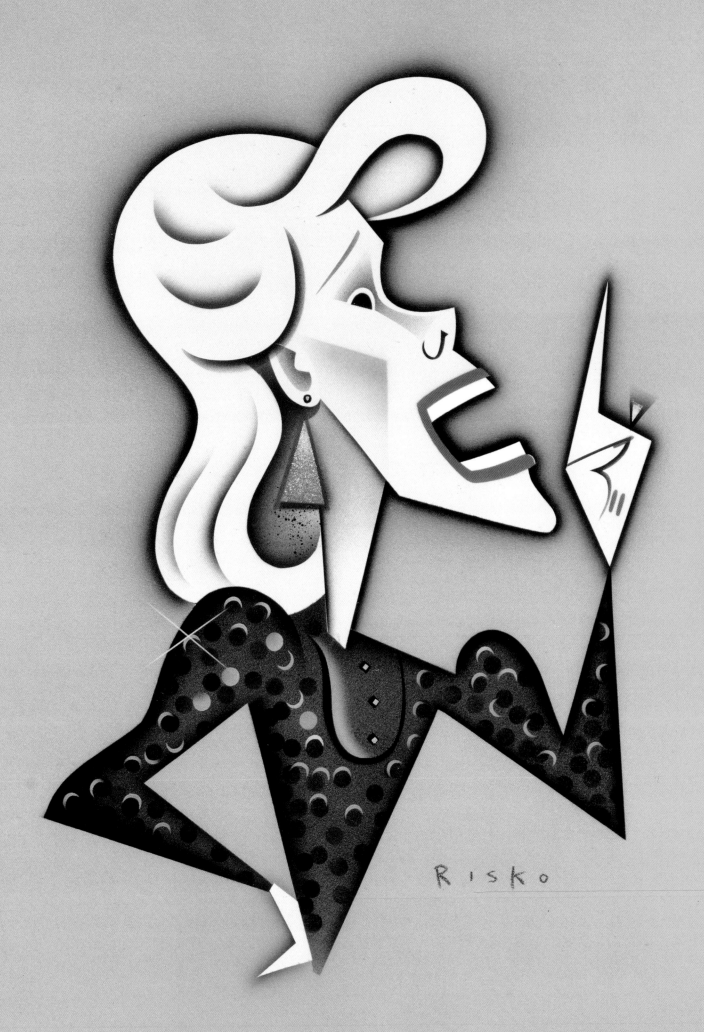

Her comic timing is quicker than a paper cut.
She'll wreck your wardrobe with one facial expression.

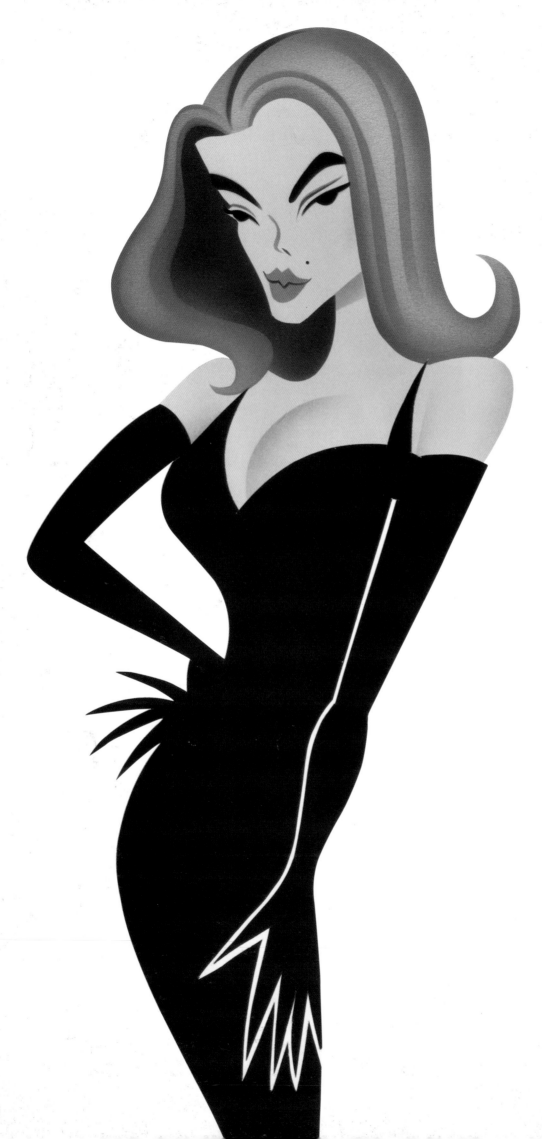

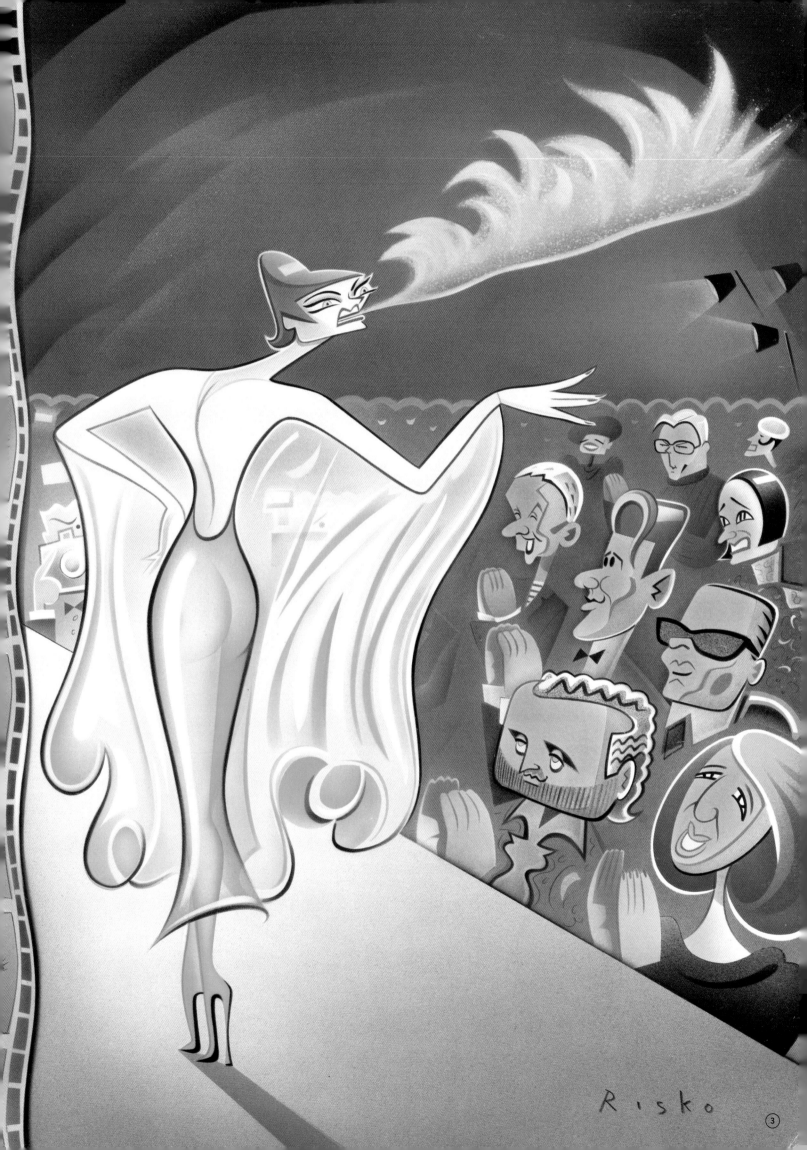

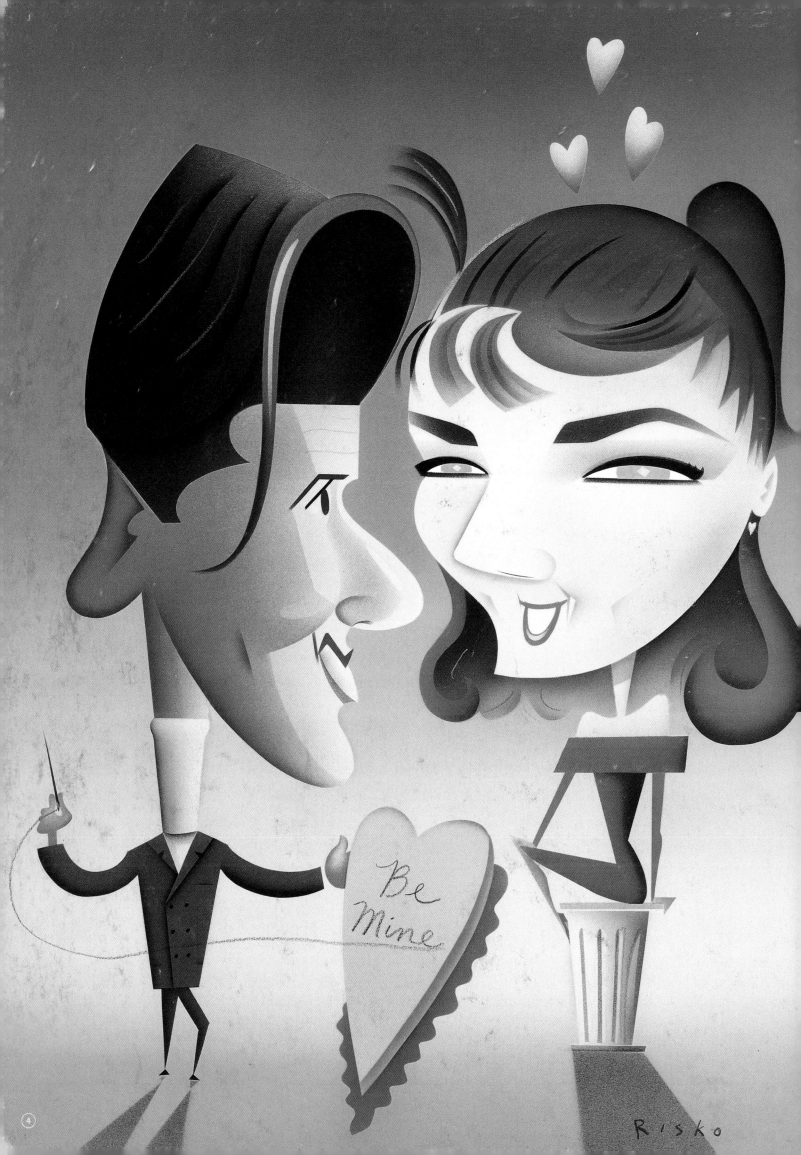

Be Mine

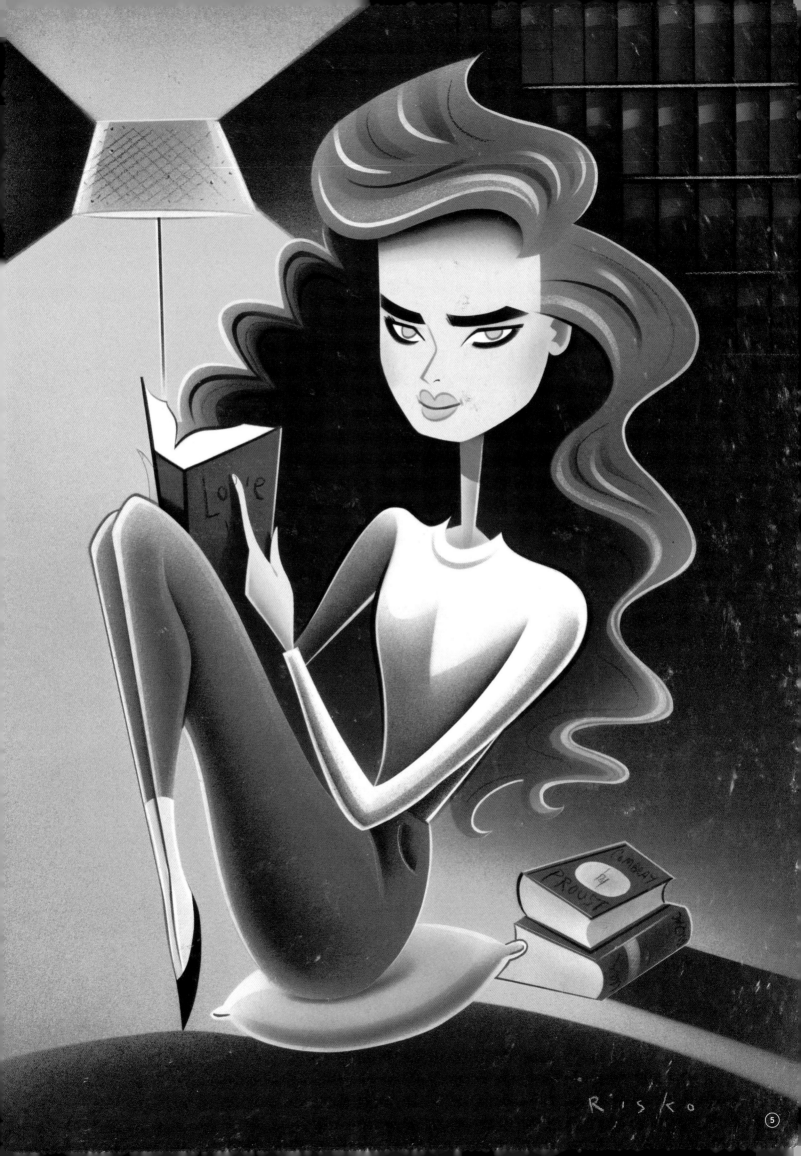

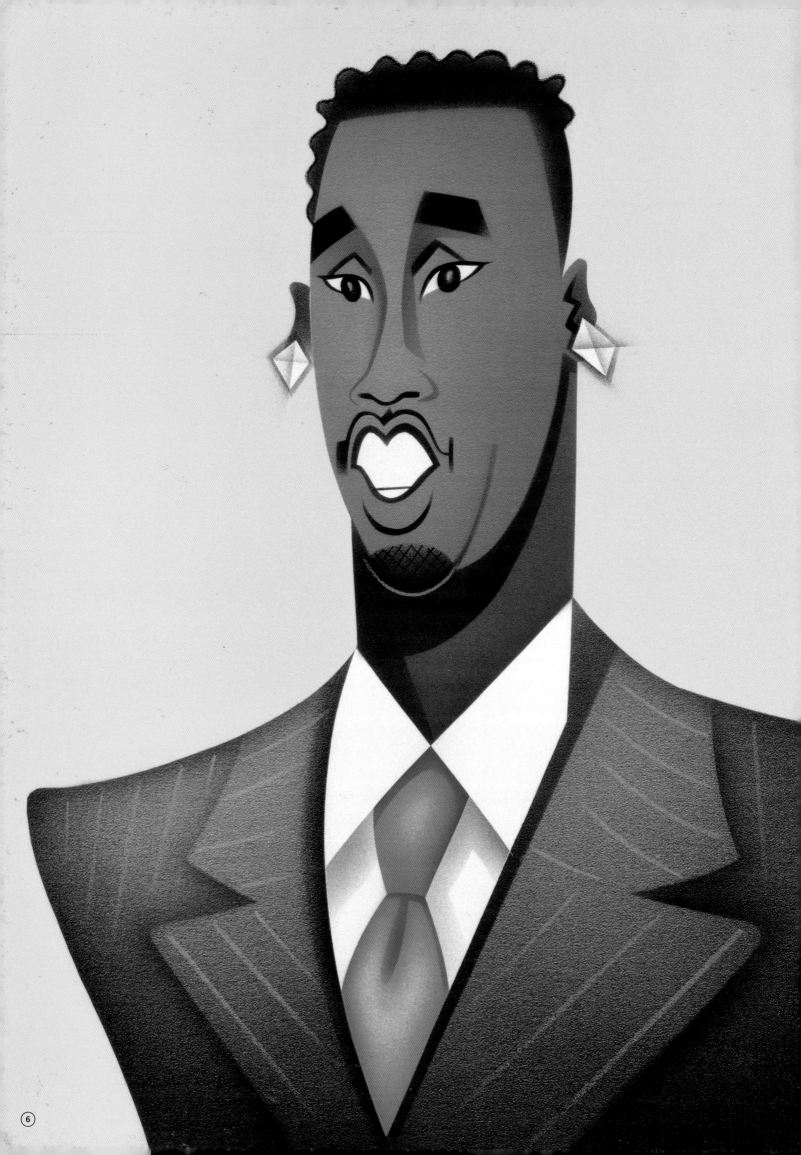

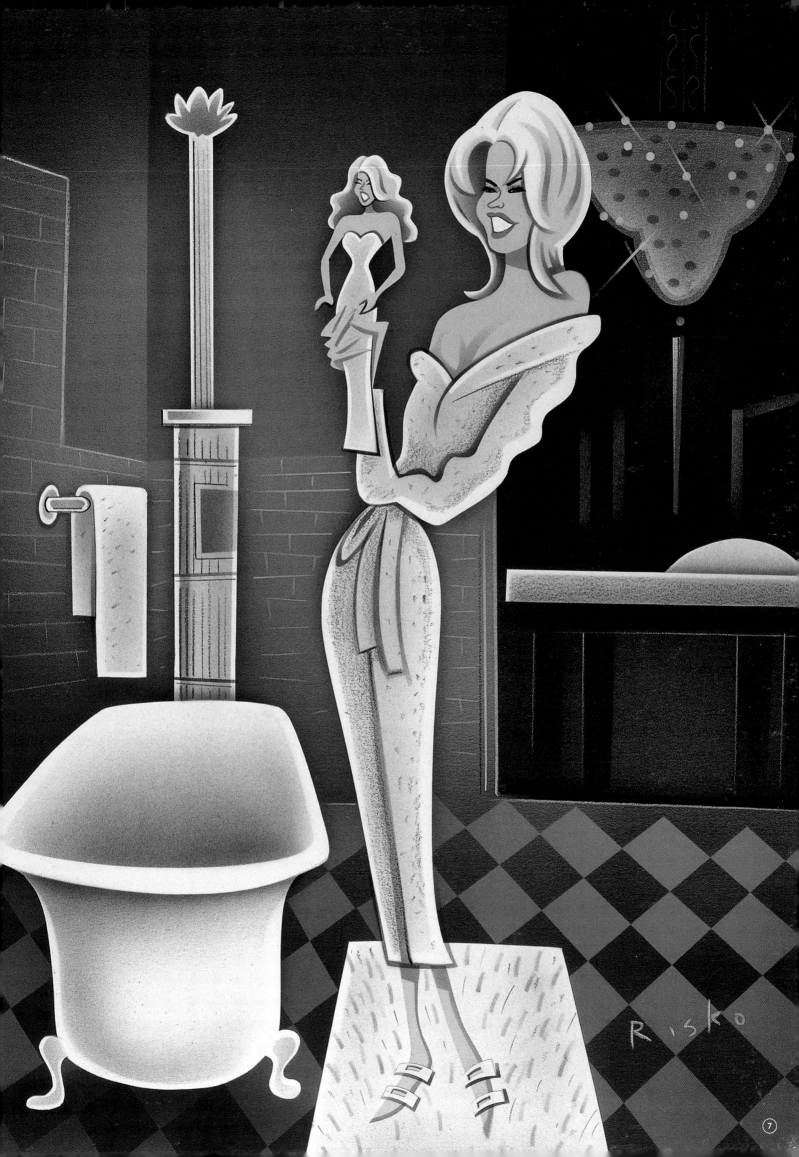

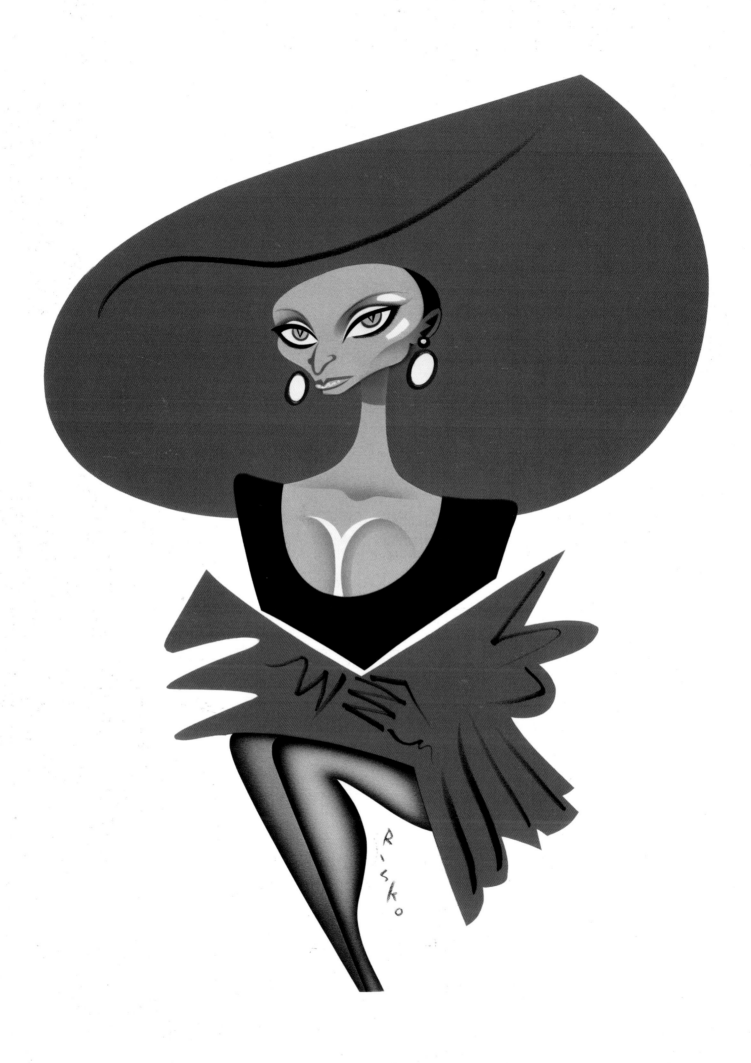

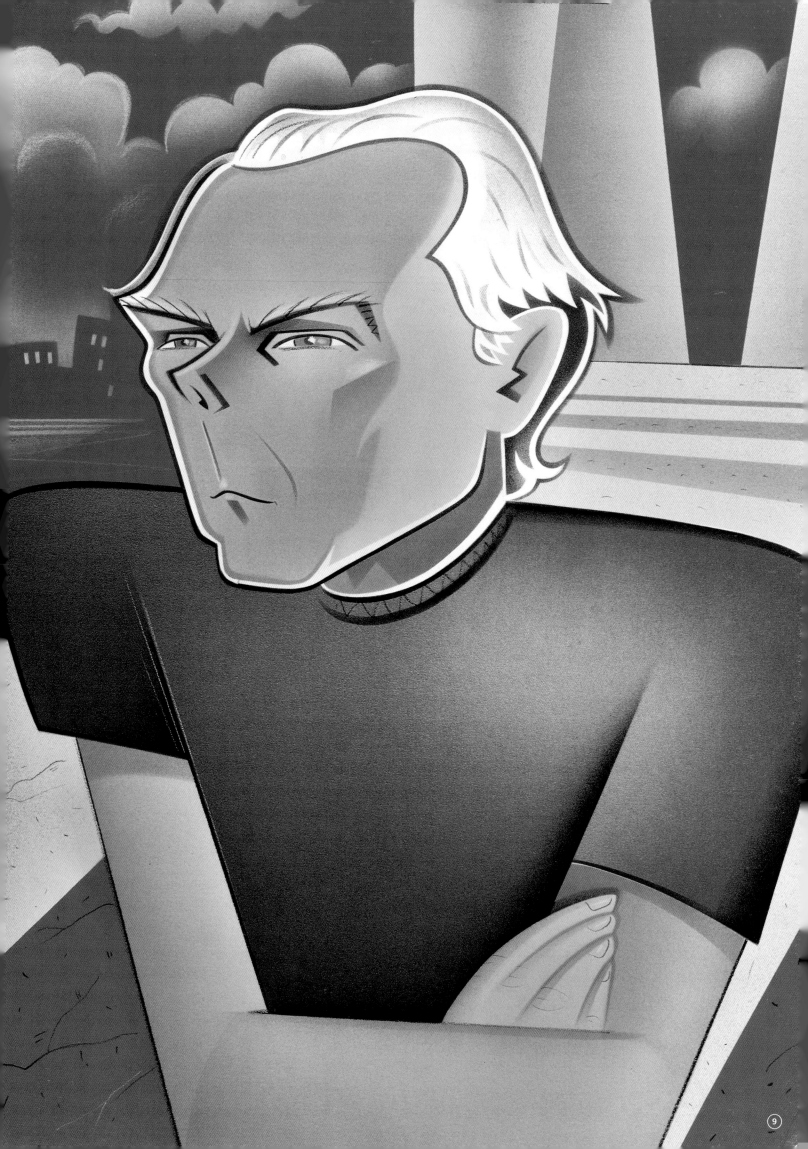

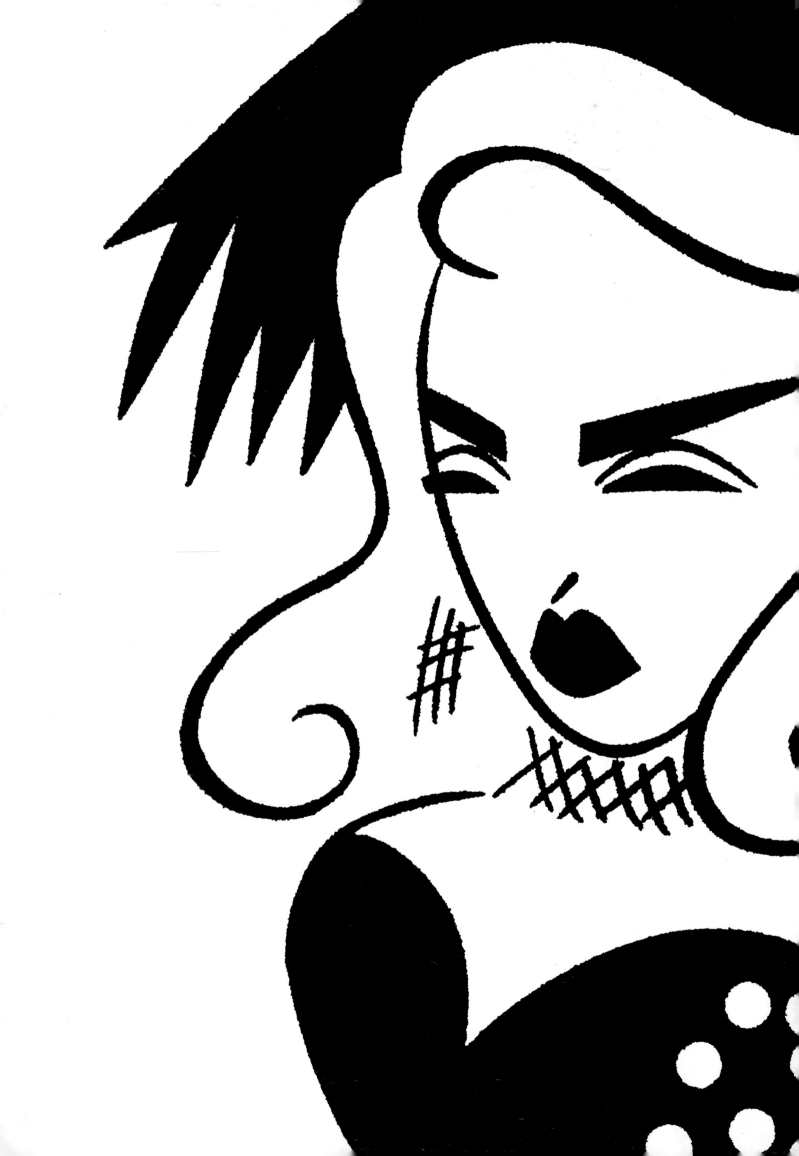

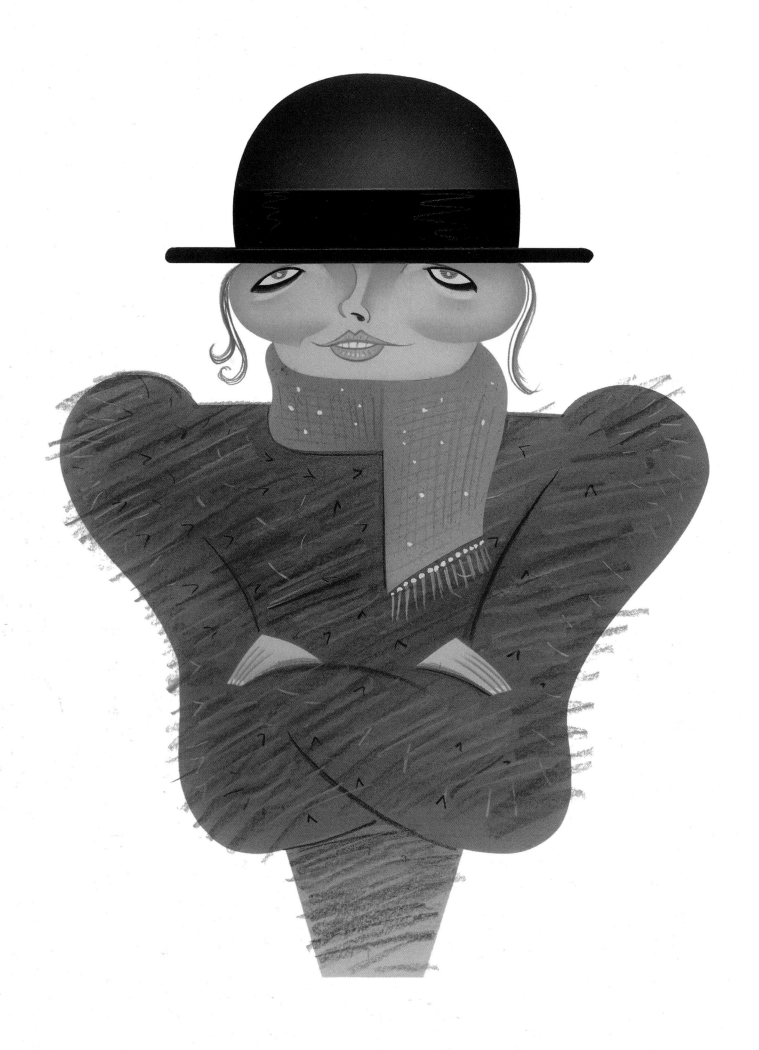

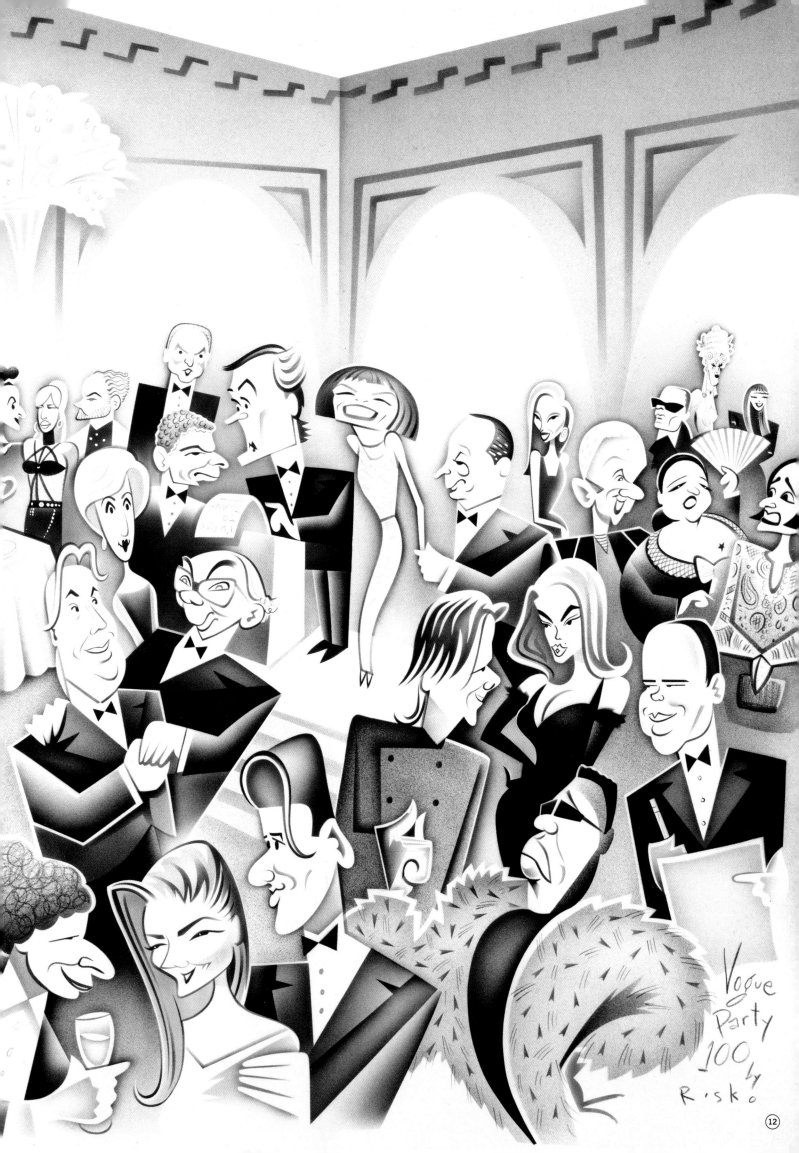

Vogue
Party
100 by
Risko

Risko

⑭

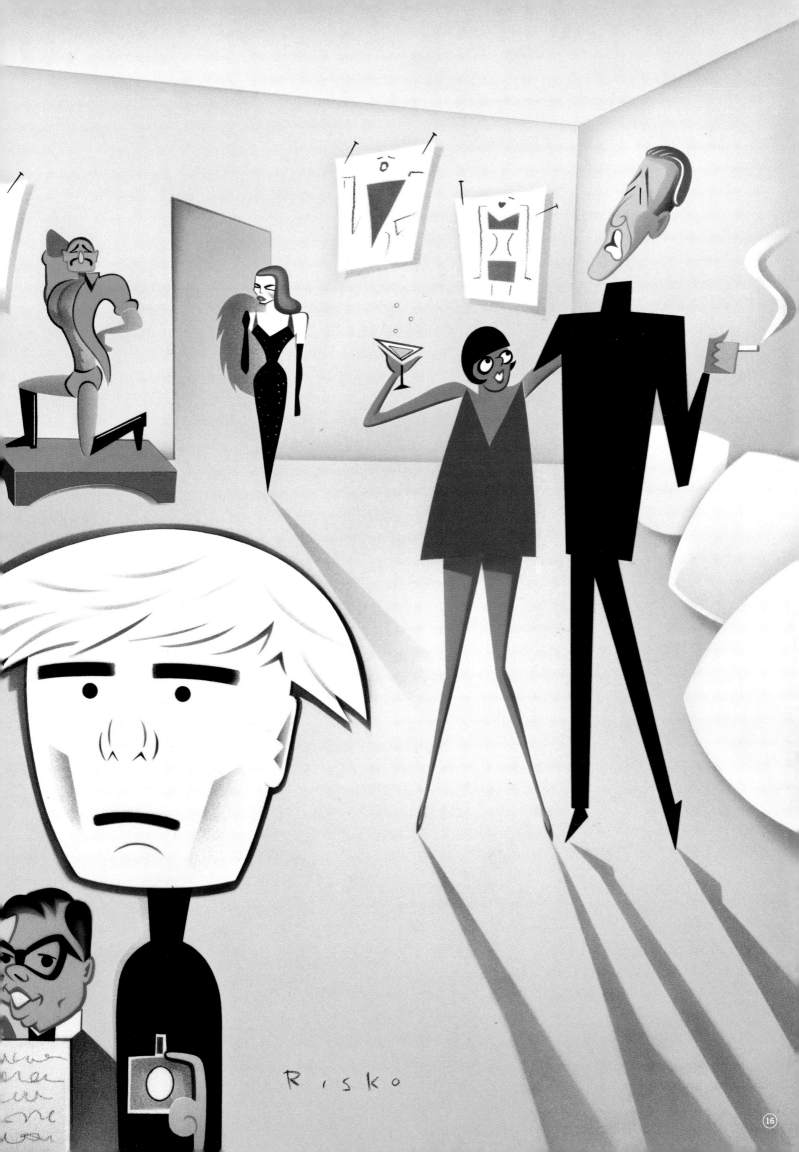

RISKO

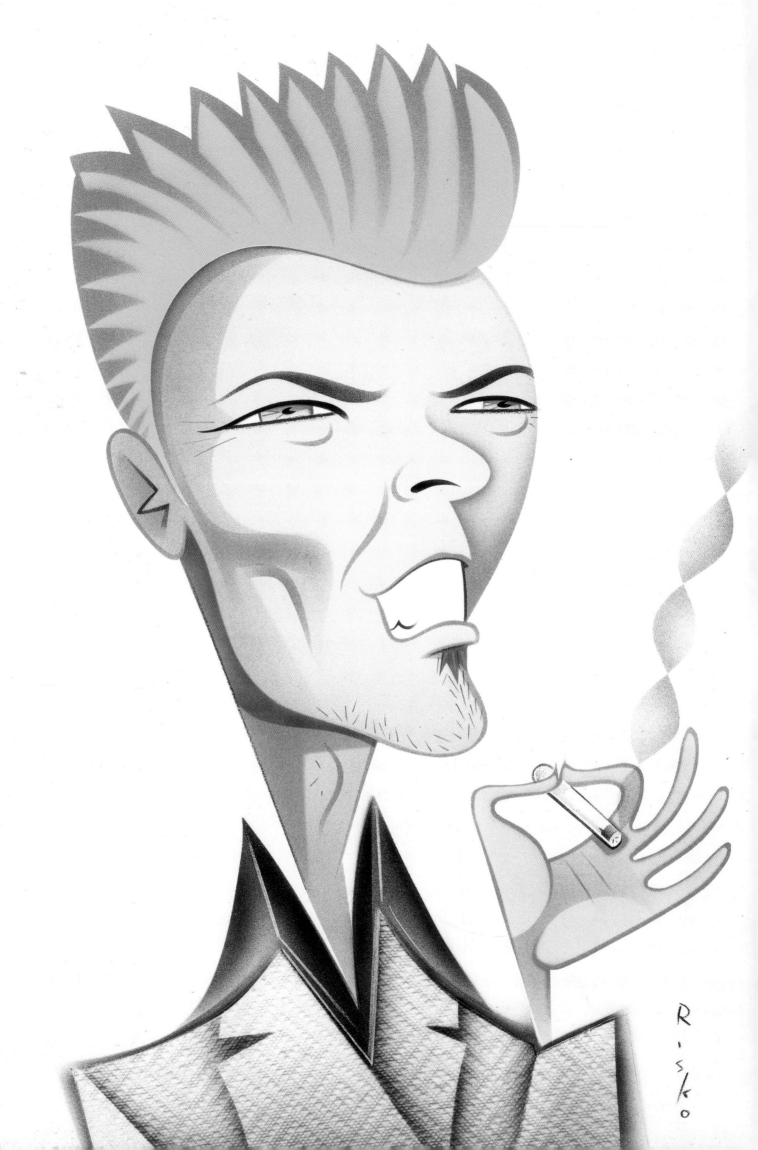

17

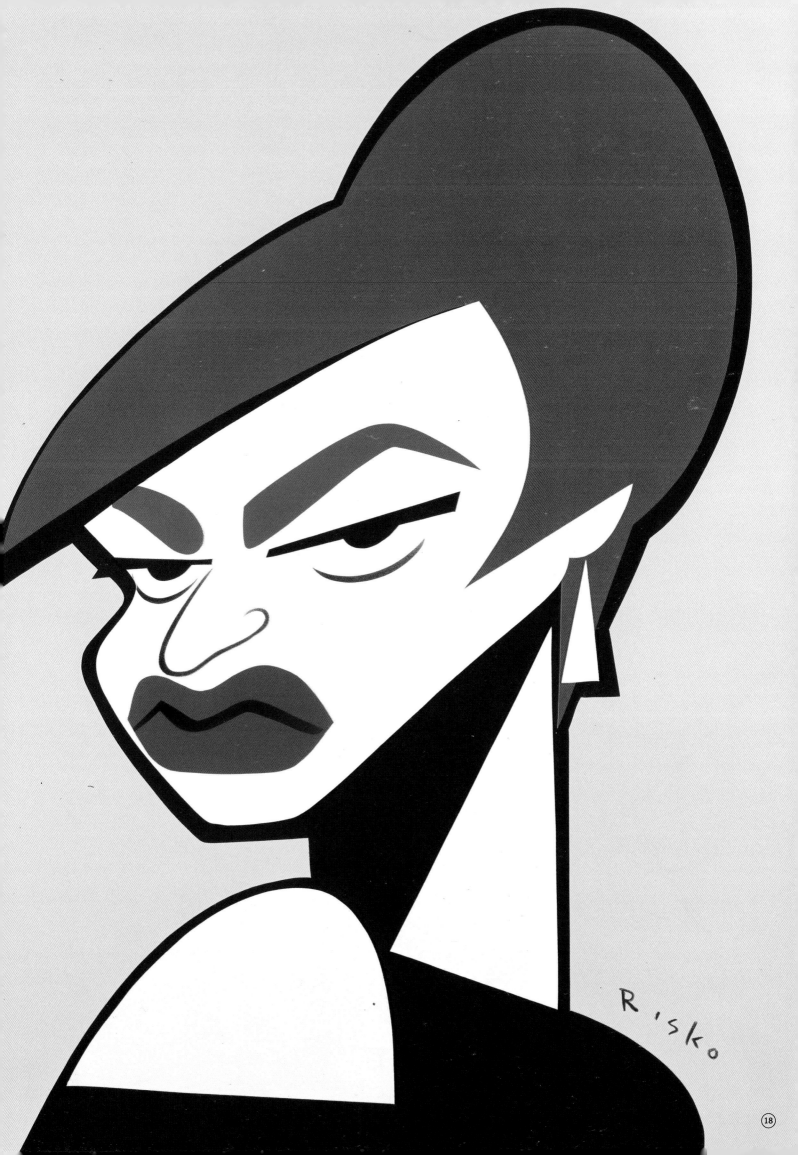

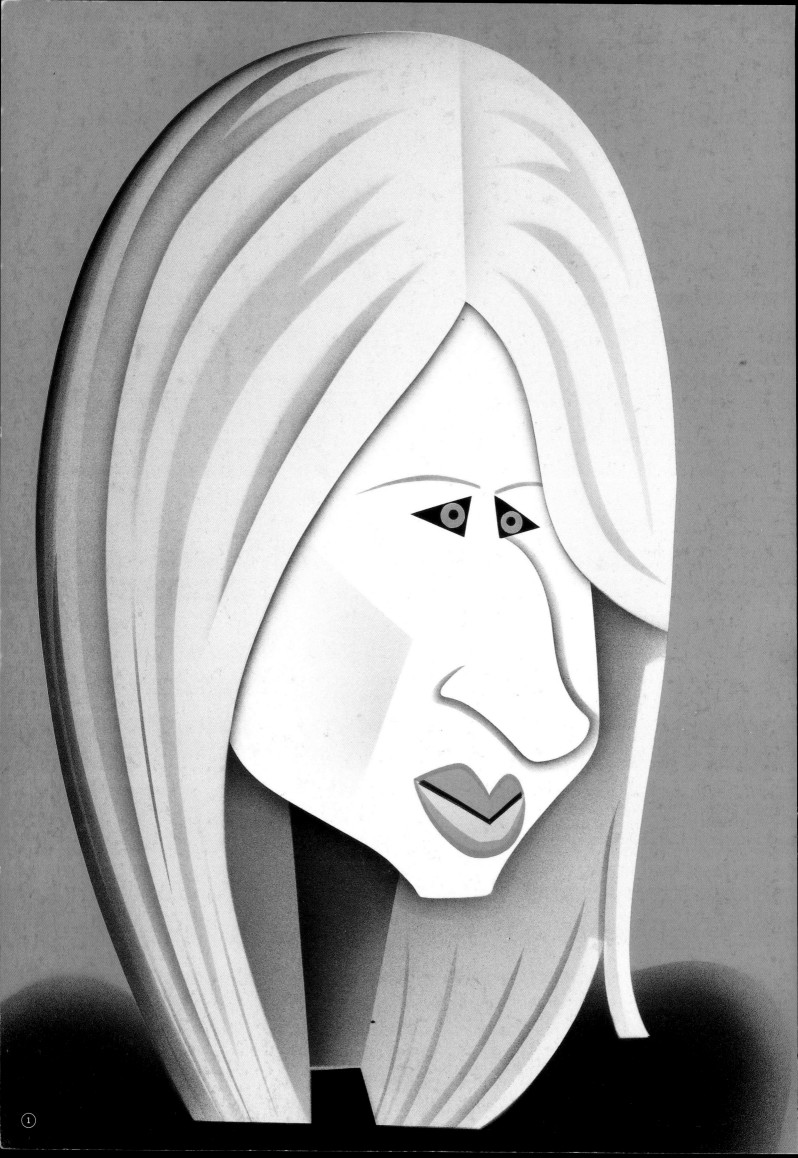

She kind of reminds me
of the Chrysler Building—fabulously unique
but doesn't blend in with anything else.

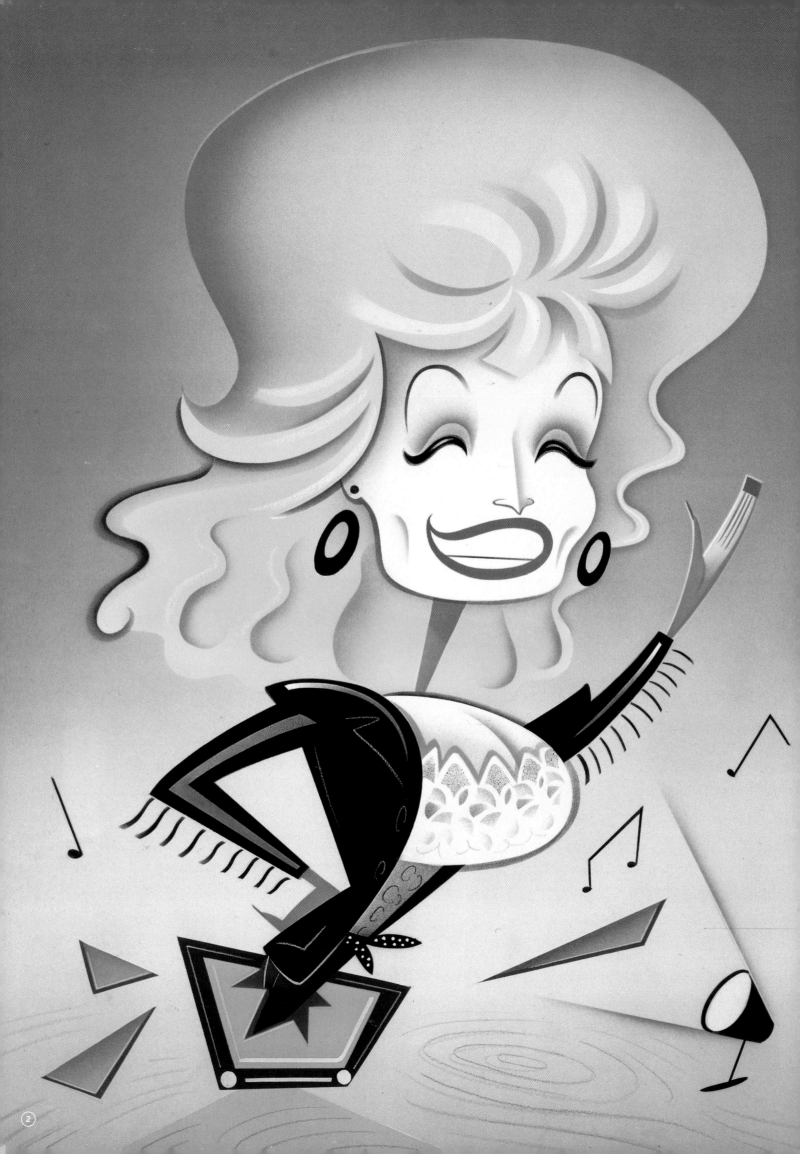

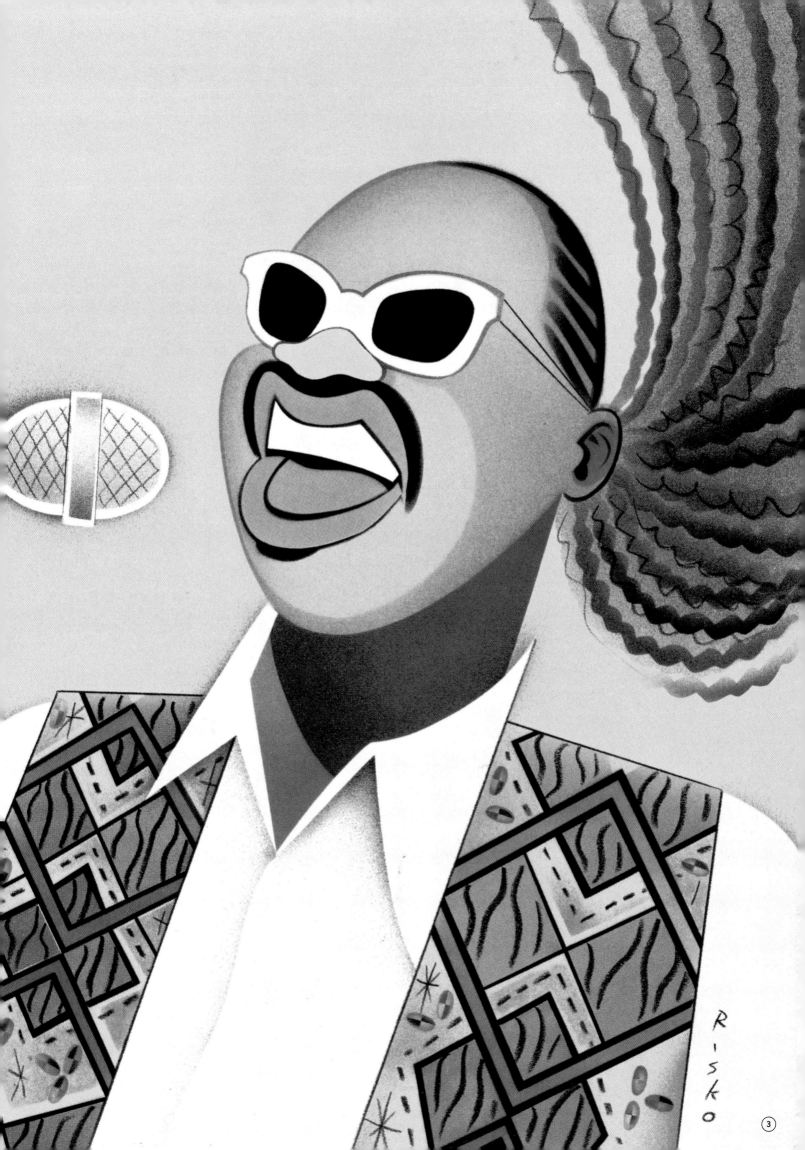

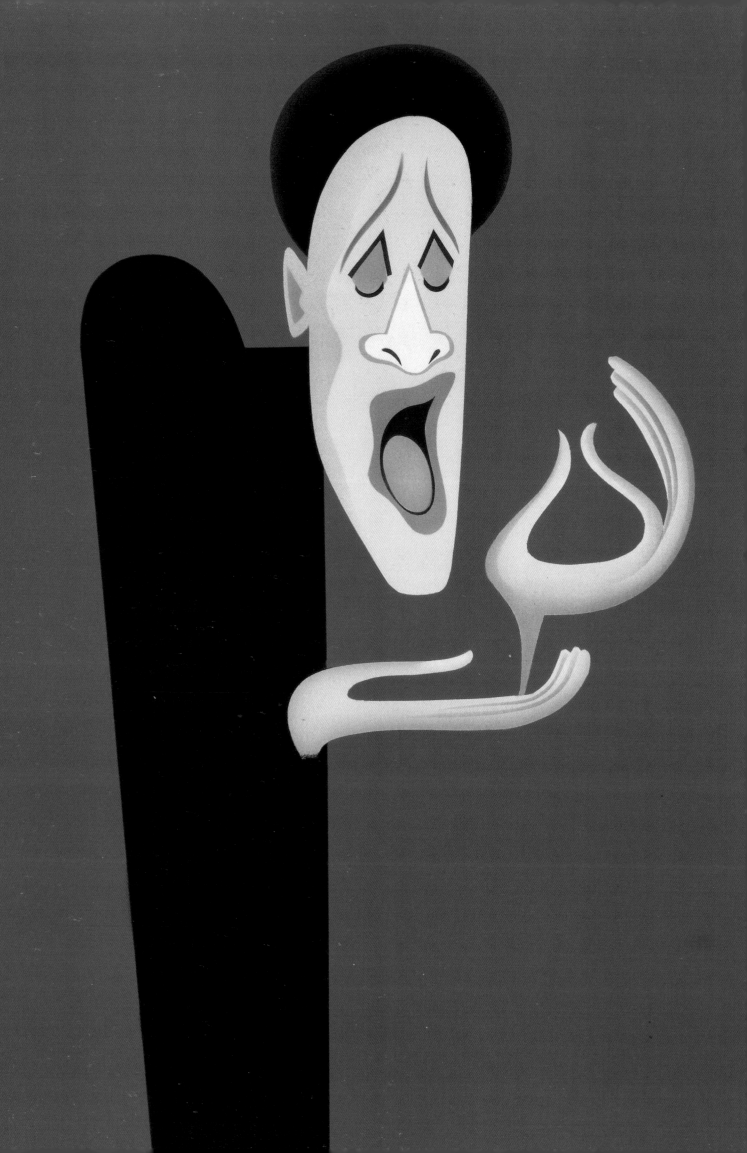

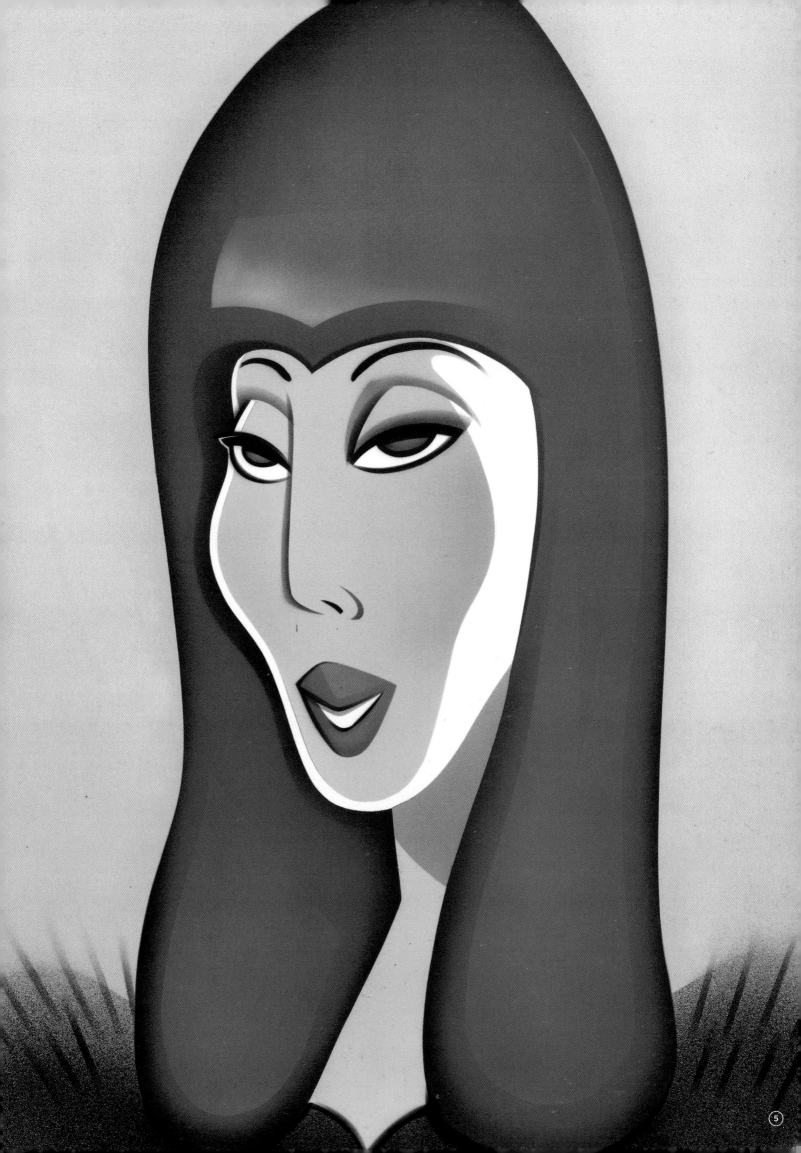

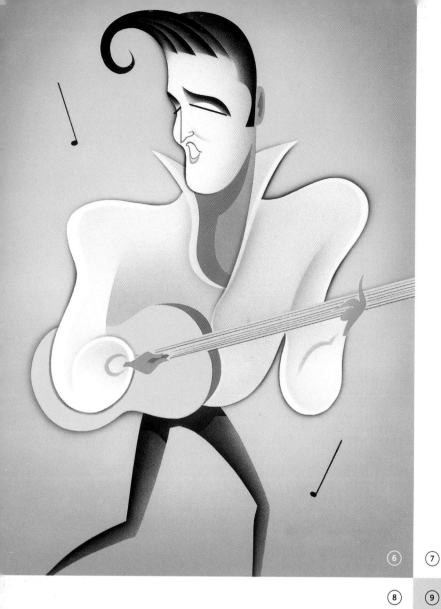

6

7

8

9

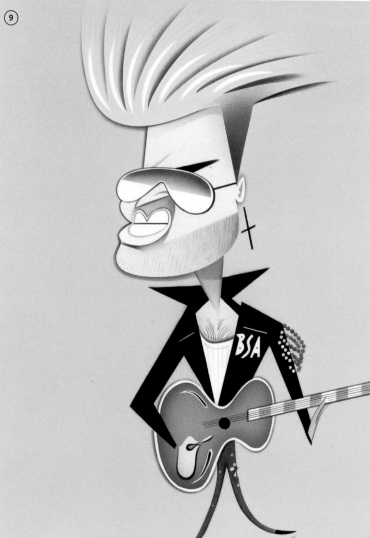

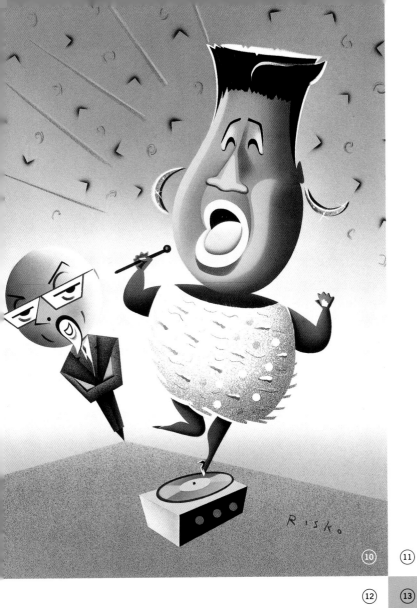

⑩

⑪

⑫
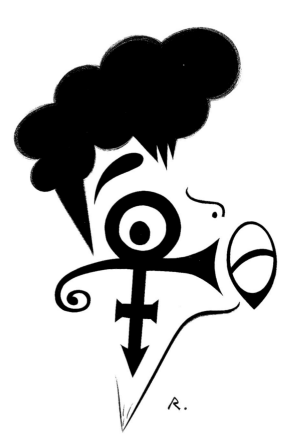

⑬
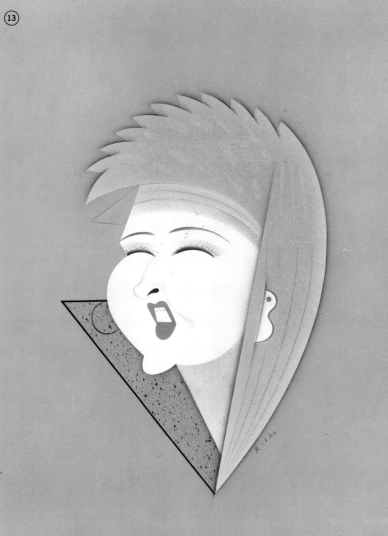

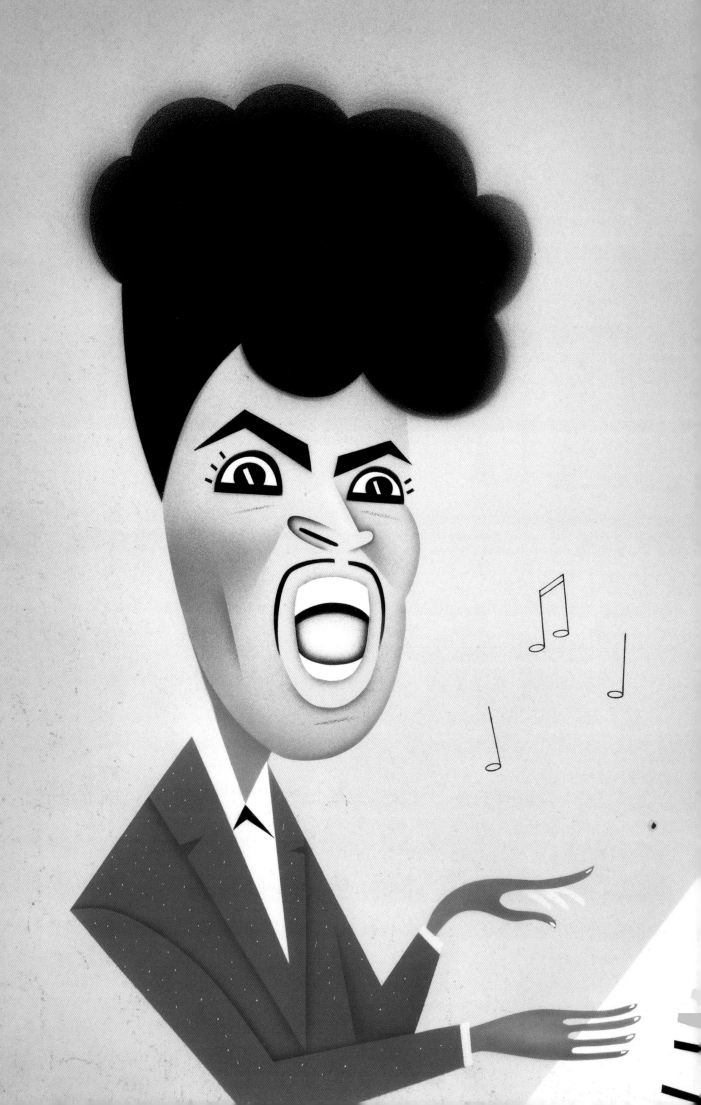

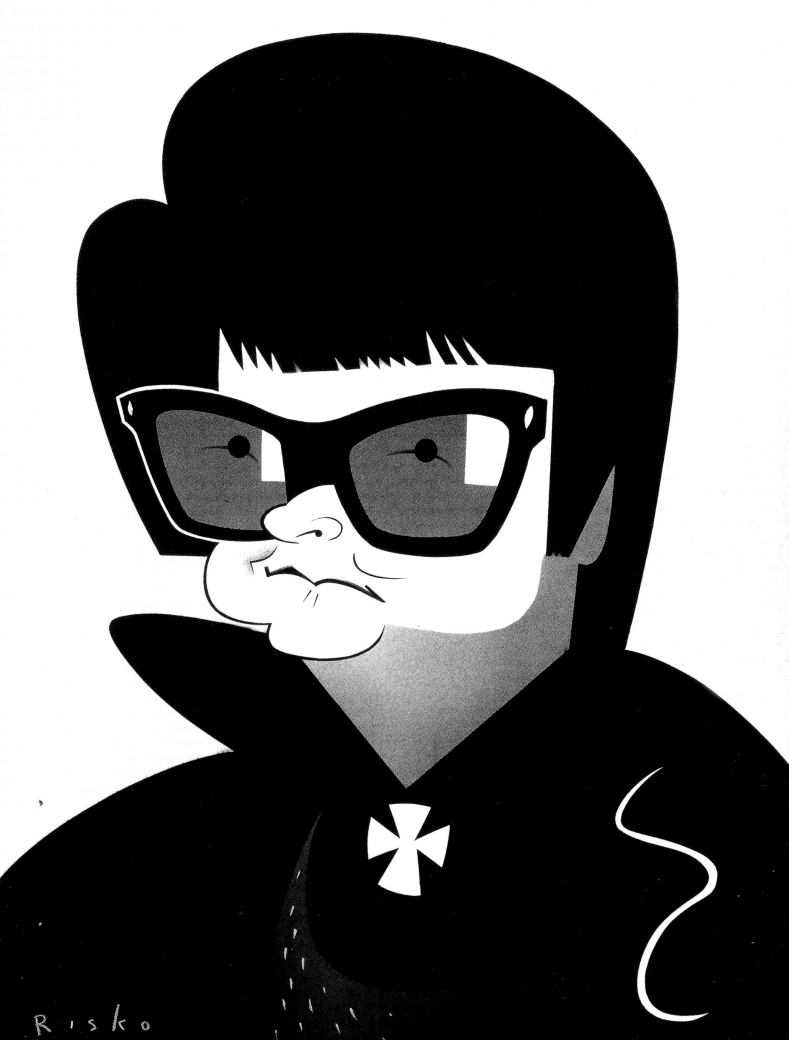

Risko

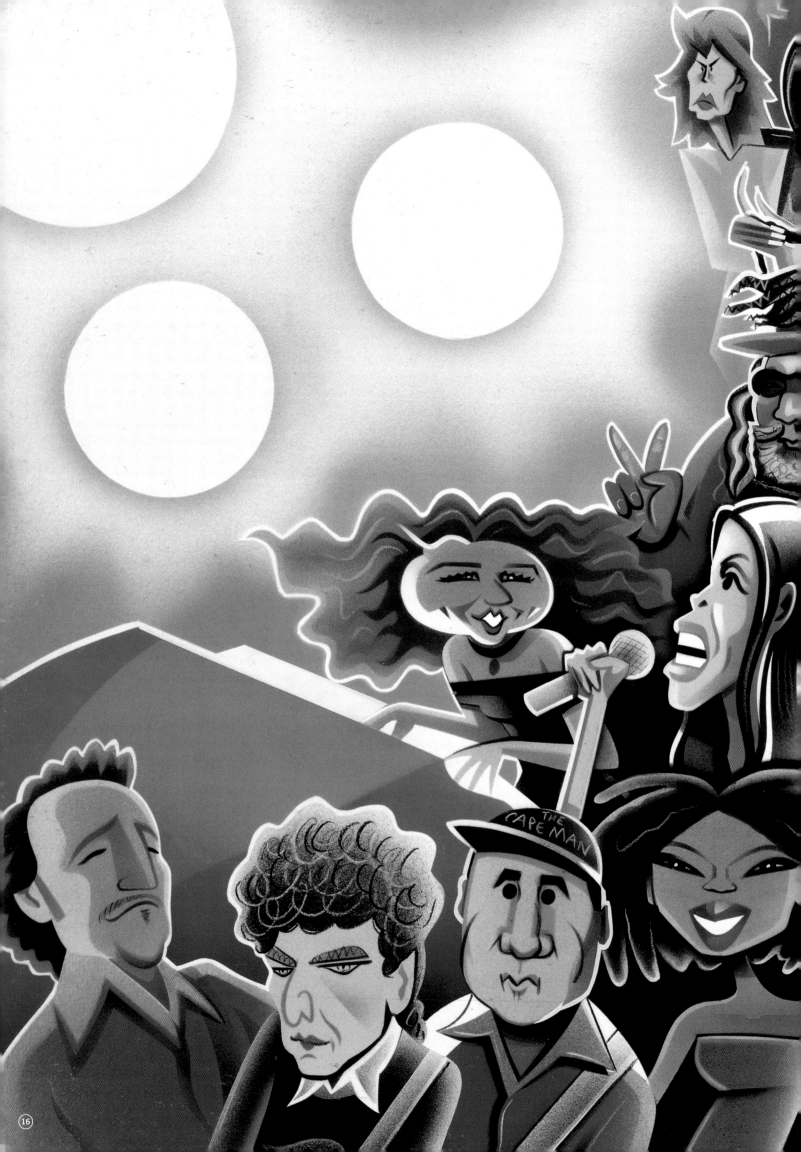

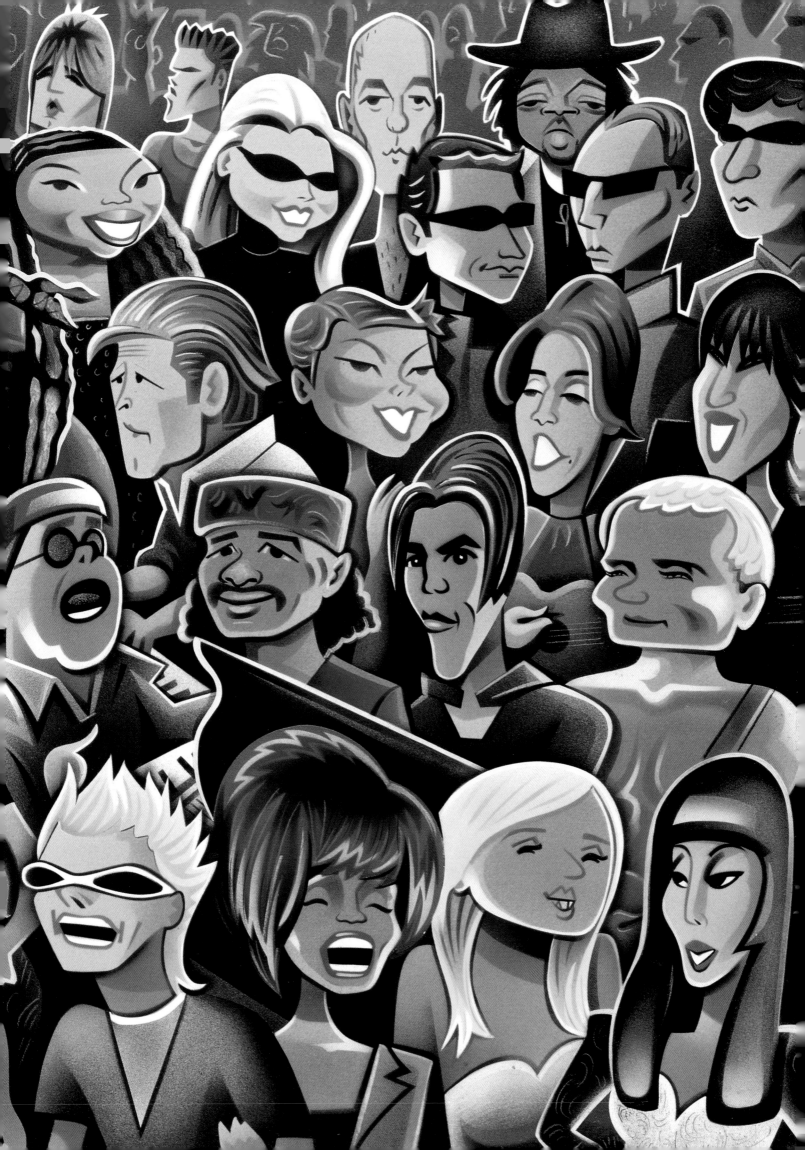

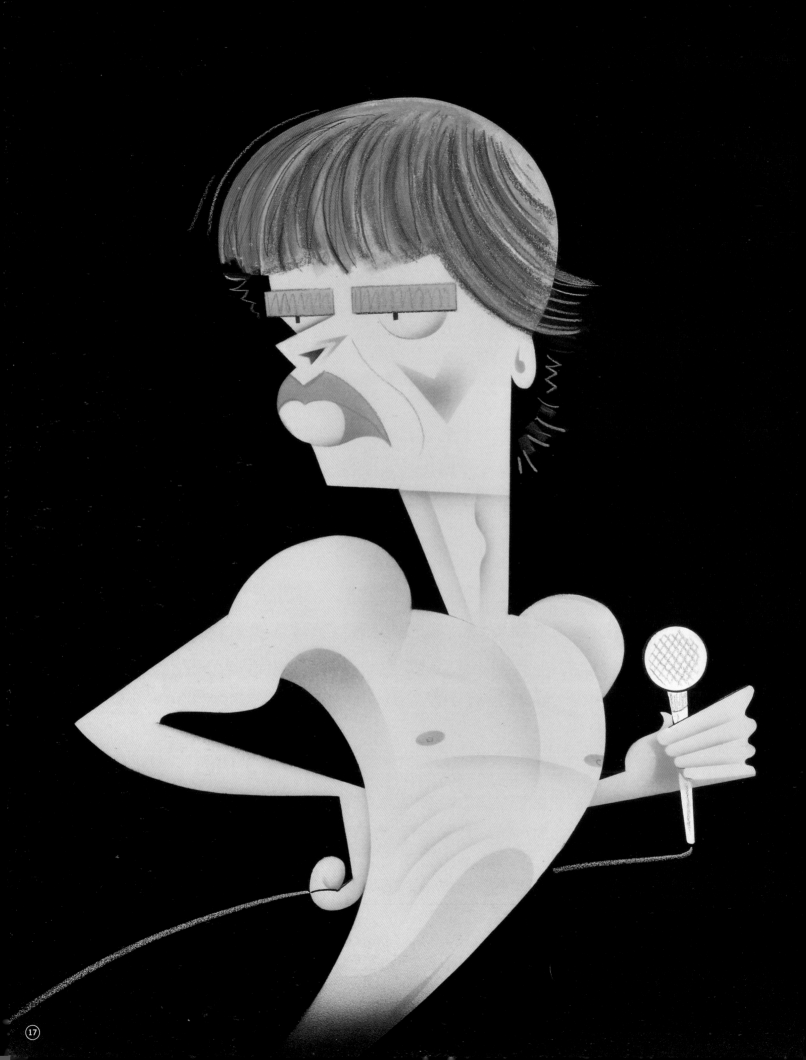

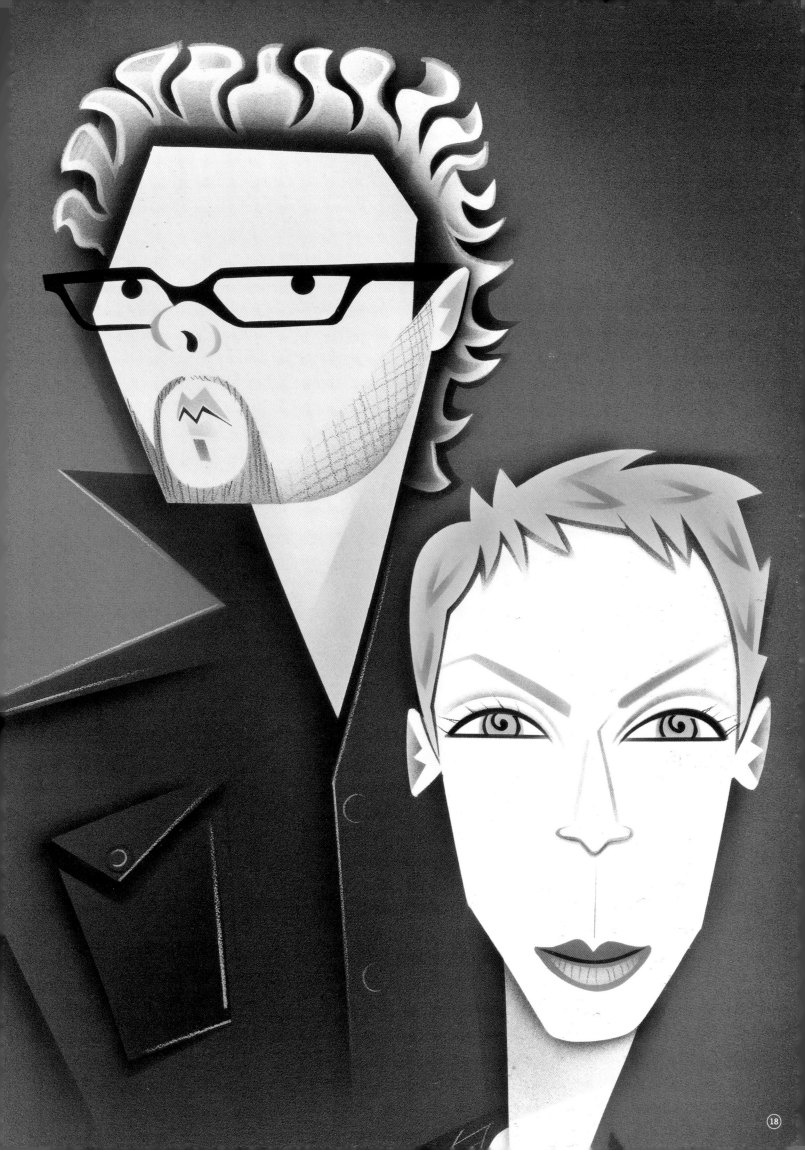

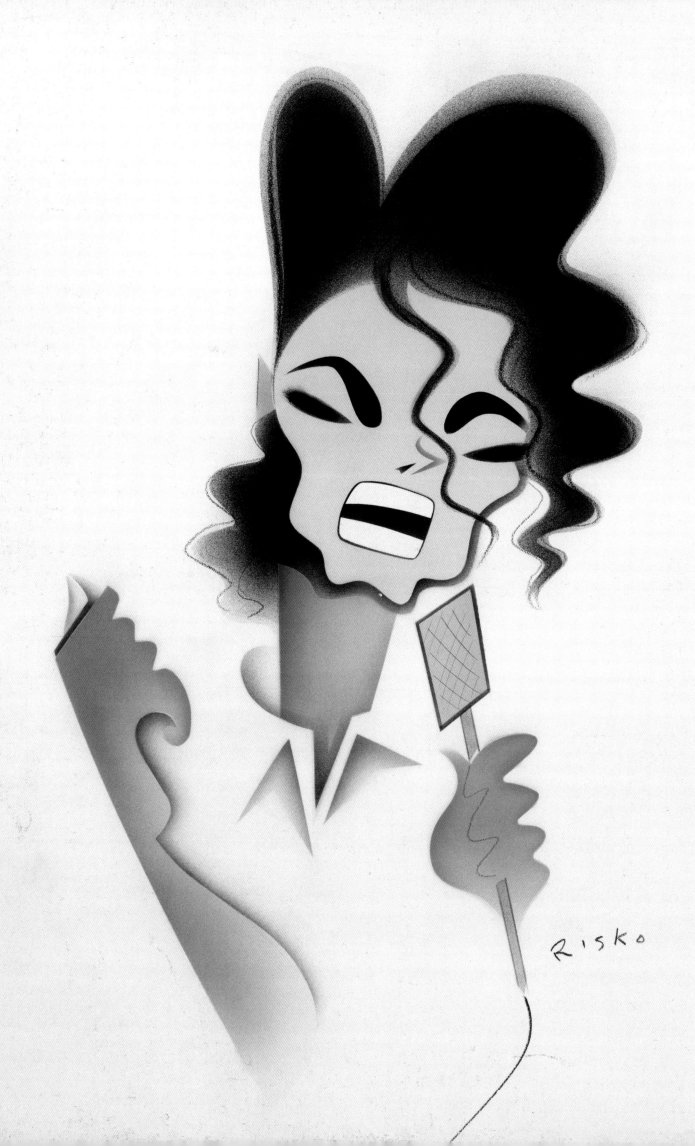

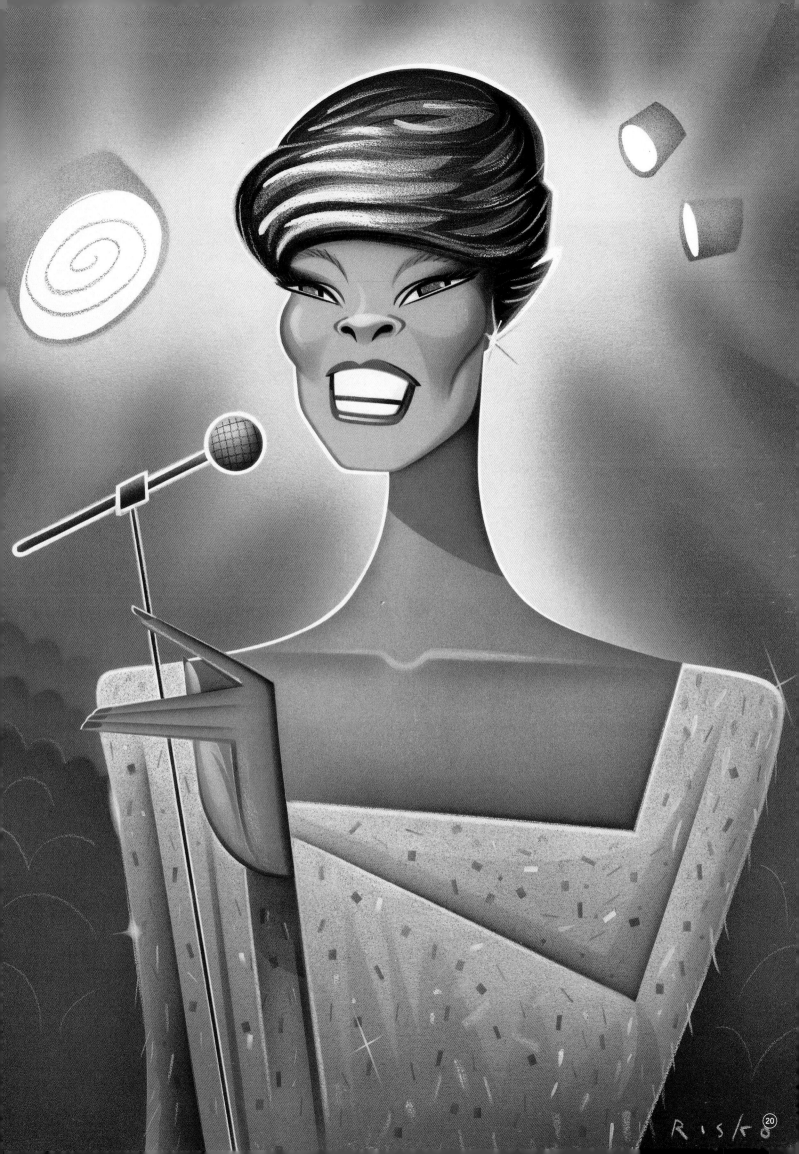

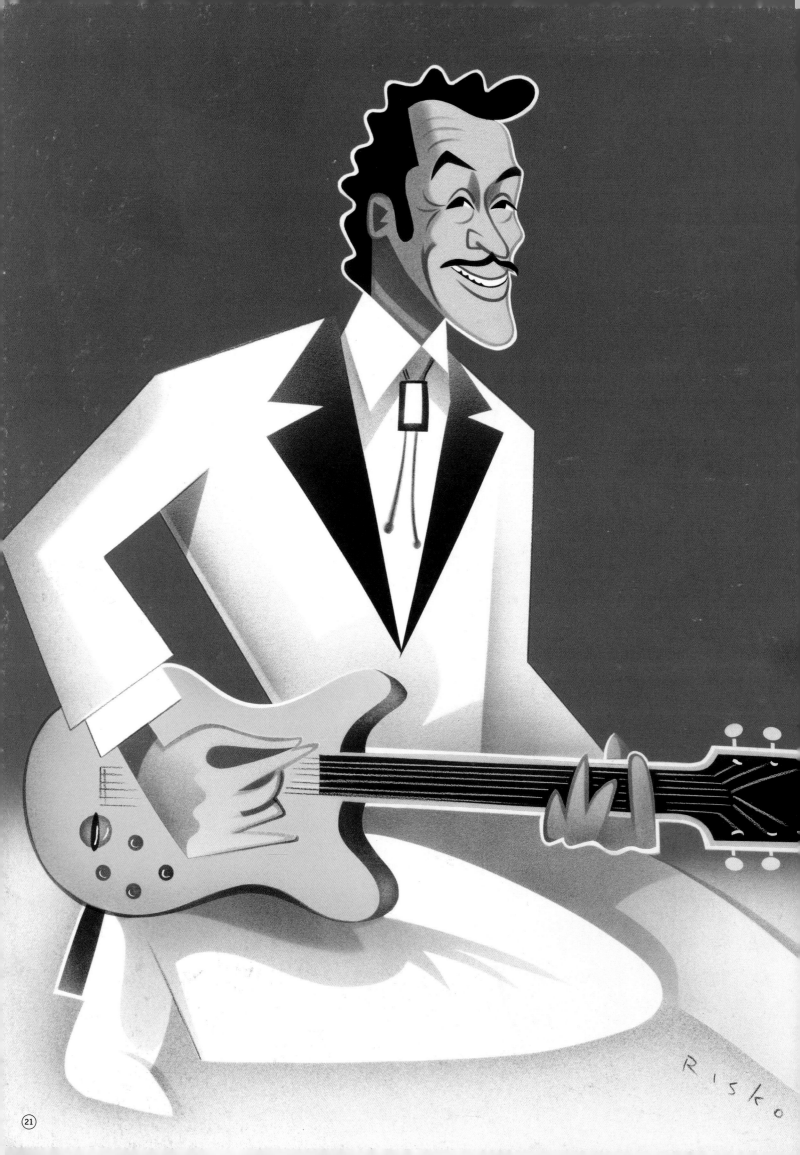

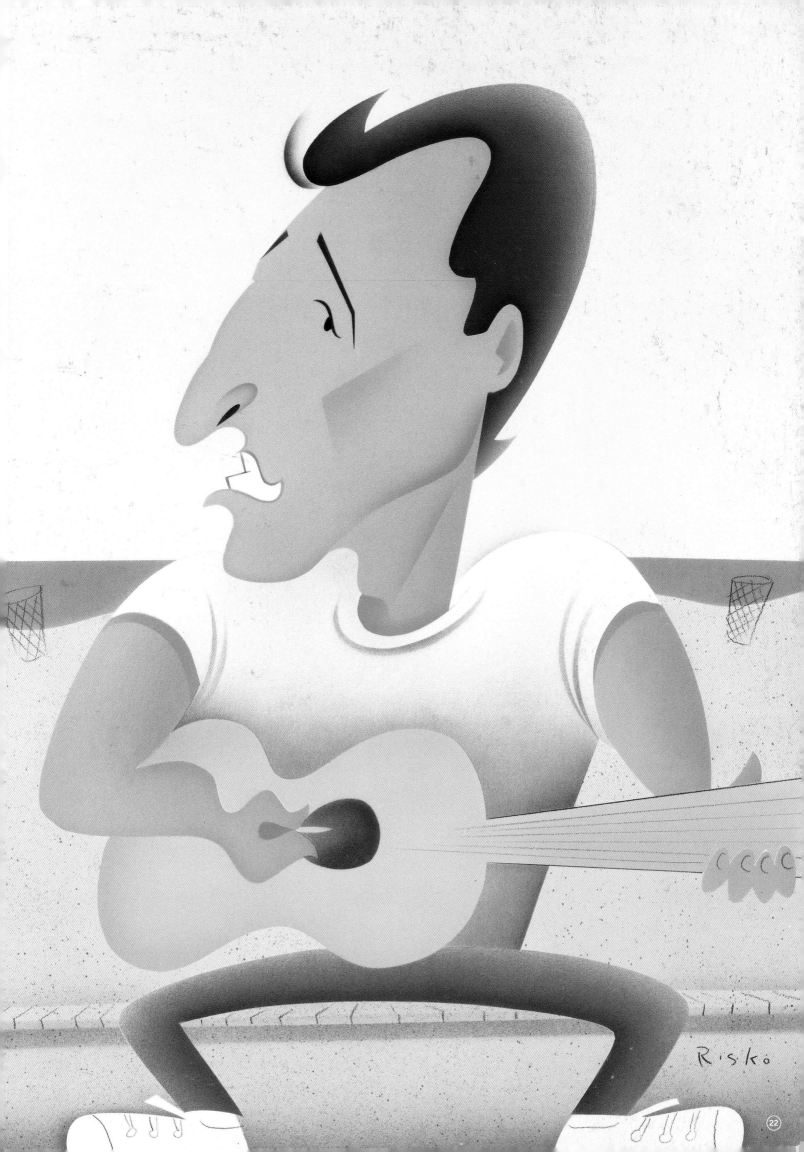

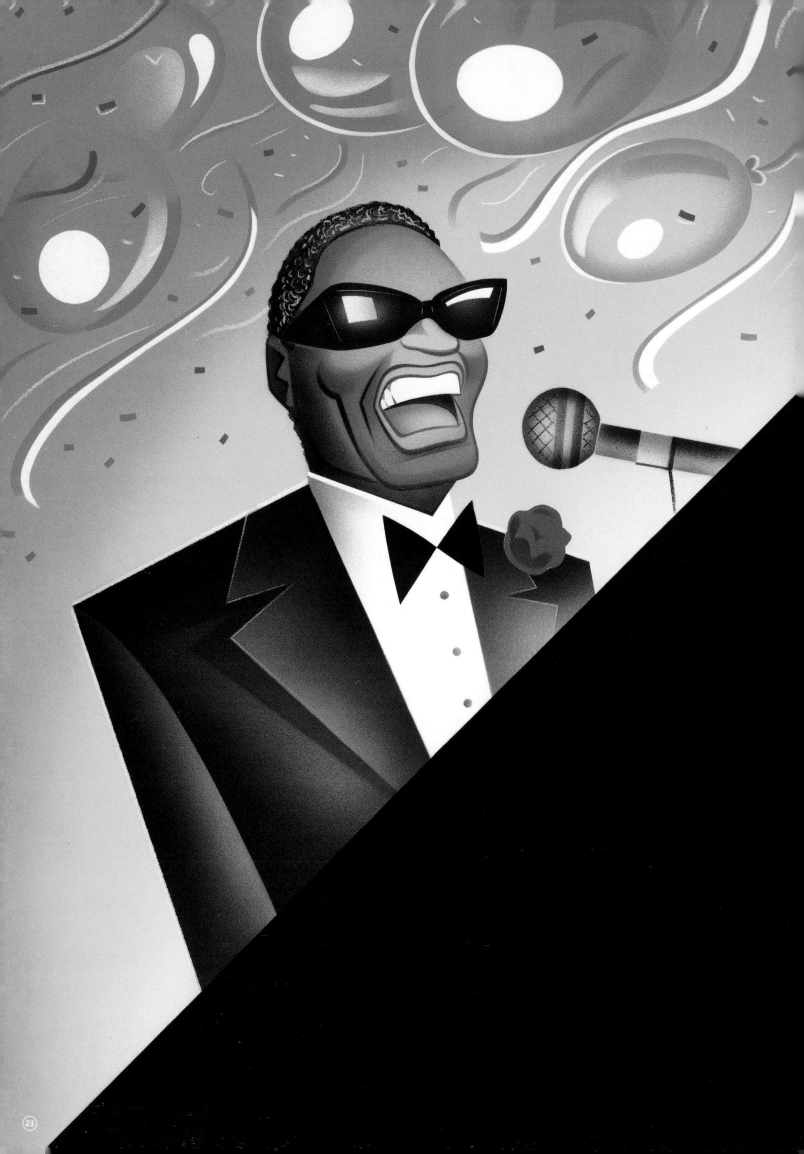

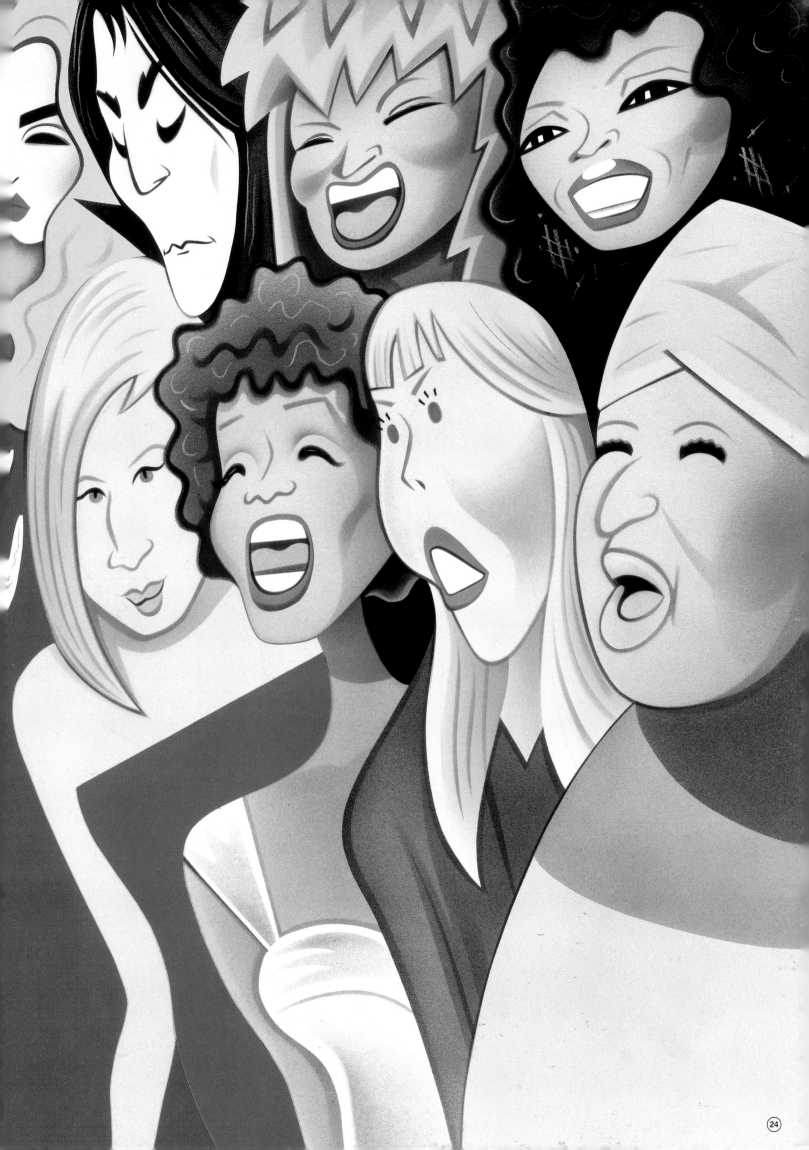

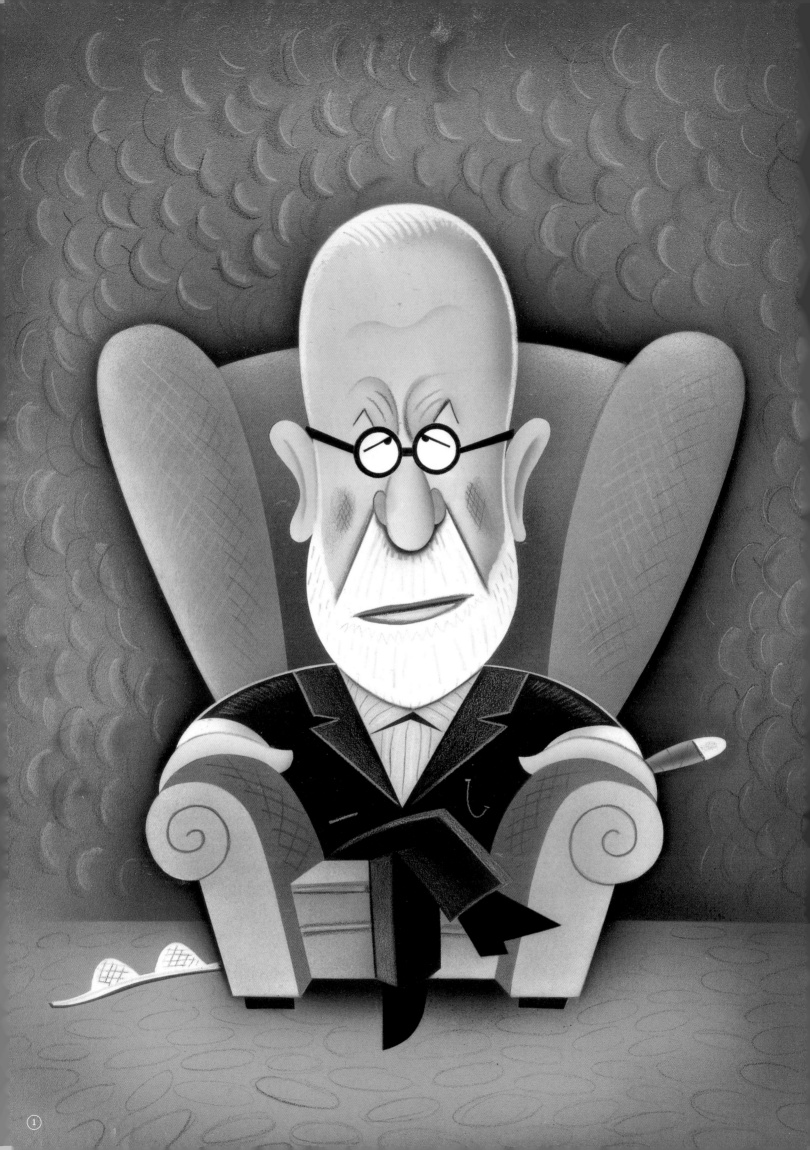

He figured out that everything boiled down
to sex but I don't think he was the first
to come to that conclusion.

① Sigmund Freud

② Carrie Fisher

③ Norman Lear

④ Gore Vidal

⑤ Paglia, Steinem, Friedan

⑥ Tom Wolfe

⑦ Jacqueline Susann

⑧ Stephen King

⑨ Fran Lebowitz

⑩ Dominick Dunne

⑪ Gail Sheehy

⑫ Artists and Writers

⑬ Kurt Vonnegut

⑭ Truman Capote

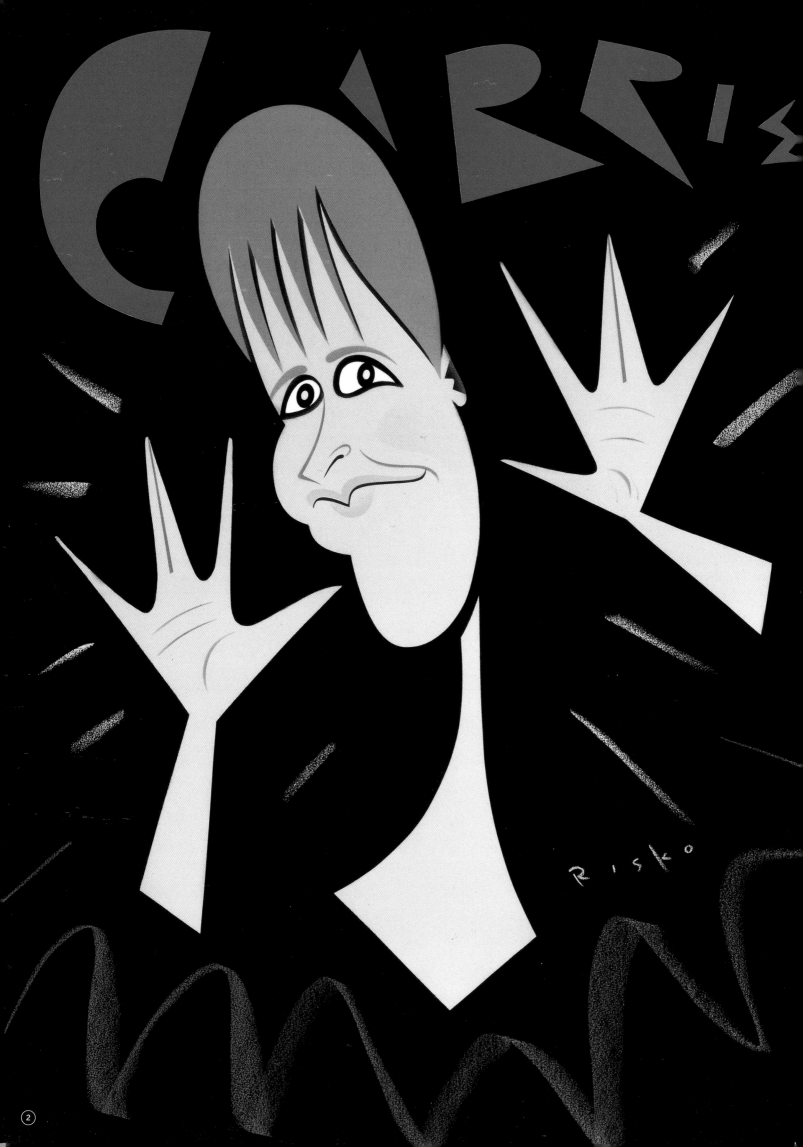

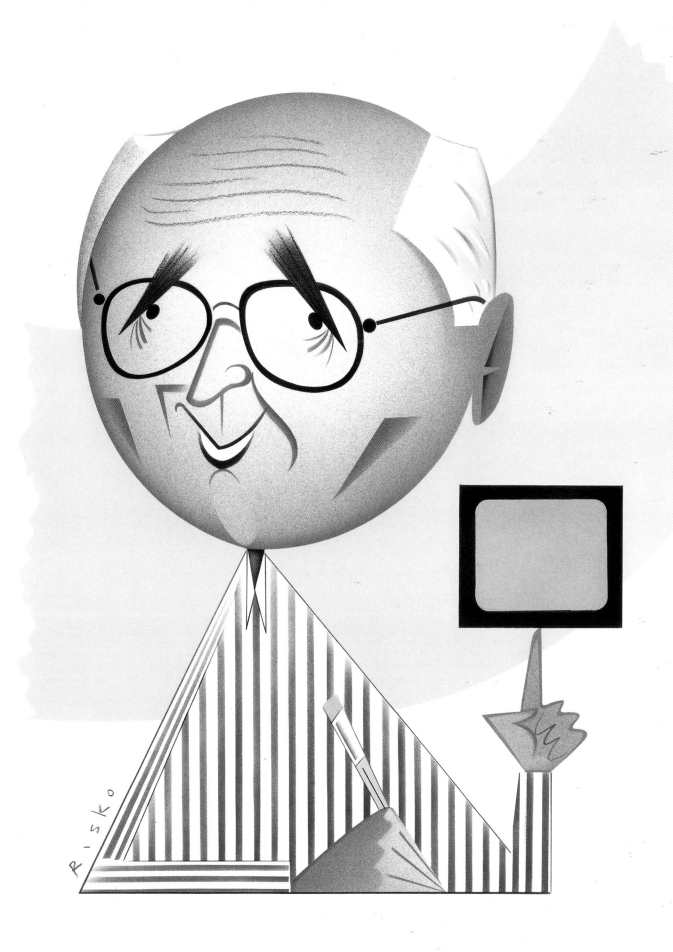

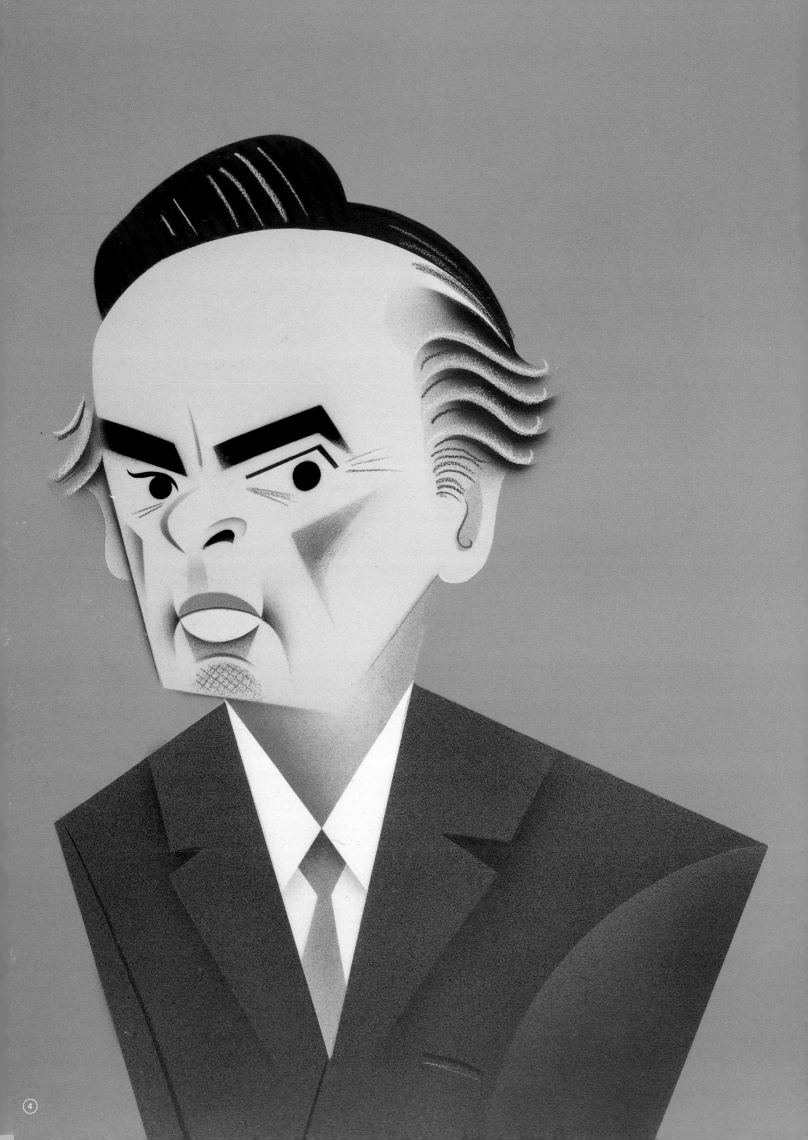

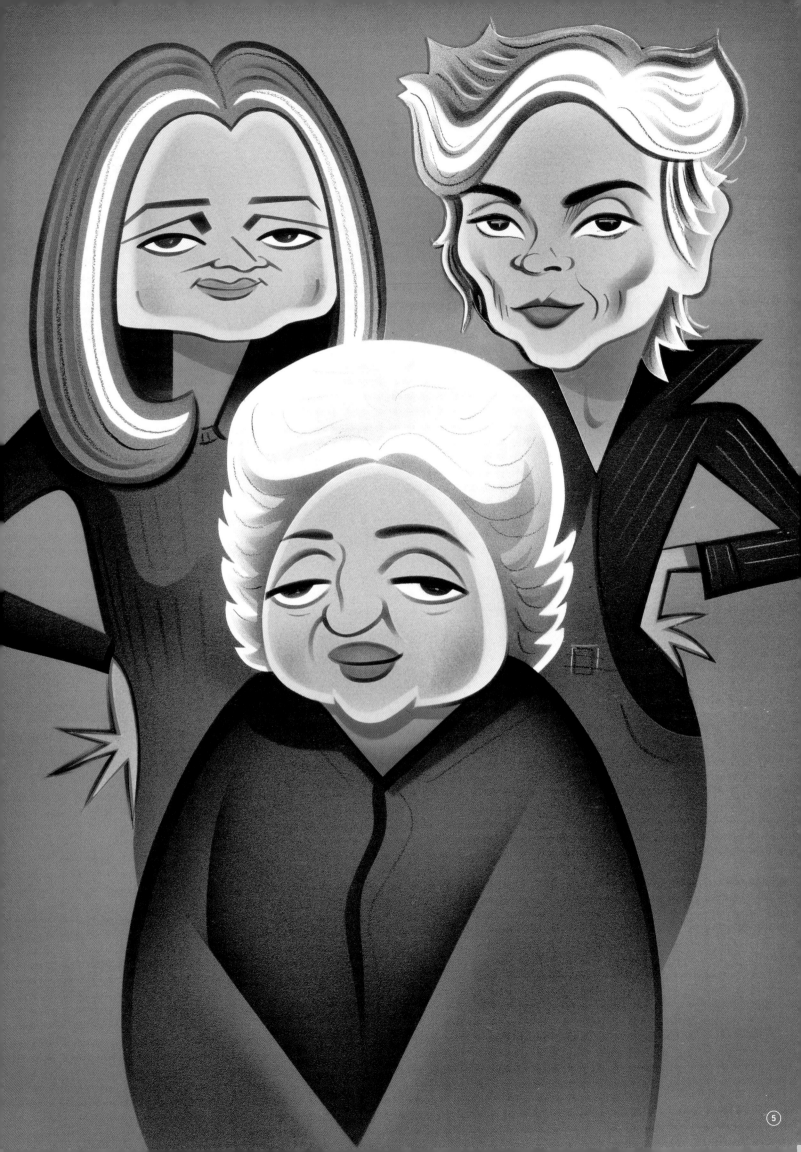

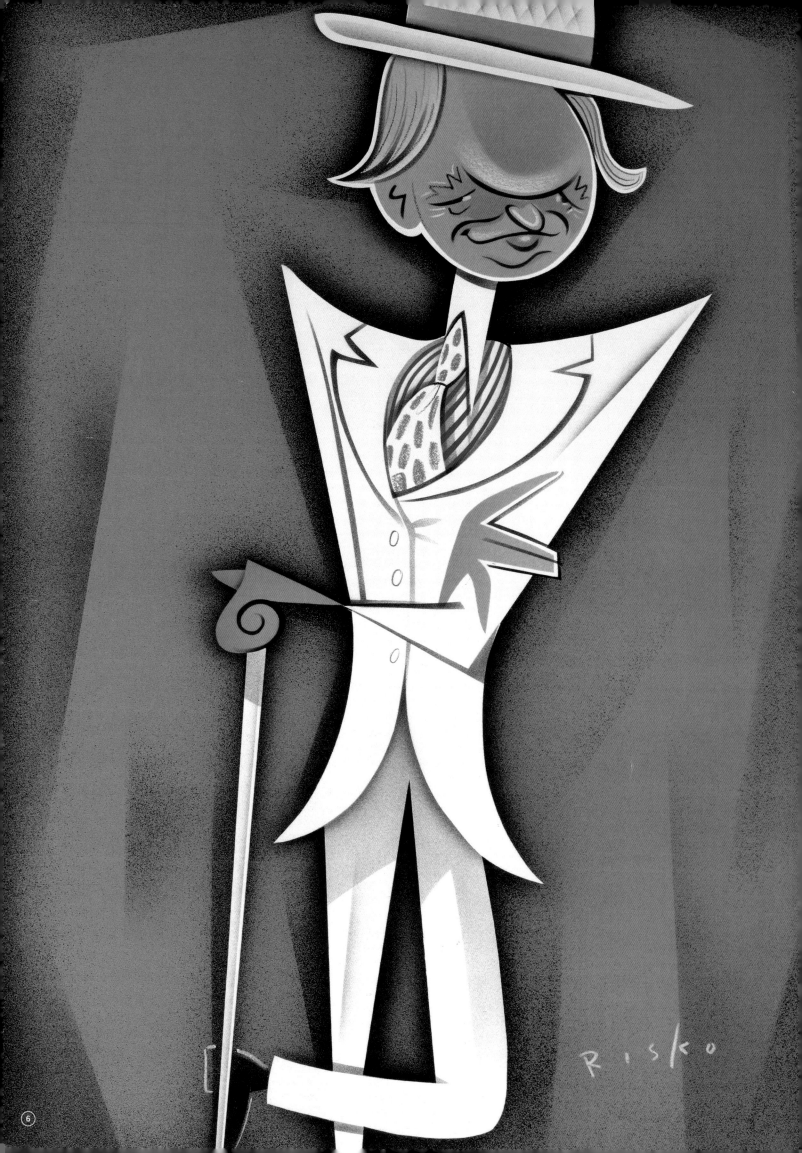

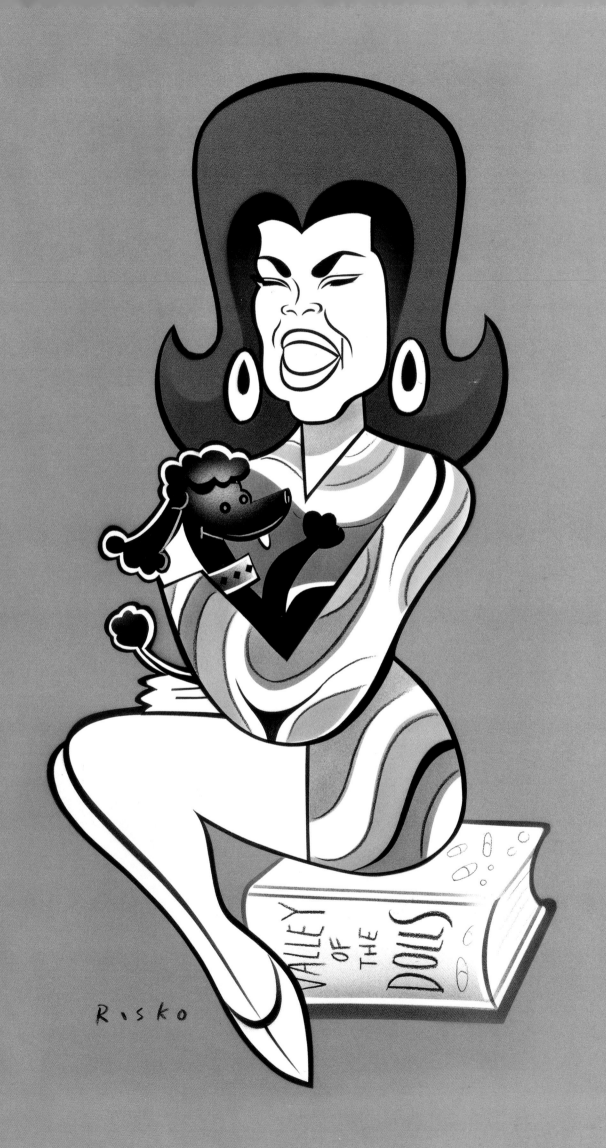

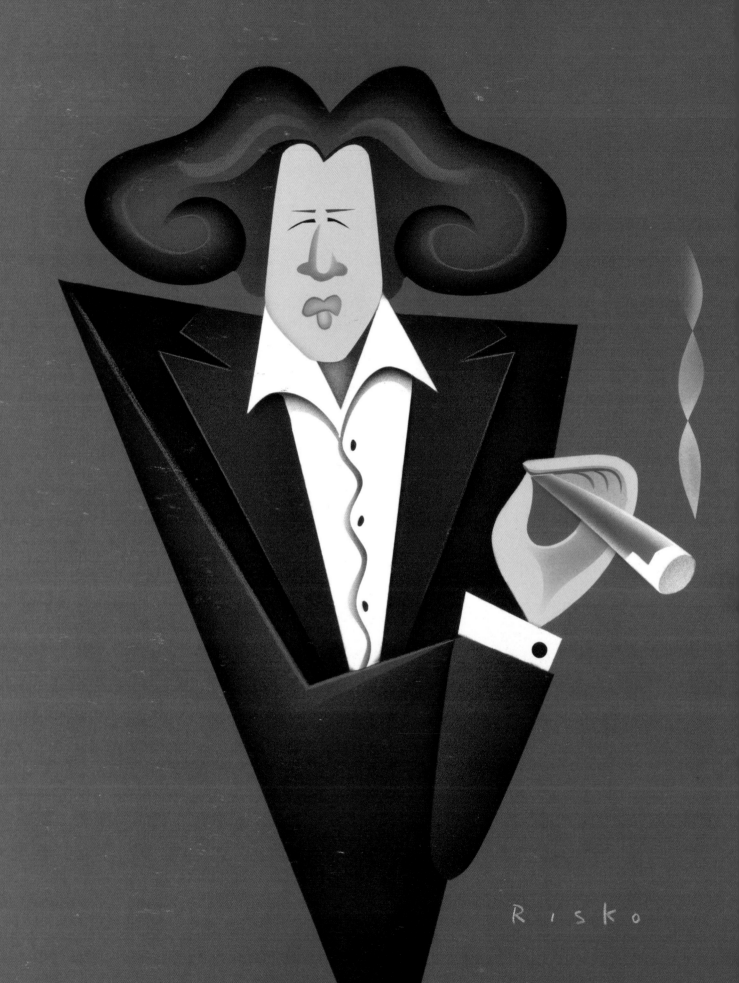

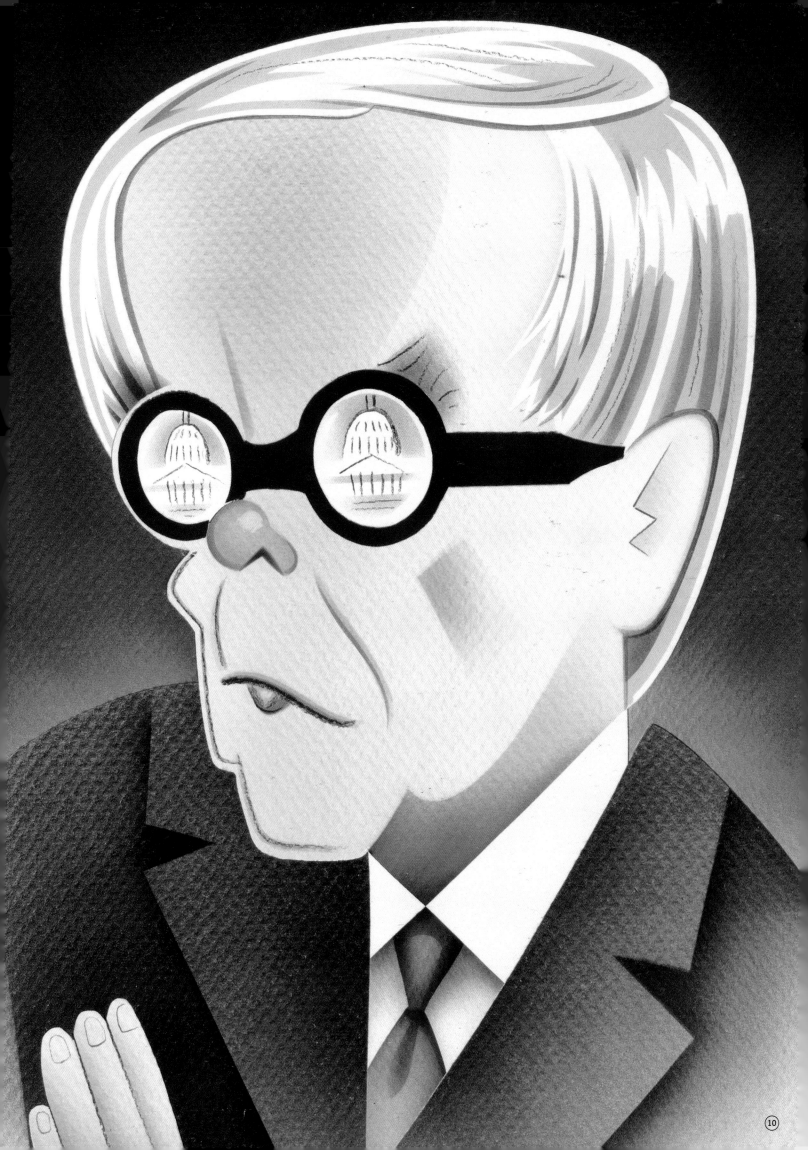

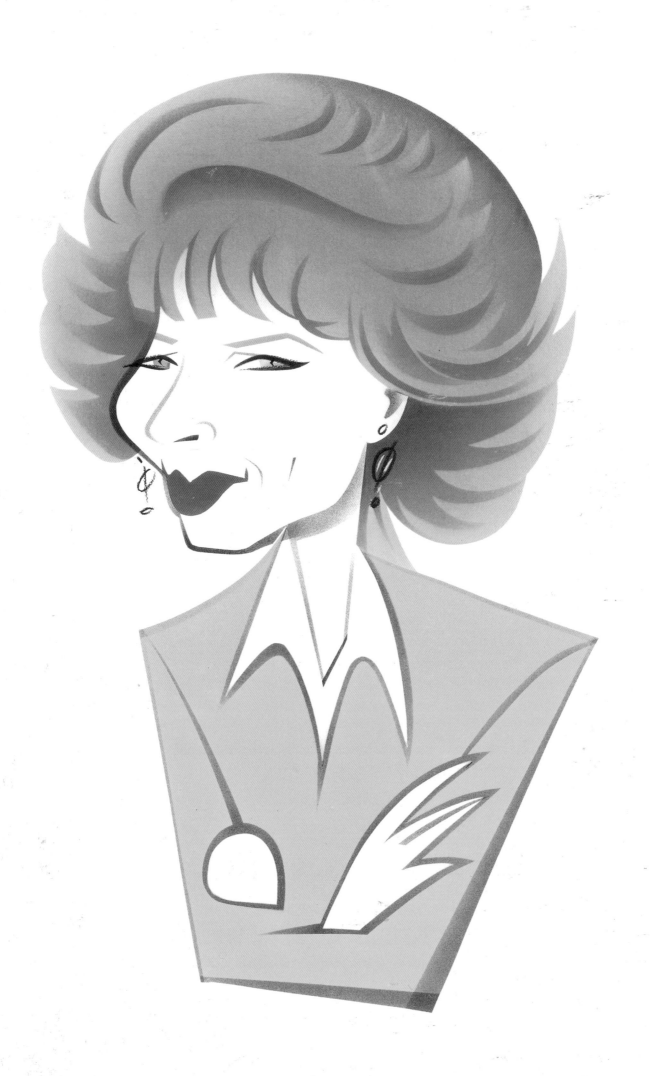

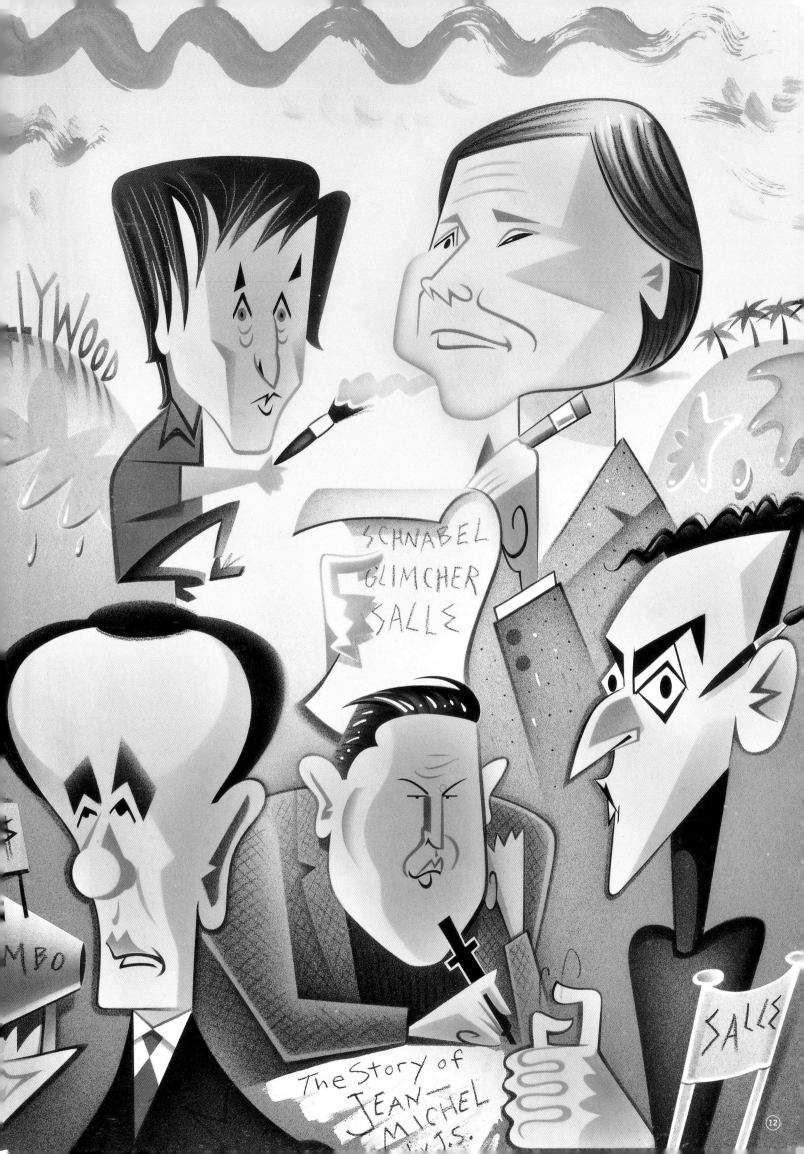

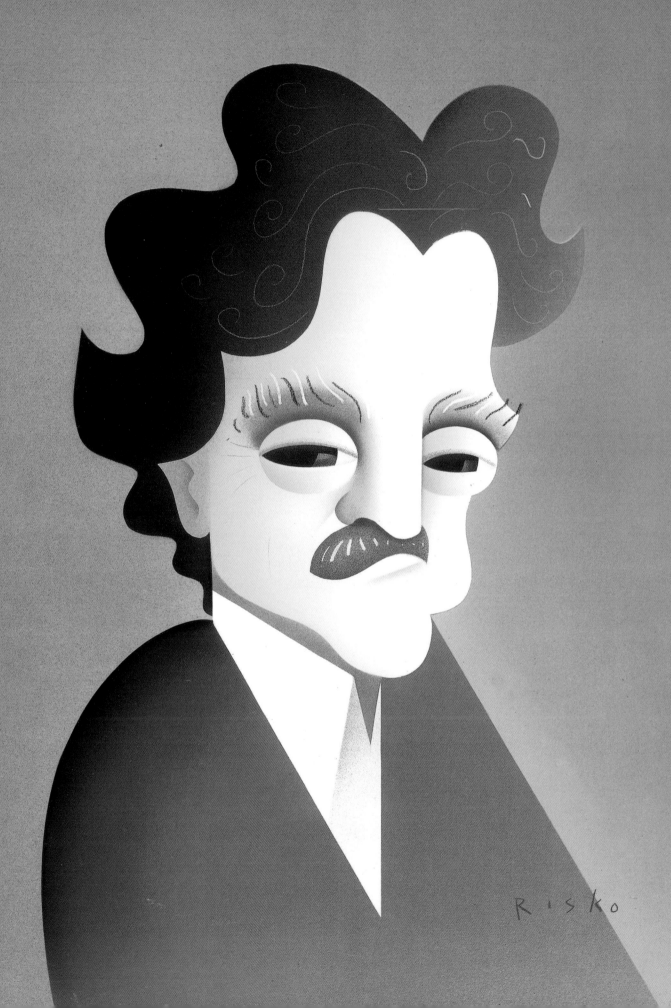

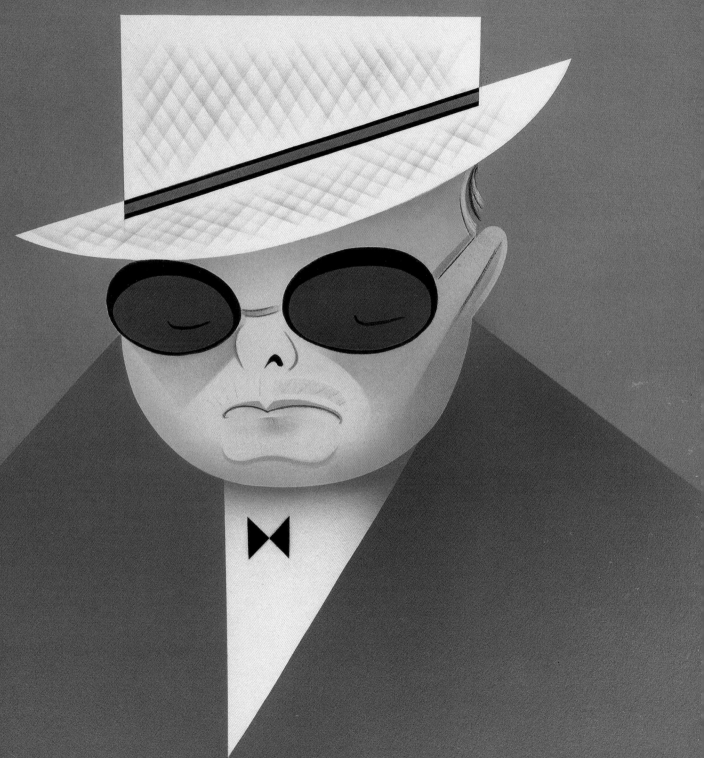

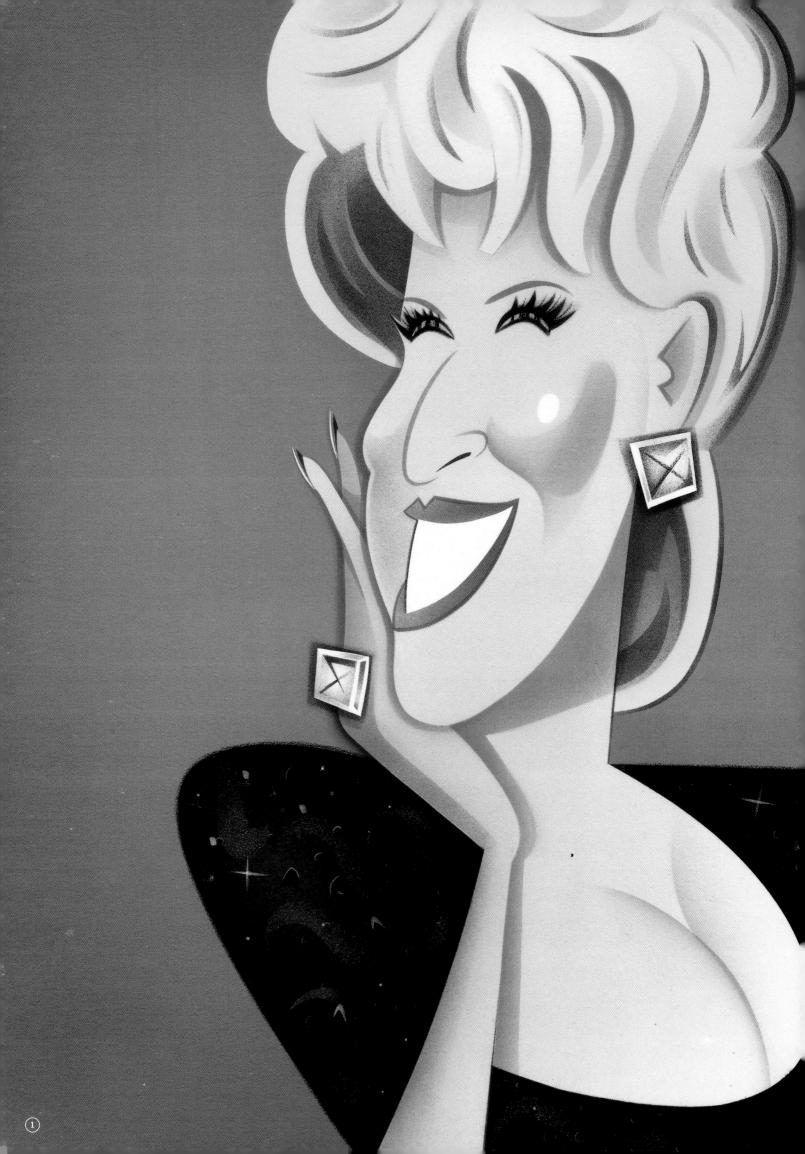

She has the same effect as mustard
on a hot dog. She takes a boring piece of meat
and gives it a sense of humor.

1 Bette Midler 16 Marilyn Monroe

2 Jack Nicholson 17 Edward Scissorhands

3 Christian Slater 18 Ron Howard

4 Cathérine Deneuve 19 De Niro and Thurman

5 E.T. 20 Grease

6 Lily Tomlin 21 Mrs. Doubtfire

7 Titanic 22 Out Cold

8 Sir Laurence Olivier 23 Sylvester Stallone

9 Macaulay Culkin 24 Boogie Nights

10 Jim Carrey 25 Spike Lee

11 Michael Caine 26 Mike Nichols

12 Julia Roberts 27 Hollywood Beach

13 John Travolta 28 Paul Newman

14 Babe 29 Goldie Hawn

15 Private Lives

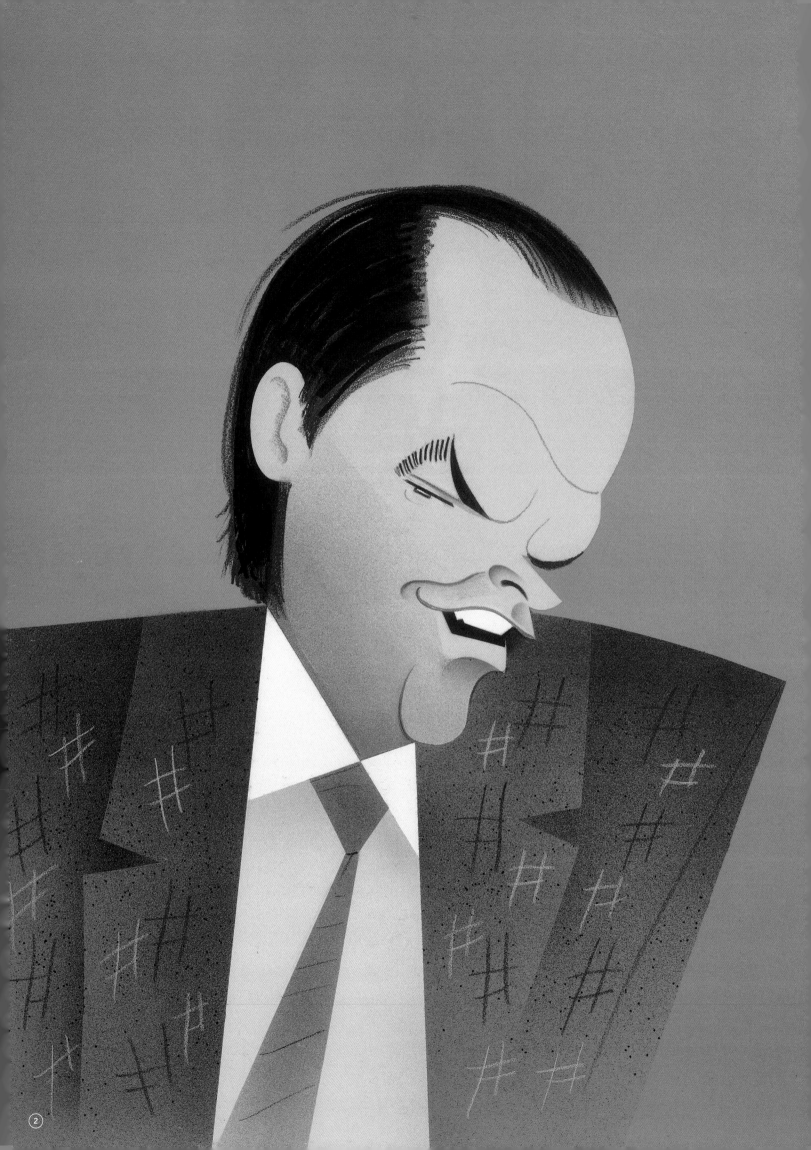

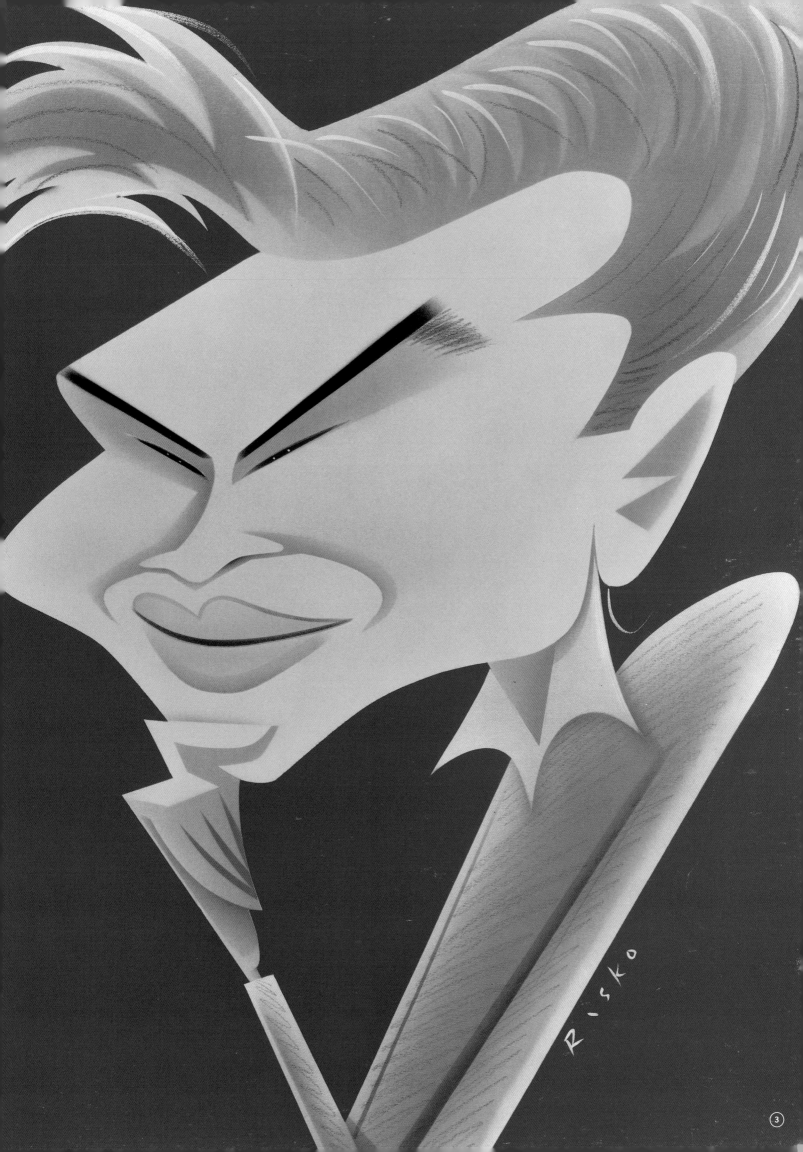

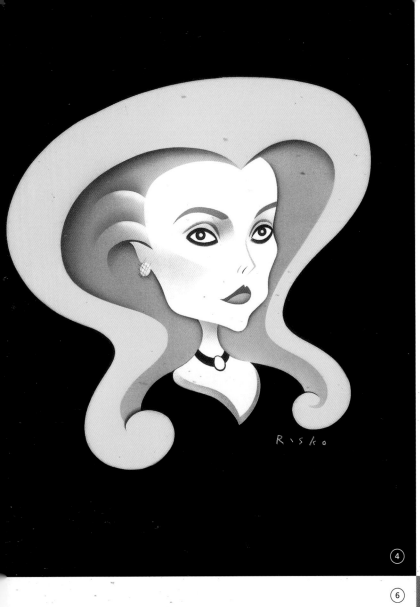

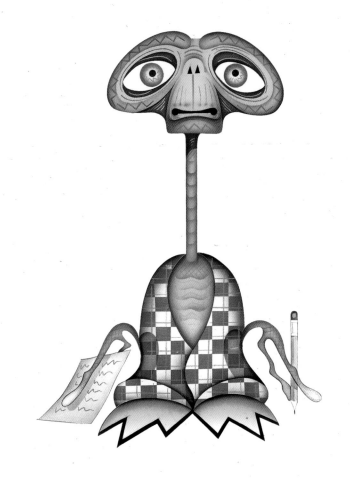

④ ⑤

⑥ ⑦

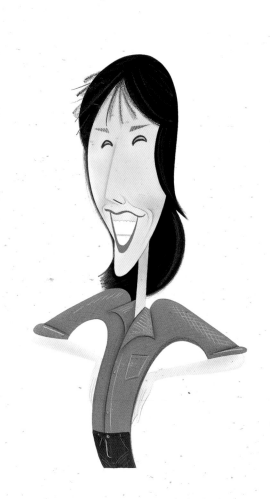

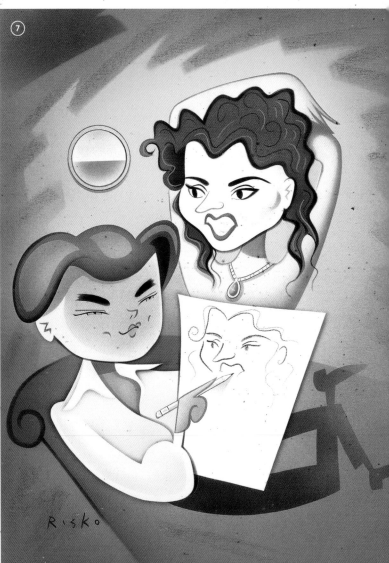

8

9

10

11

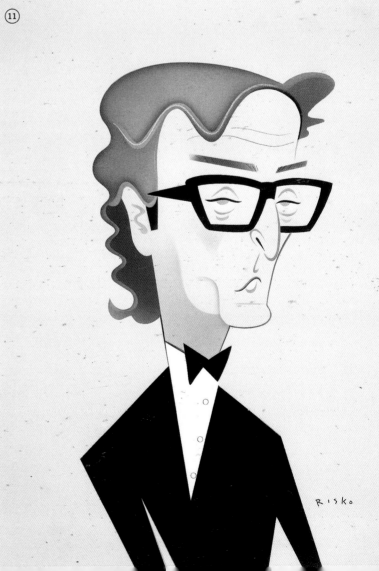

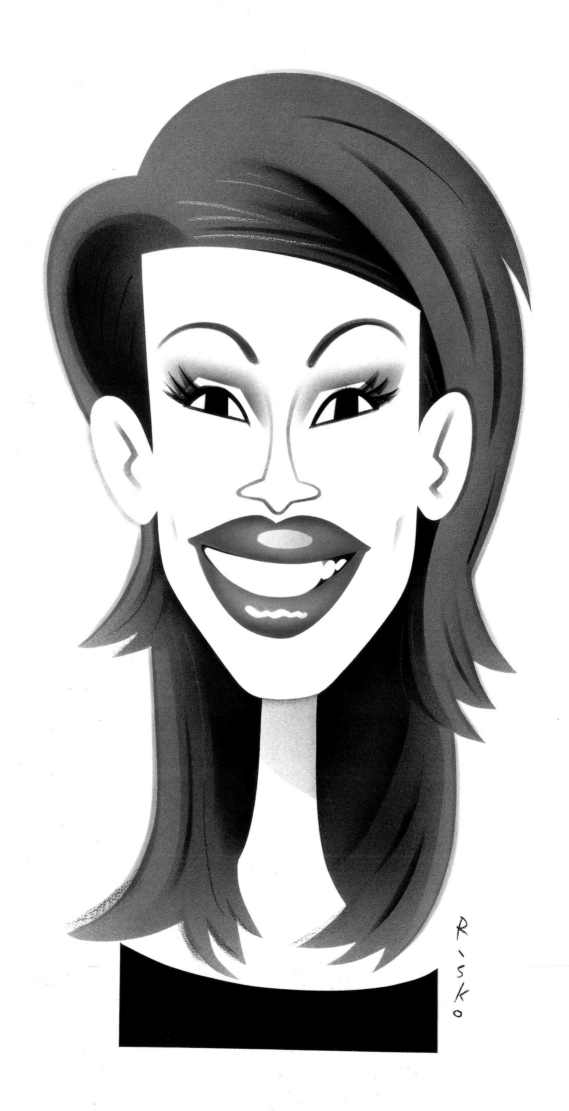

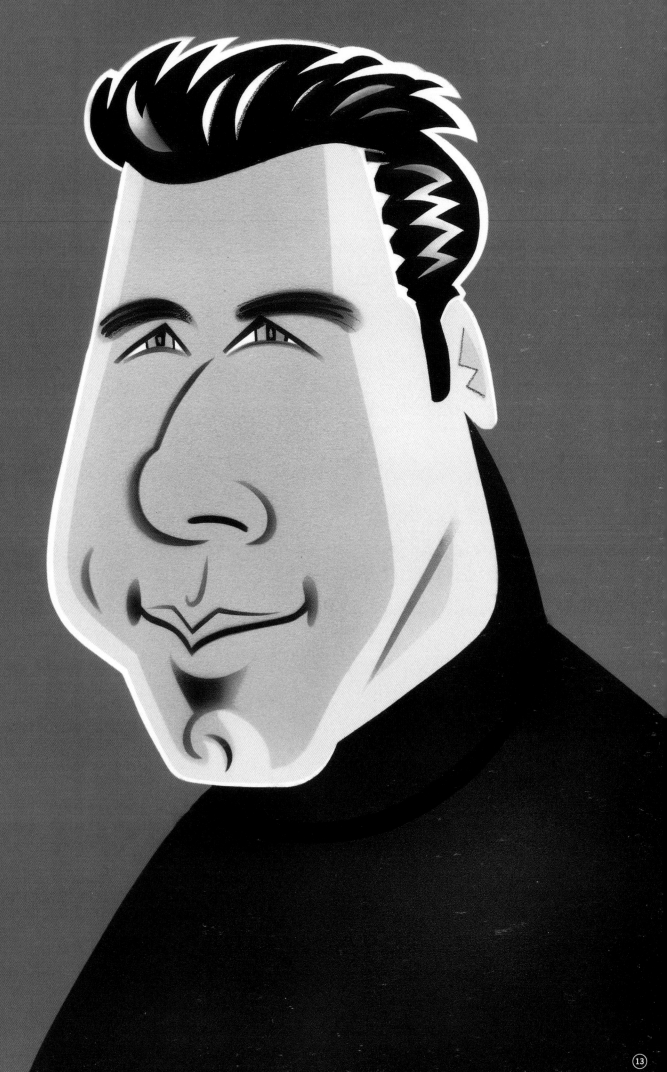

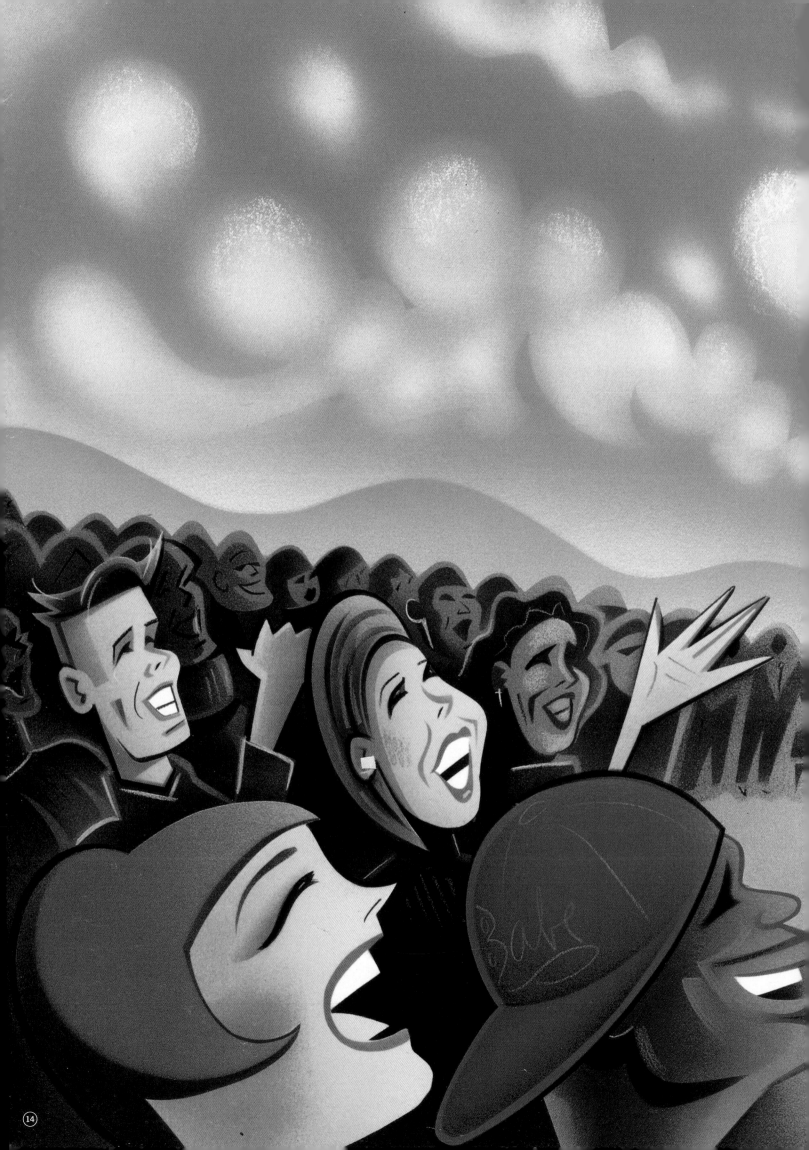

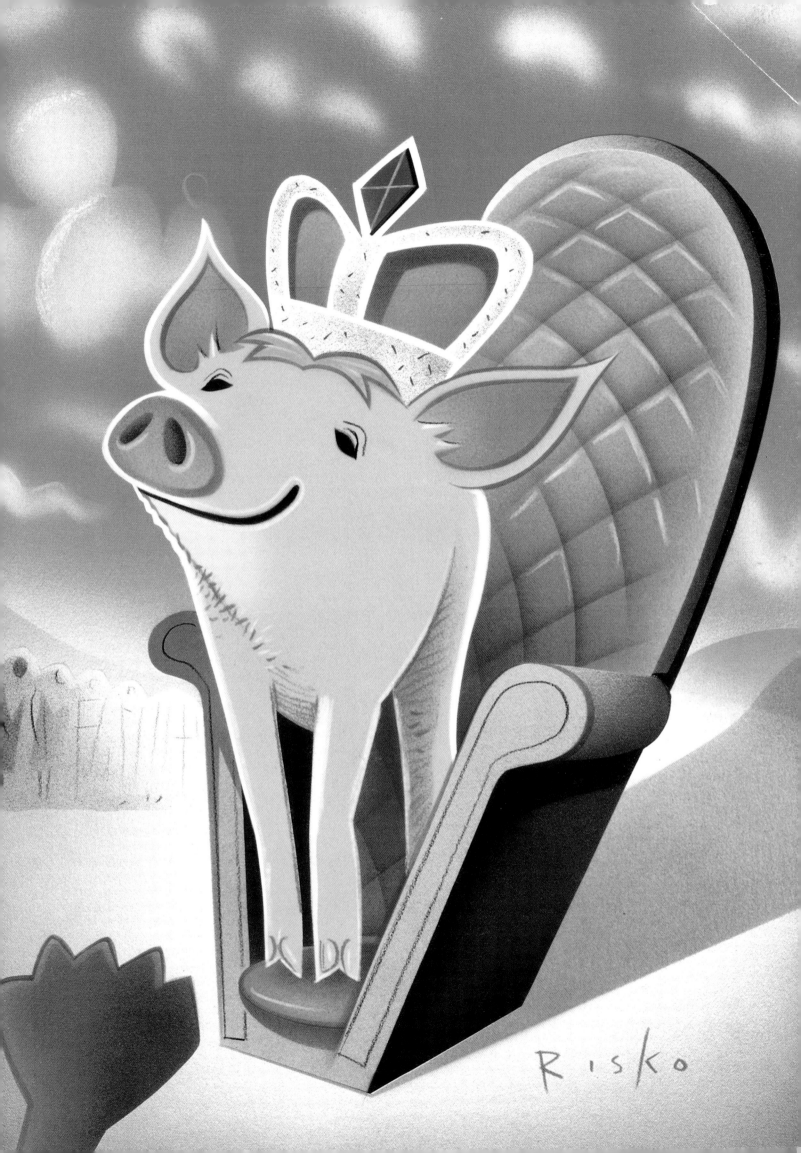

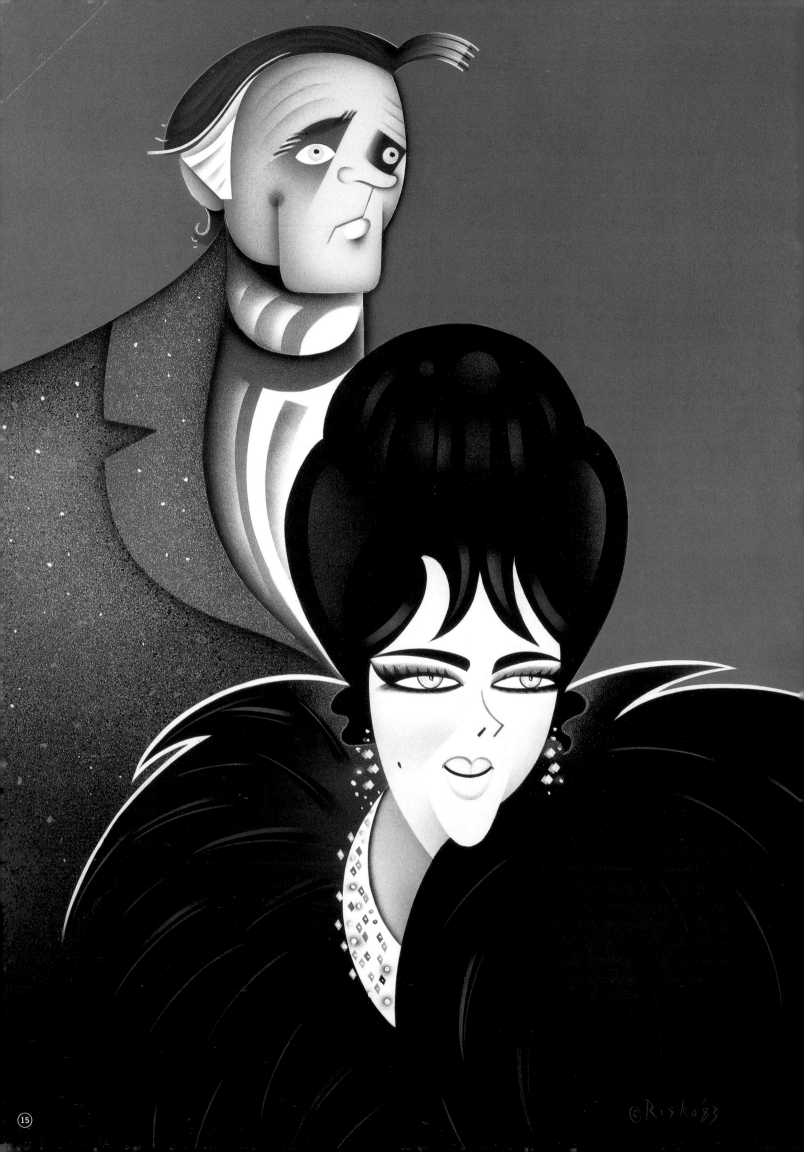

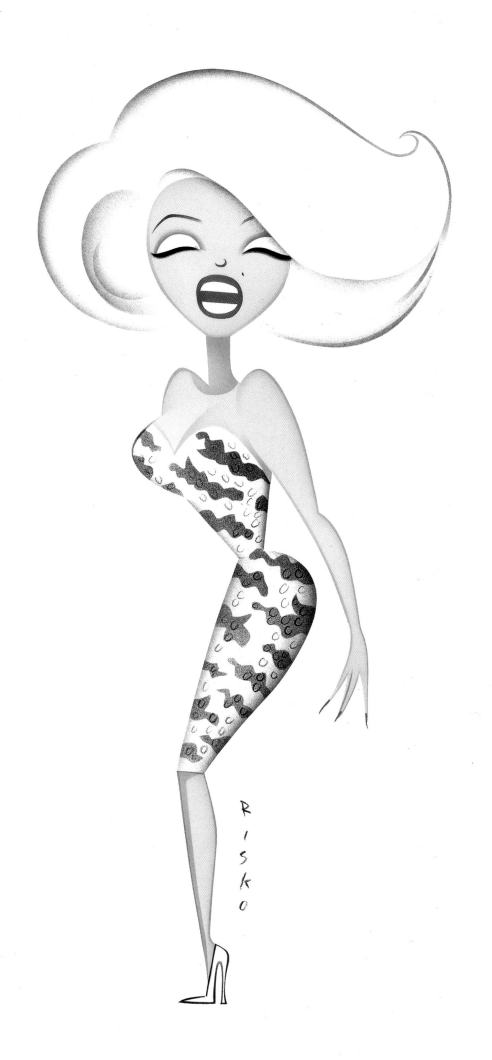

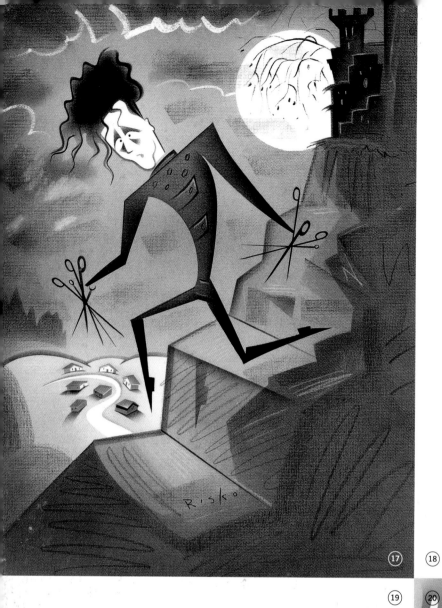

17

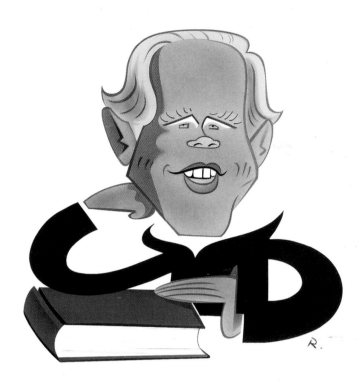

18

19

20

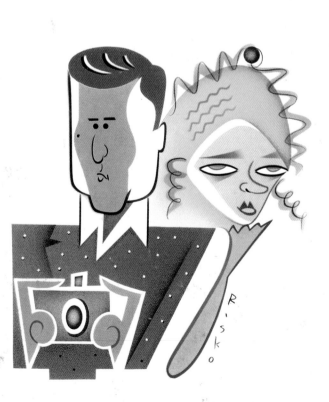

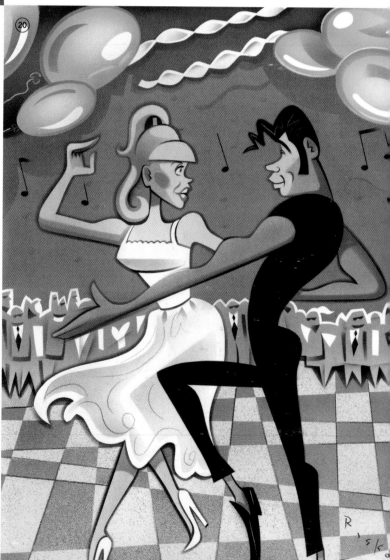

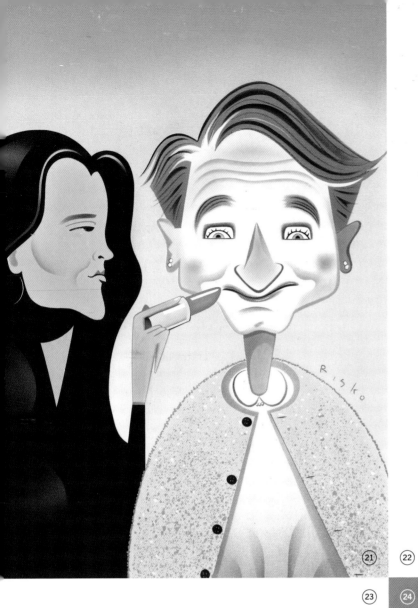

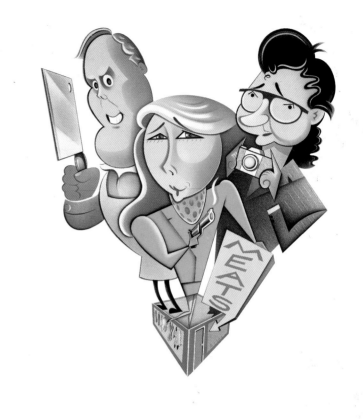

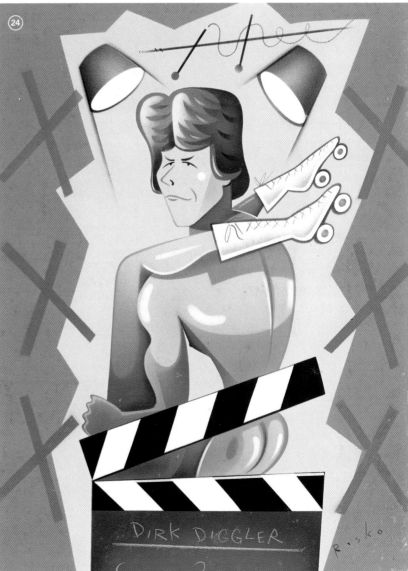

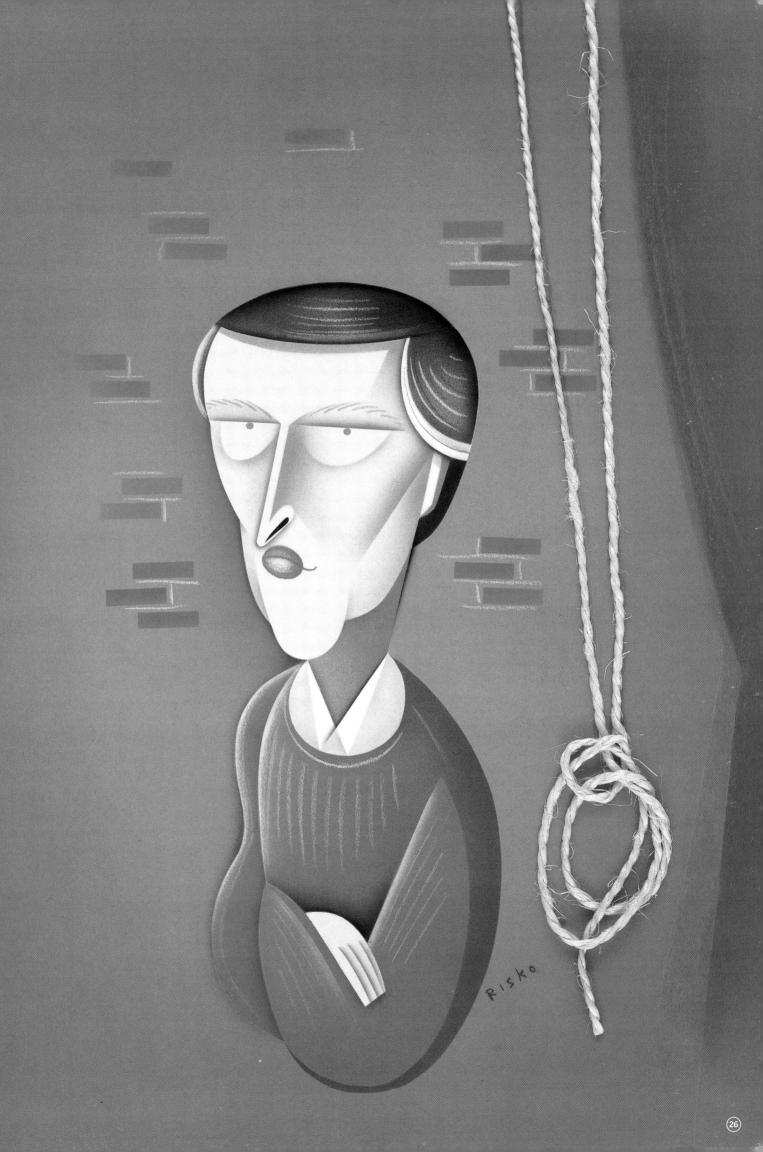

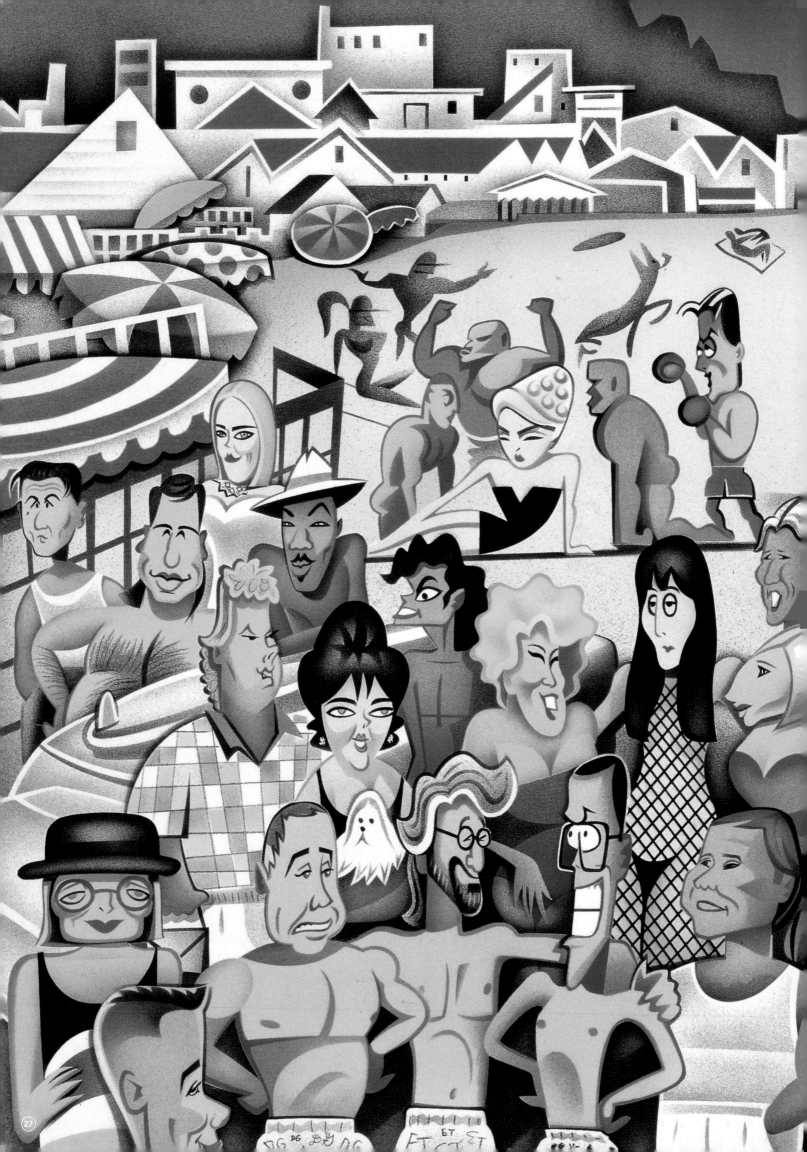

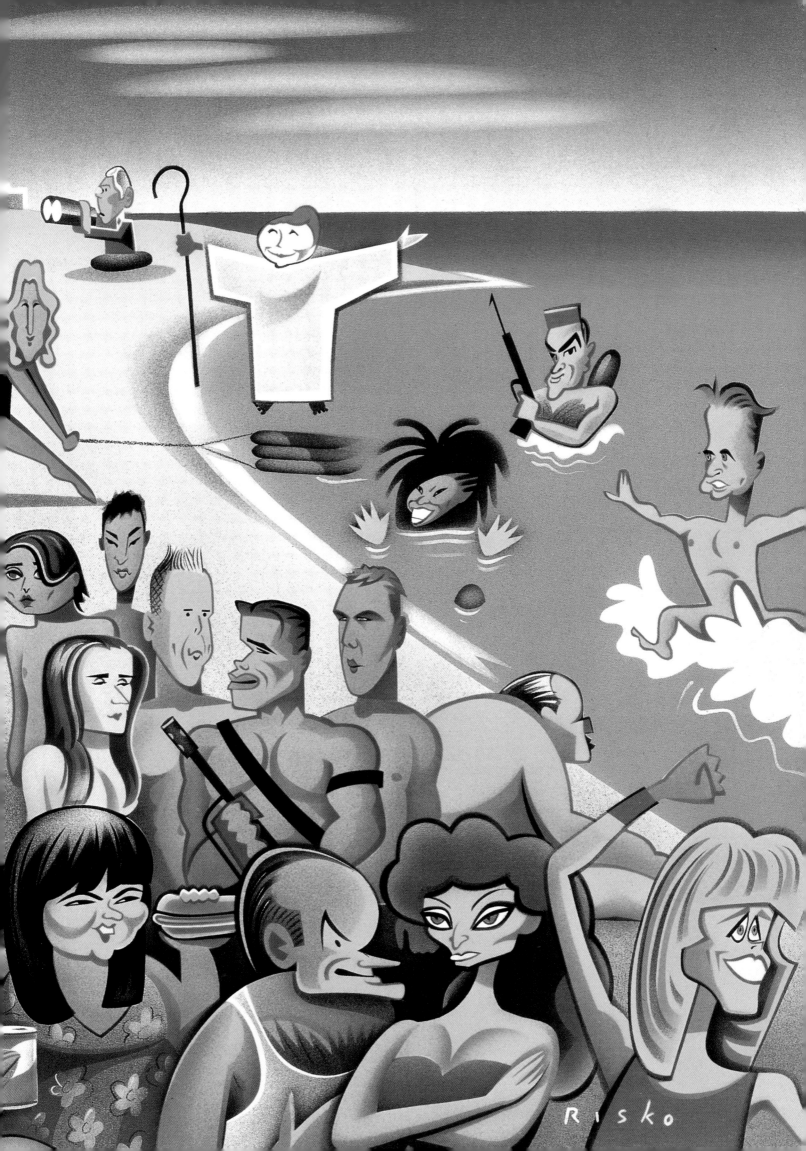

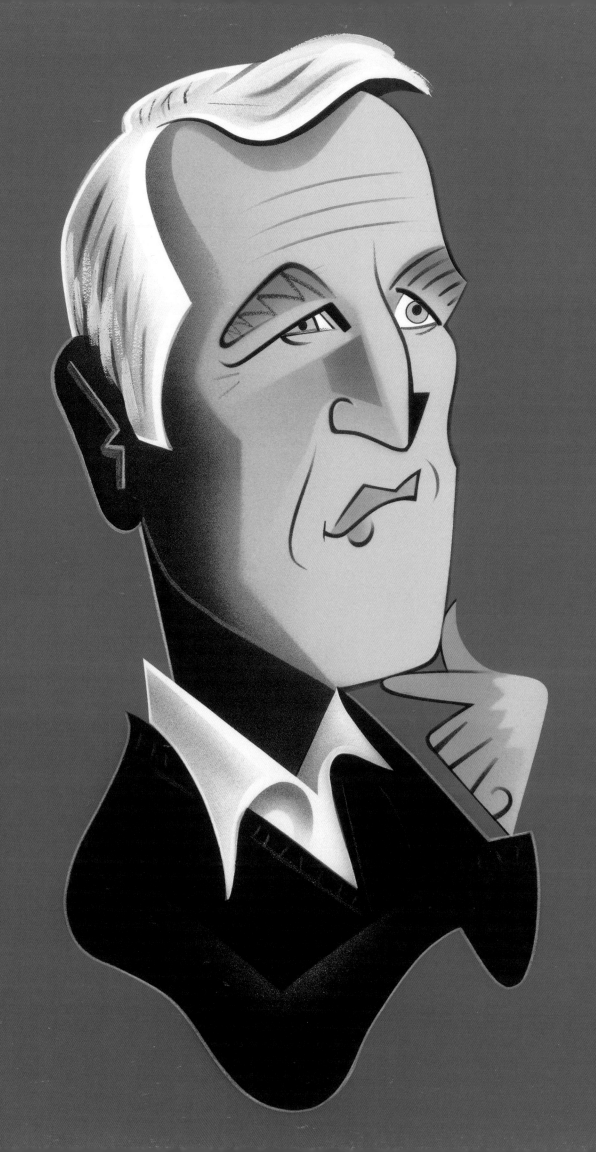

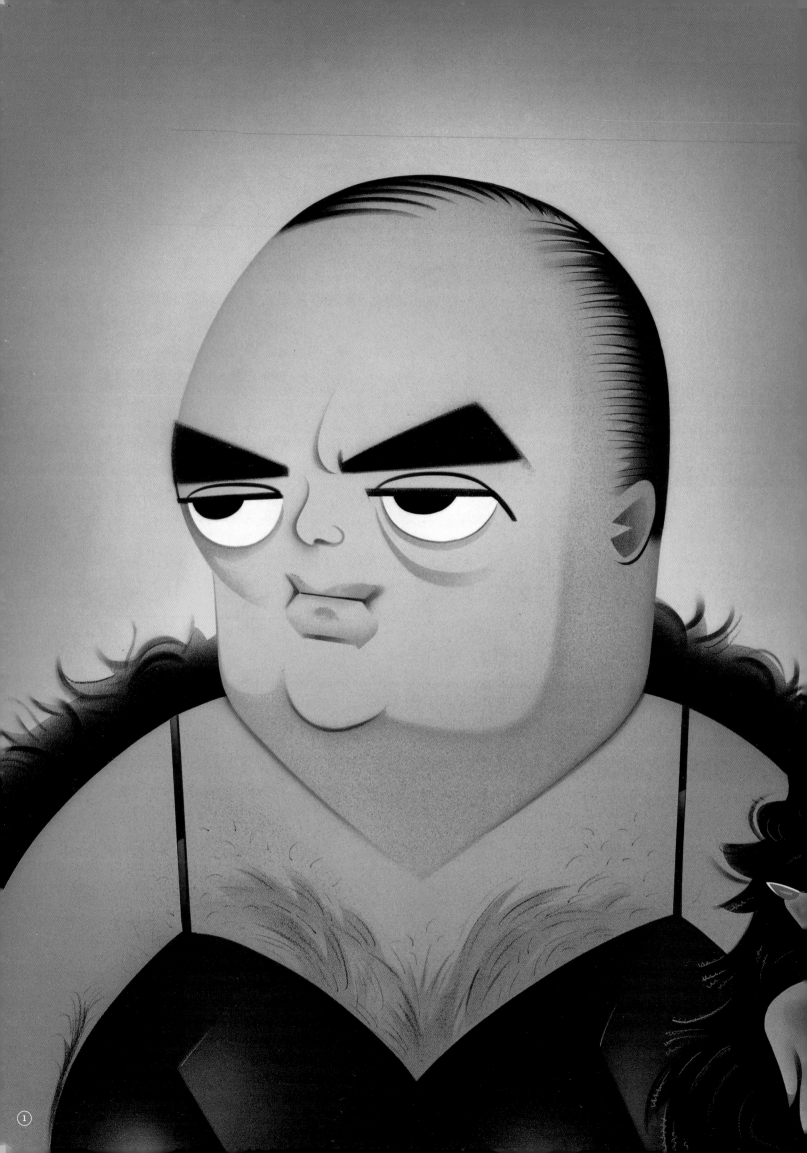

No wonder he was bitter—
he didn't make a very pretty woman.

scandals

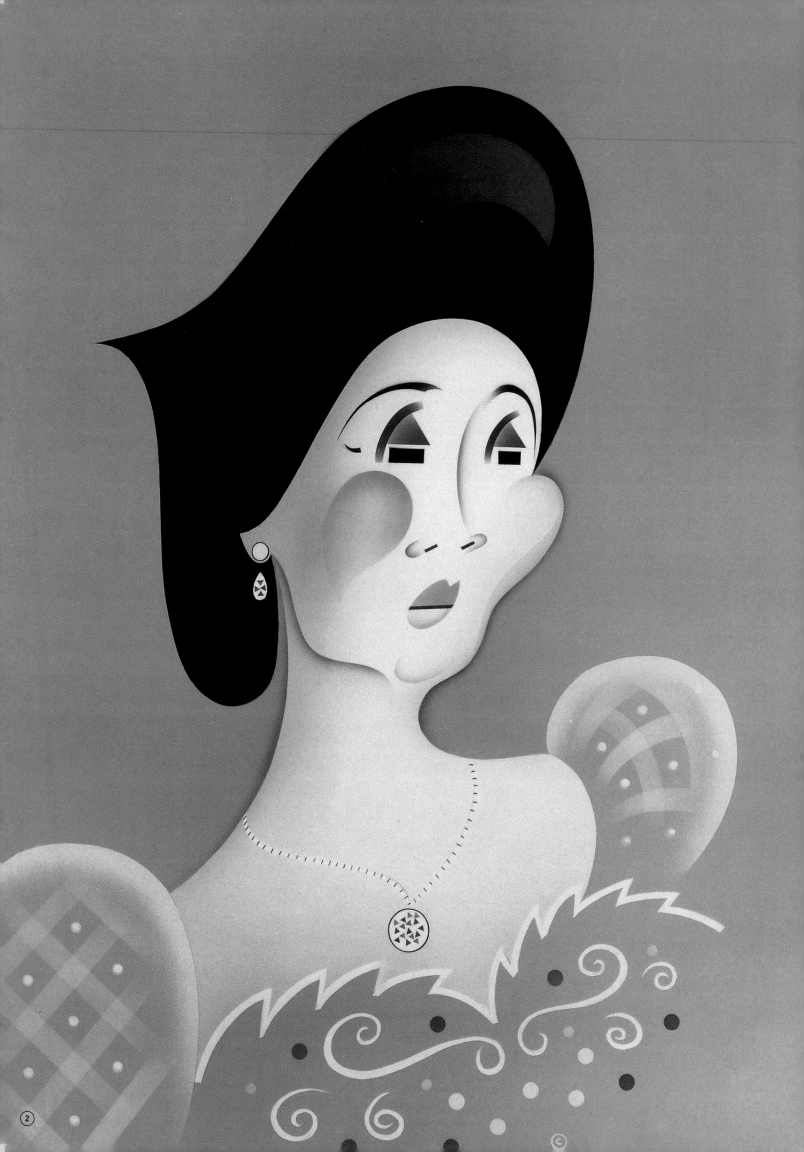

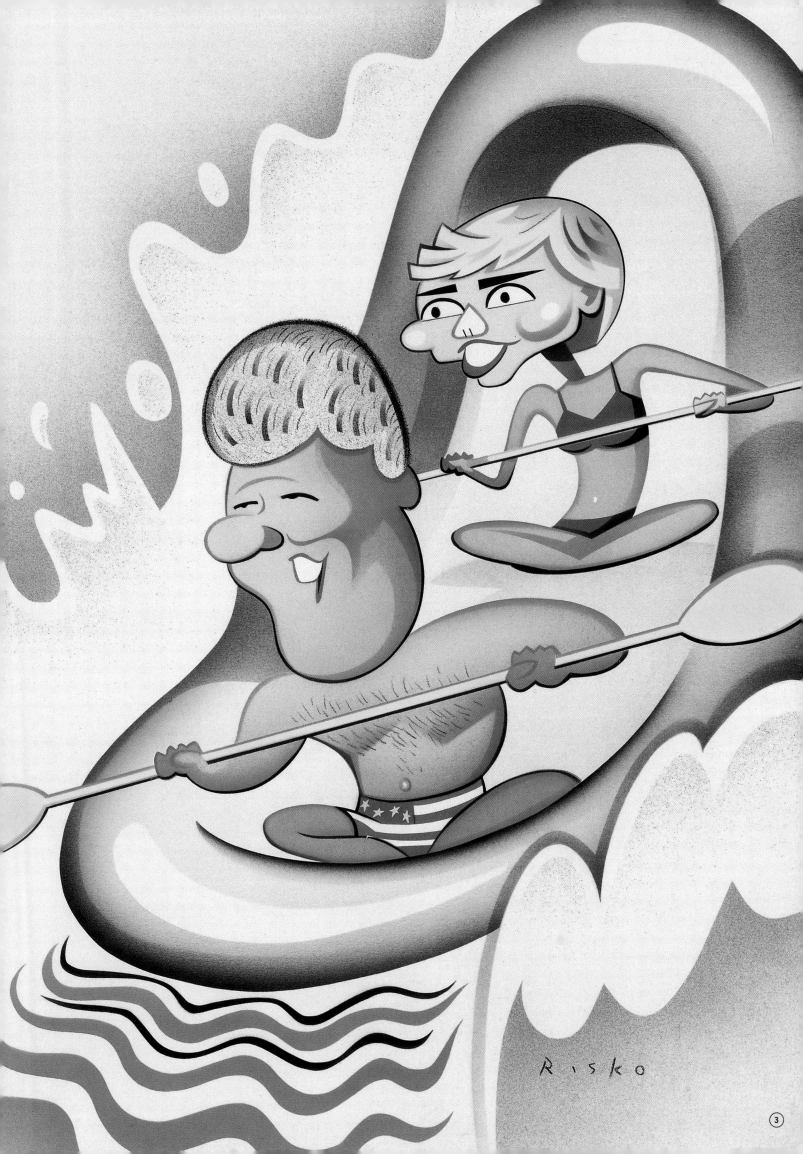

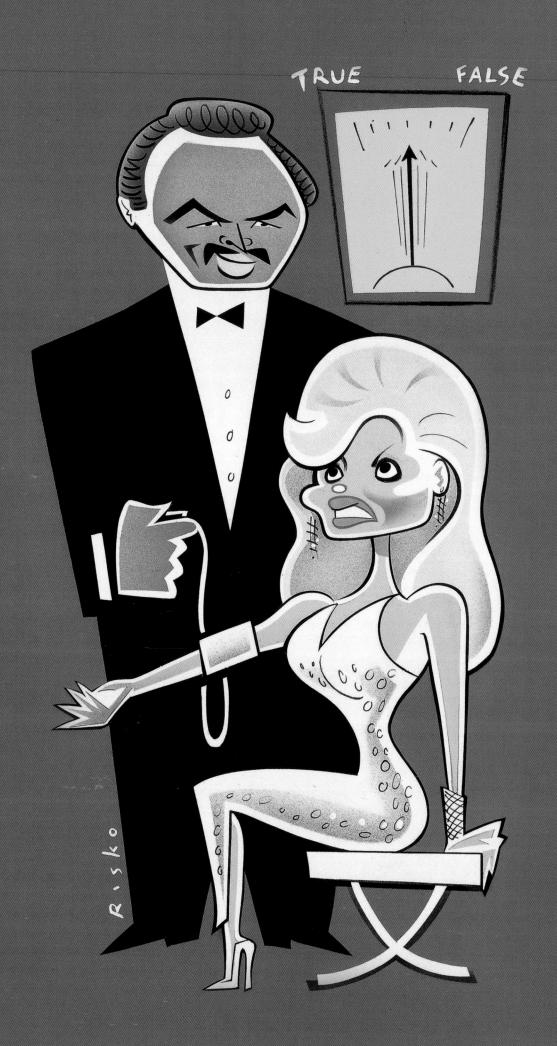

TRUE FALSE

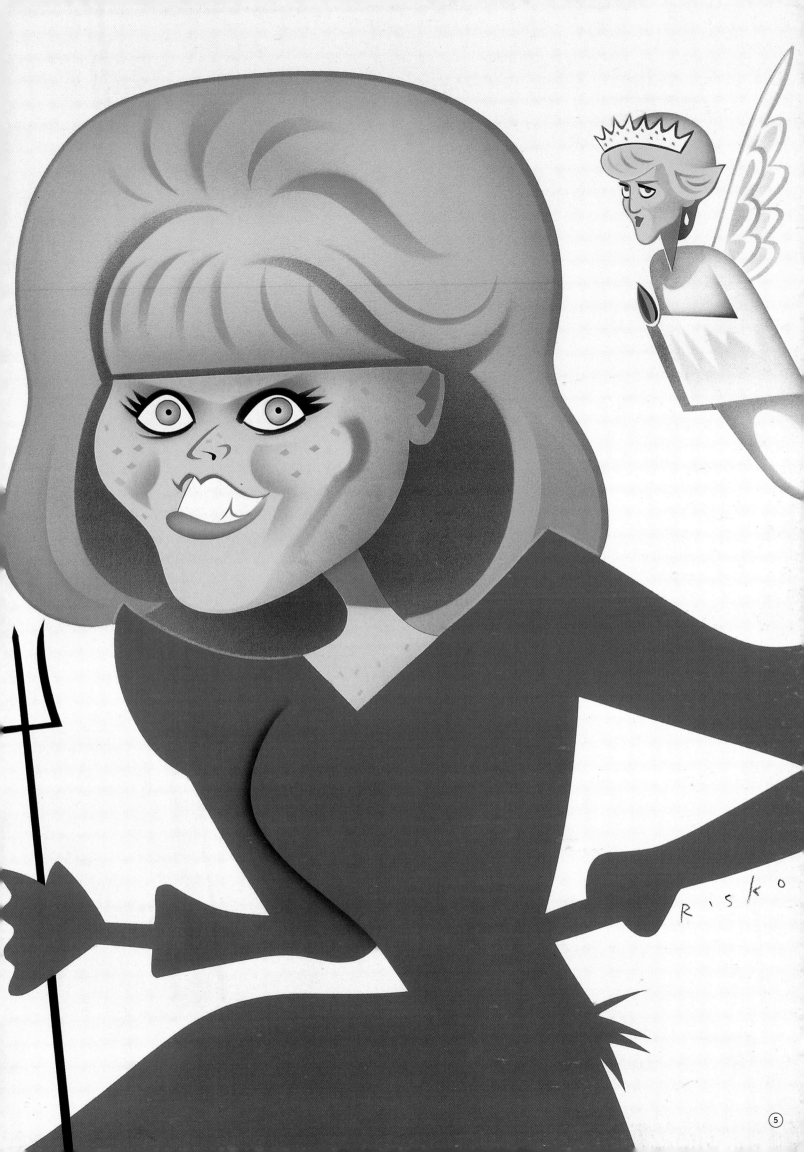

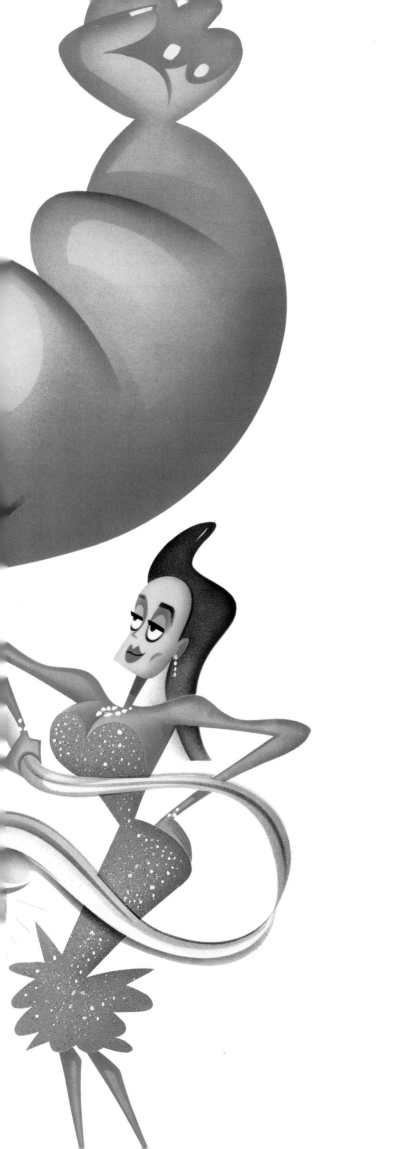

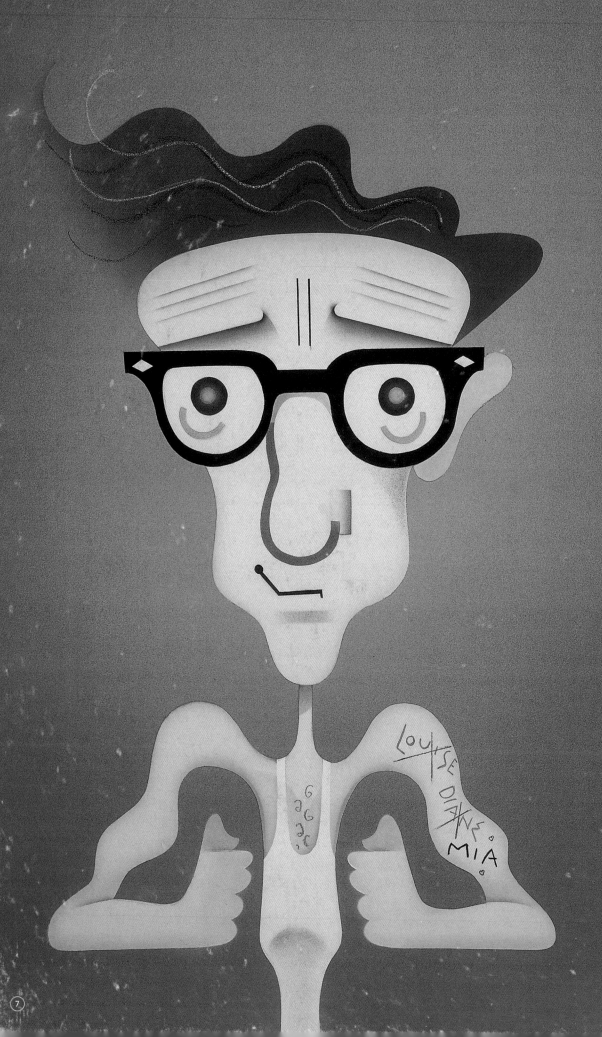

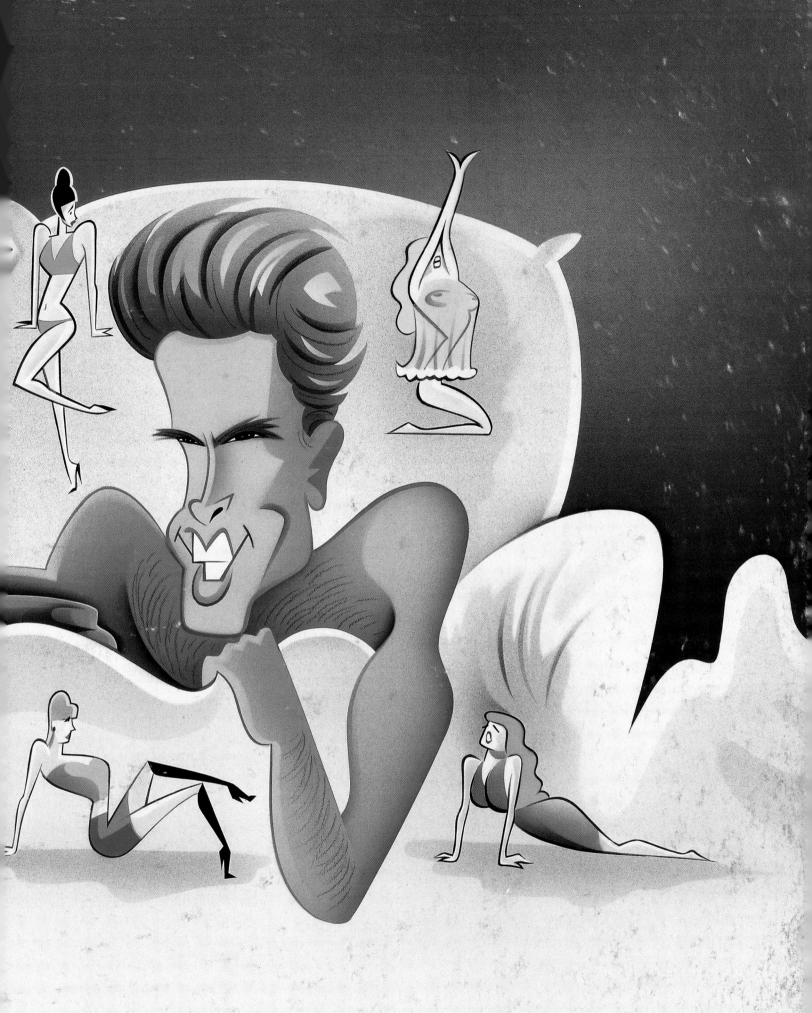

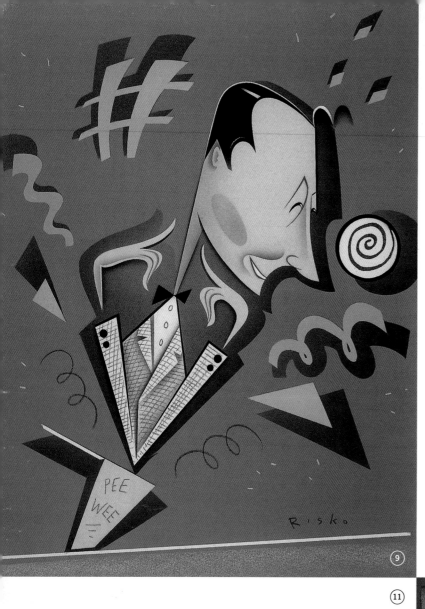

⑨

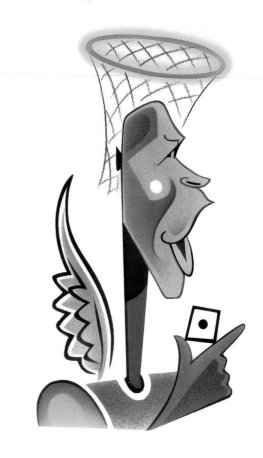

⑩

⑪

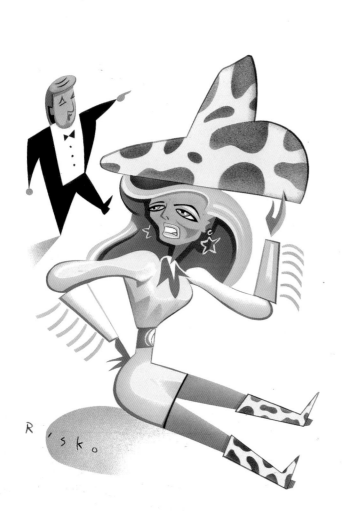

⑫

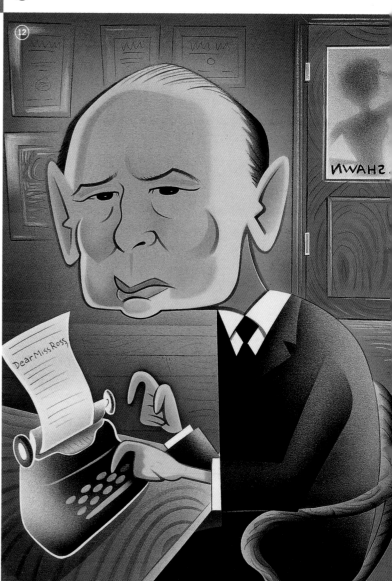

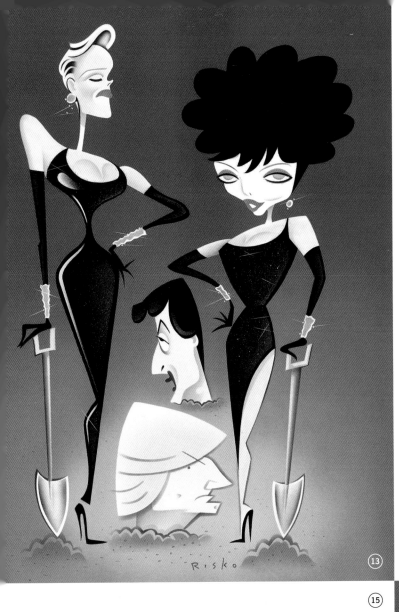

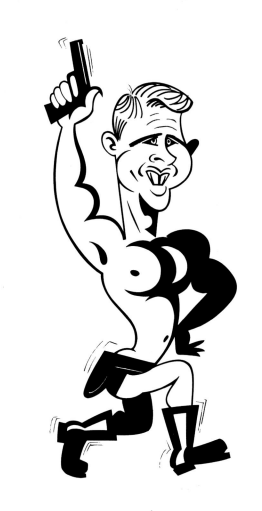

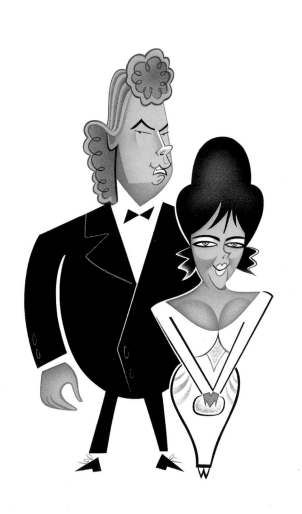

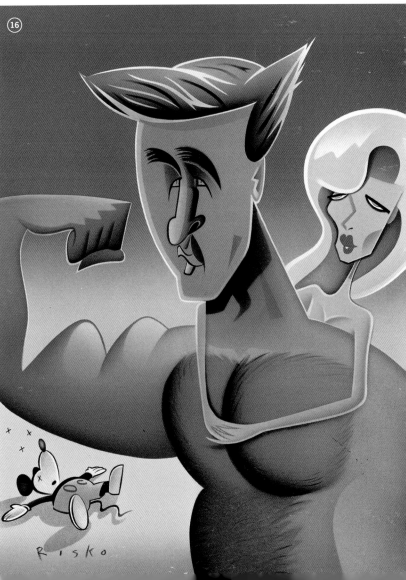

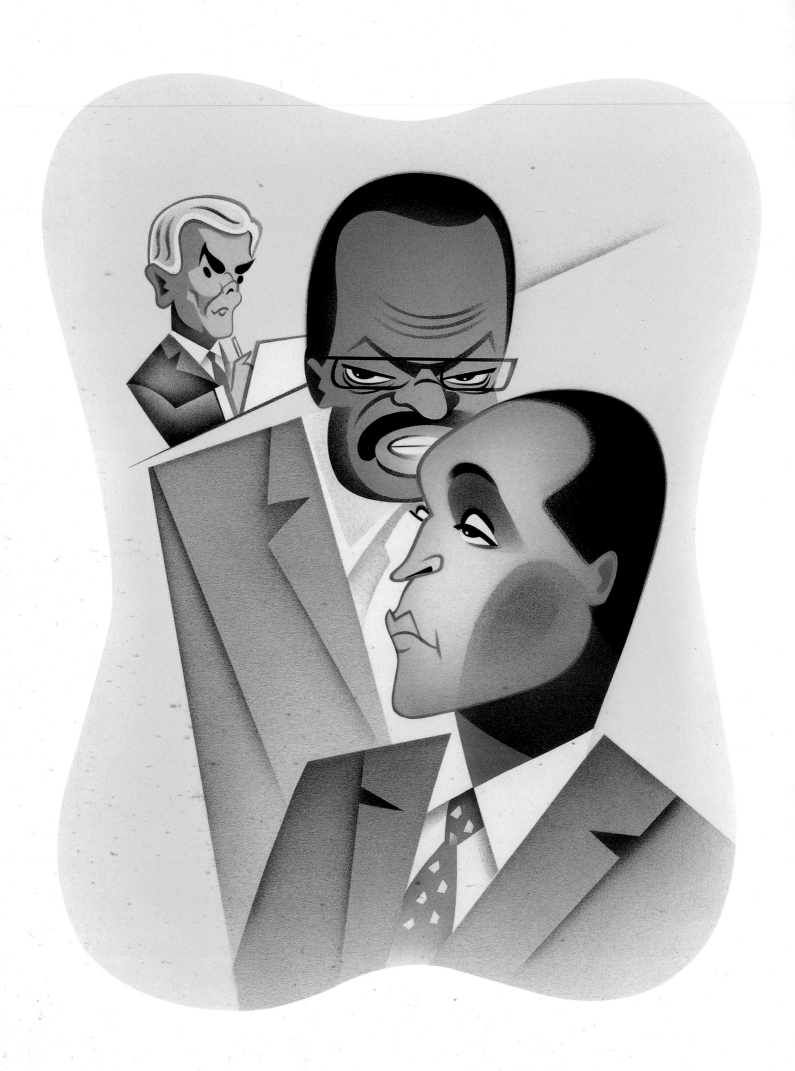

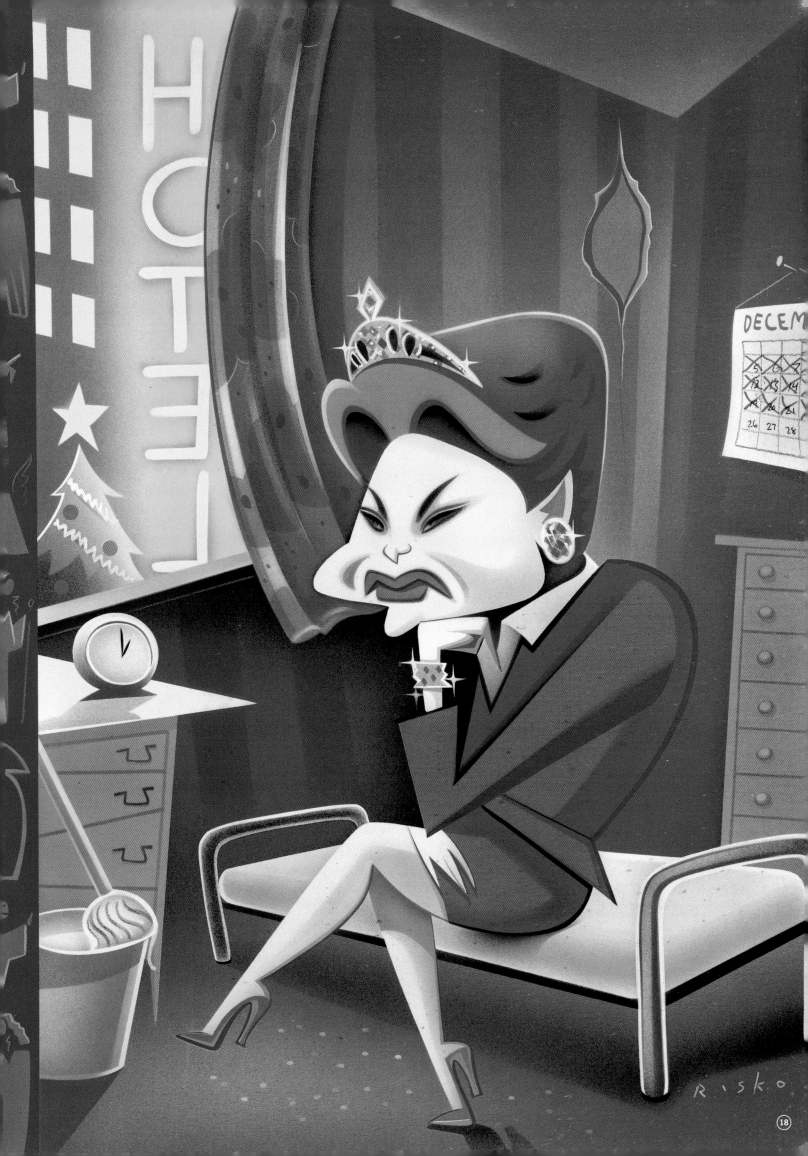

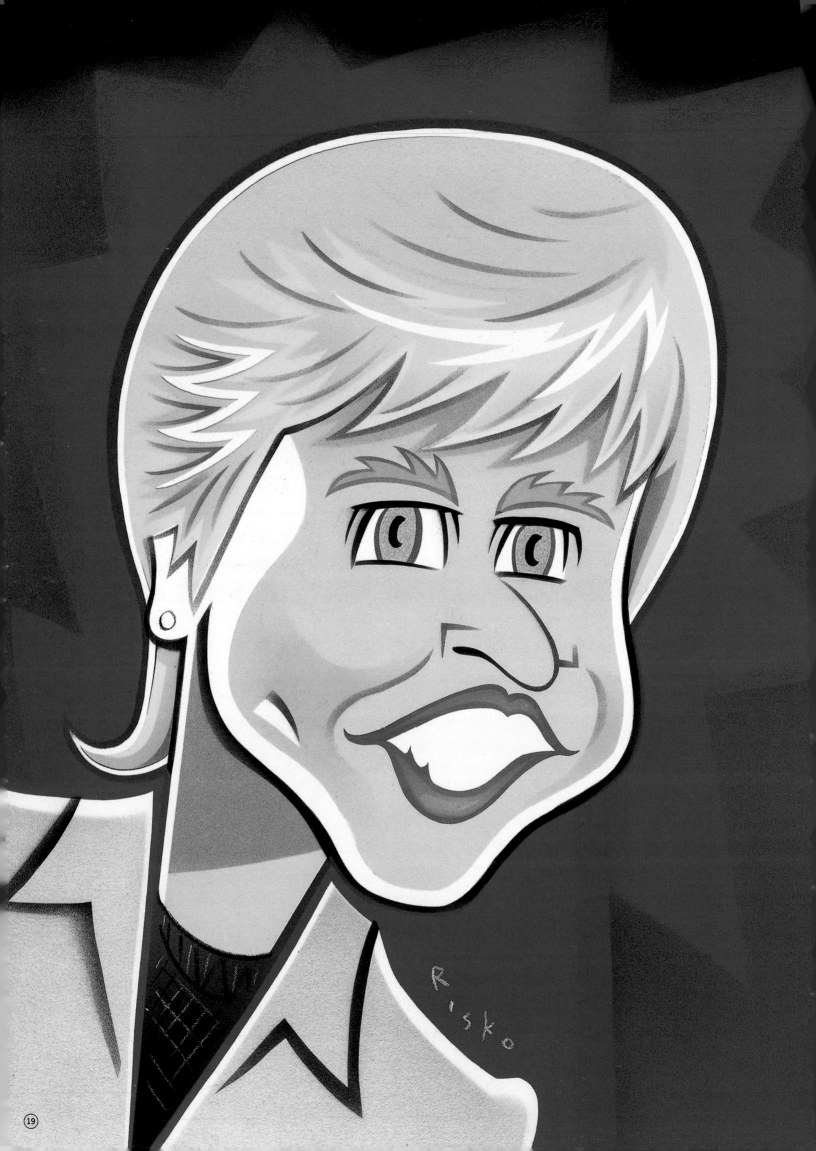

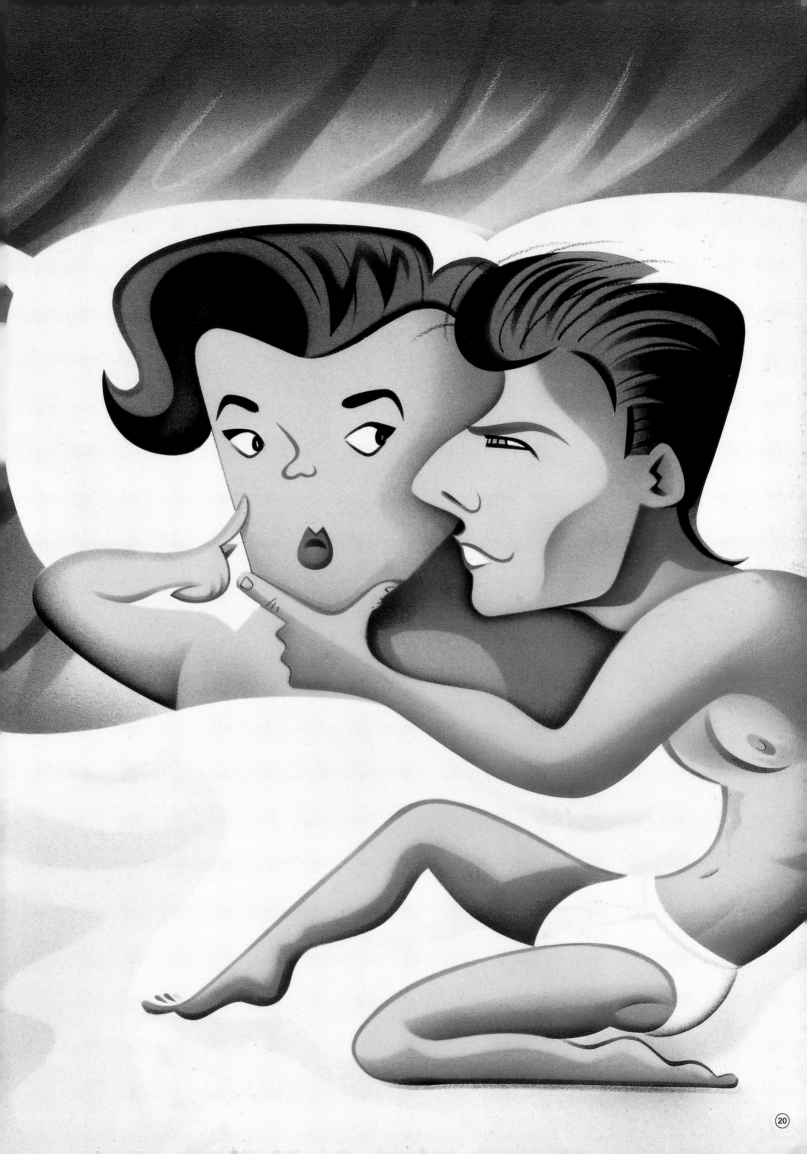

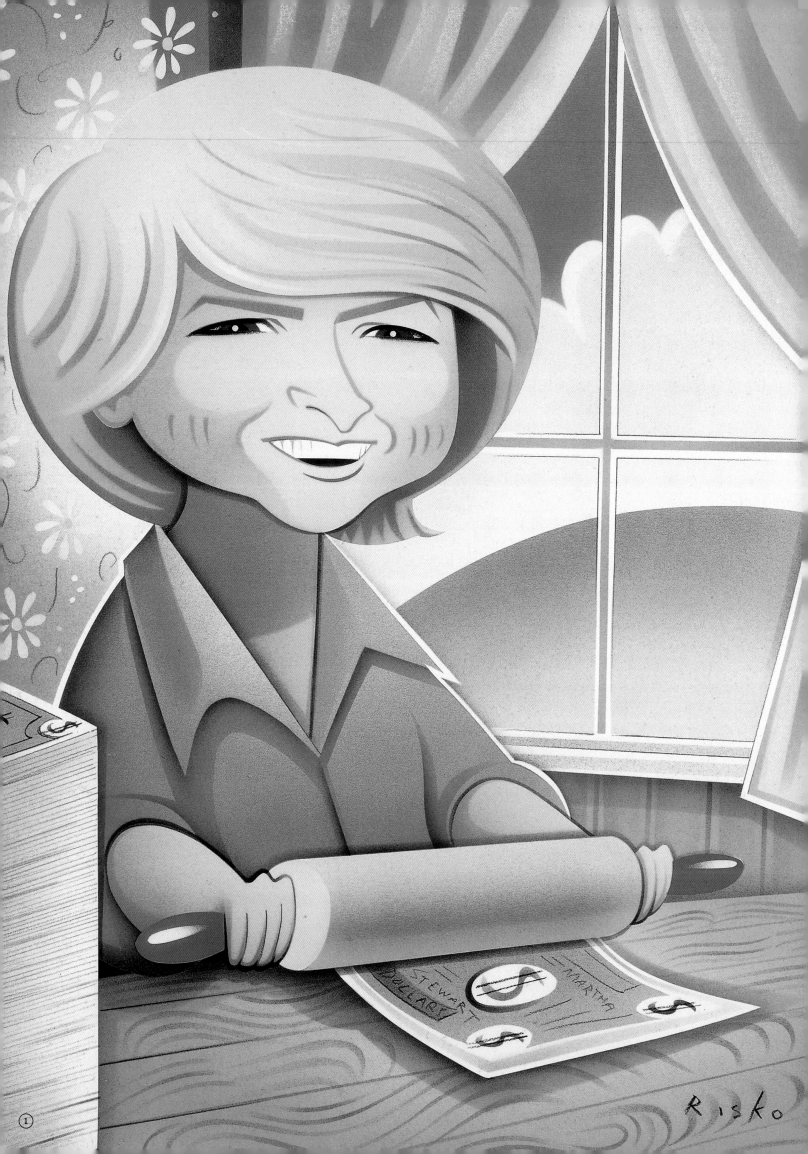

I always say there's a fine line between
marketing genius and obsessive-compulsive disorder.

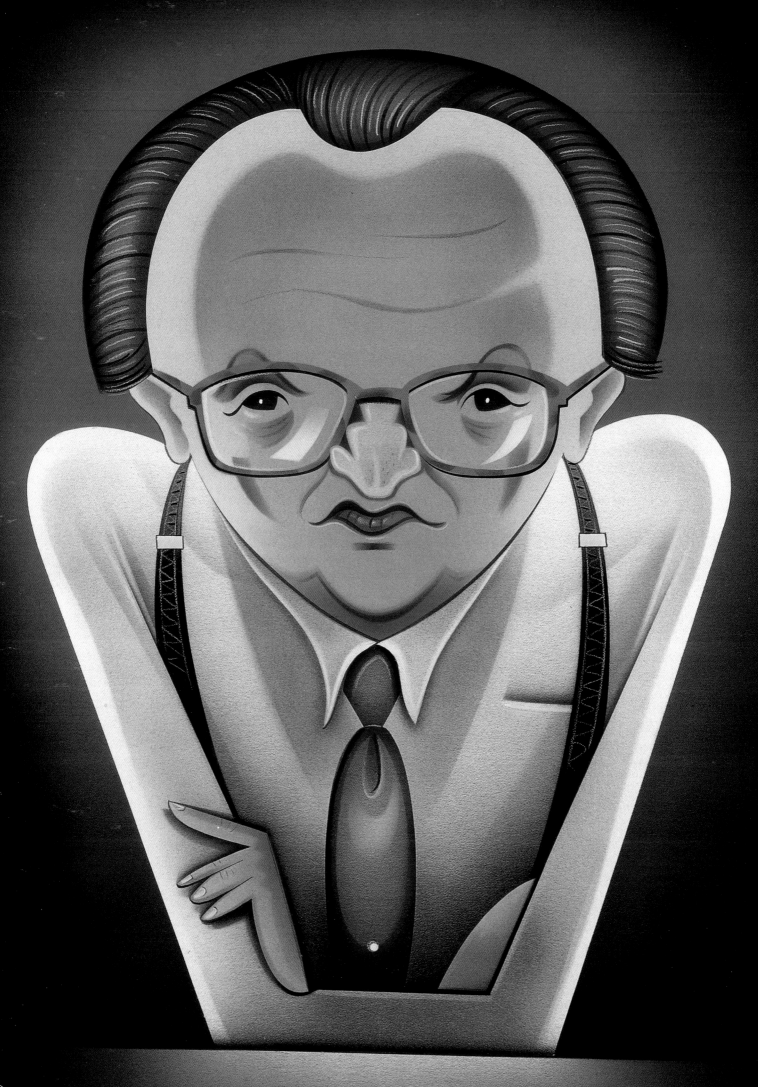

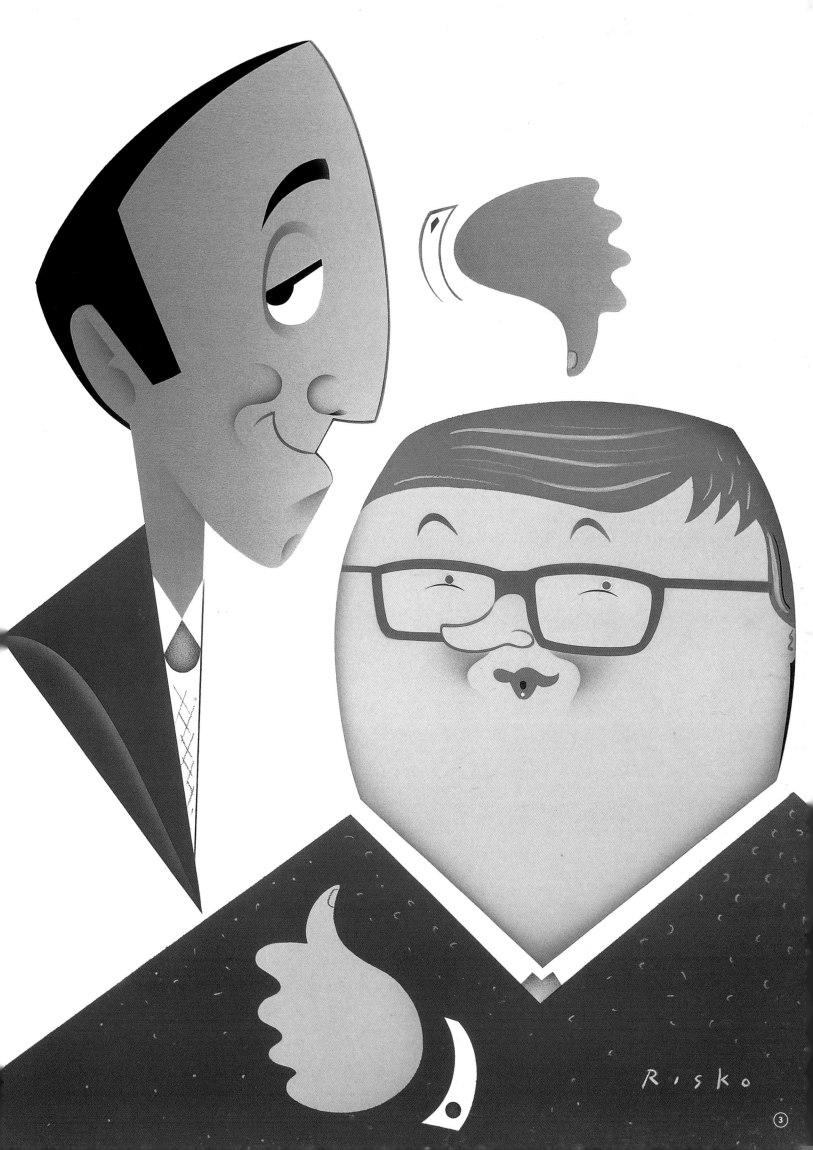

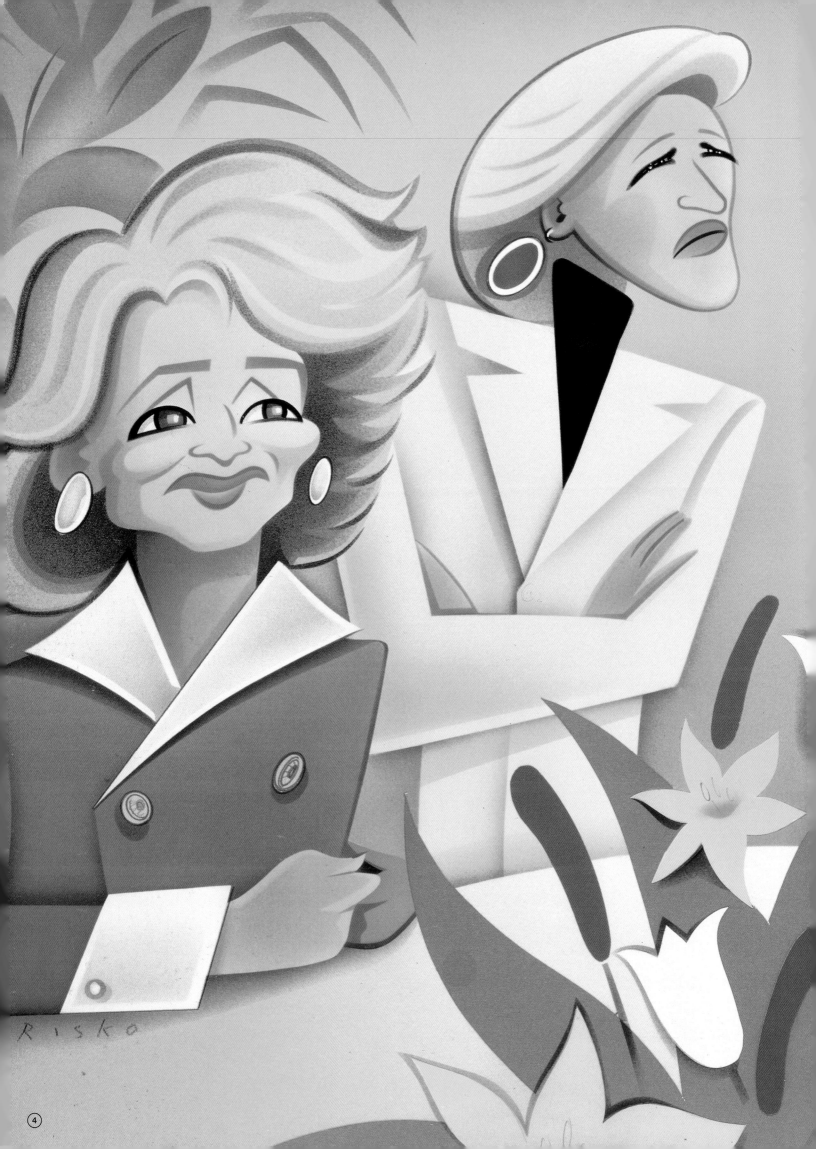

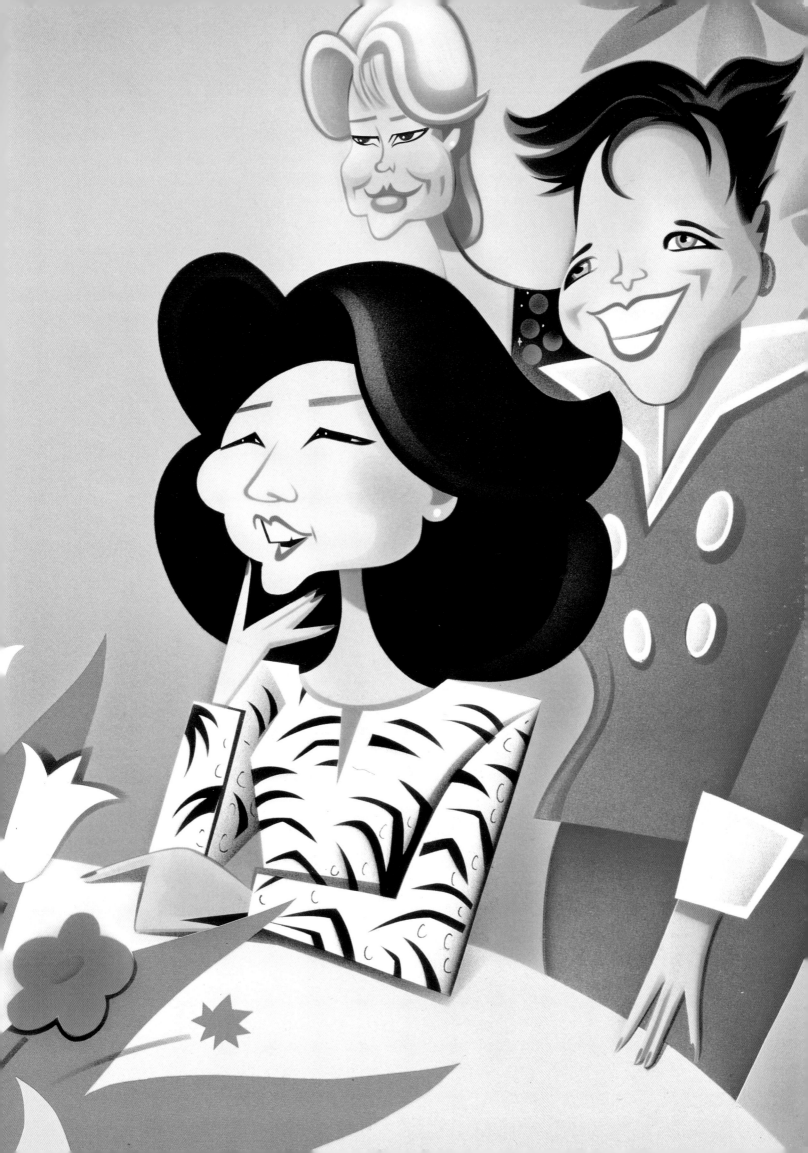

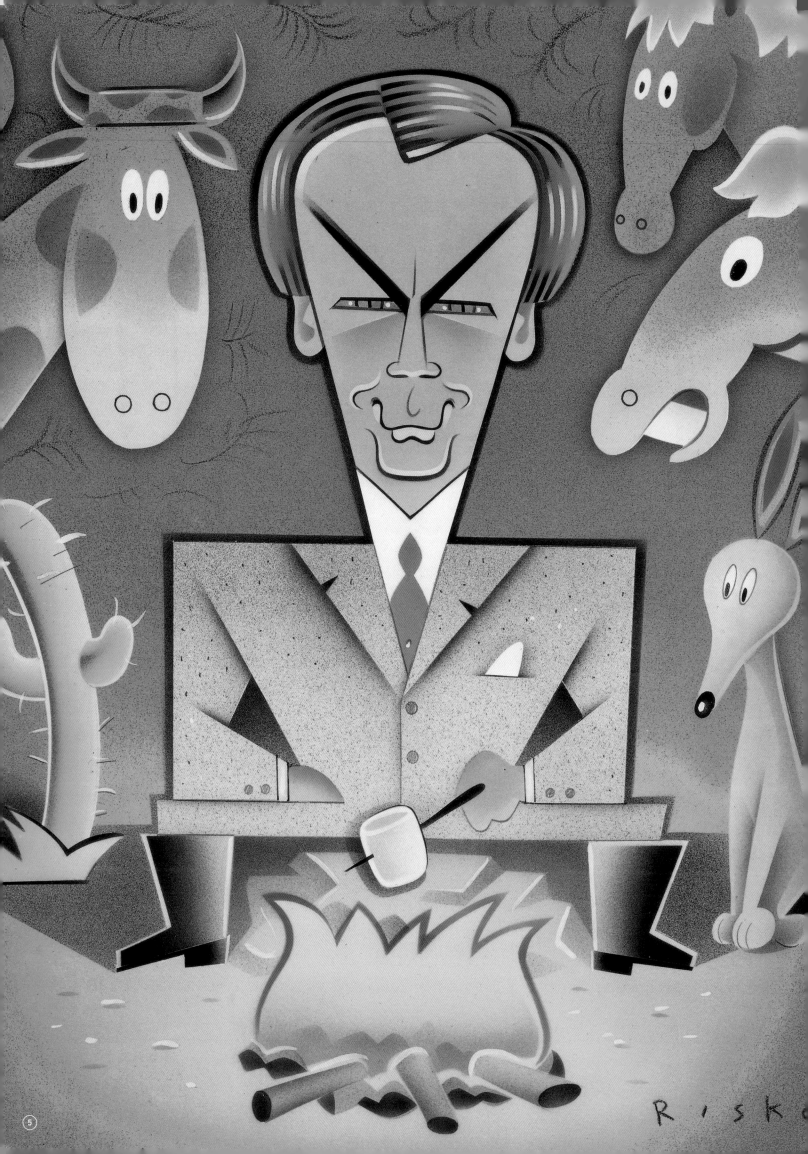

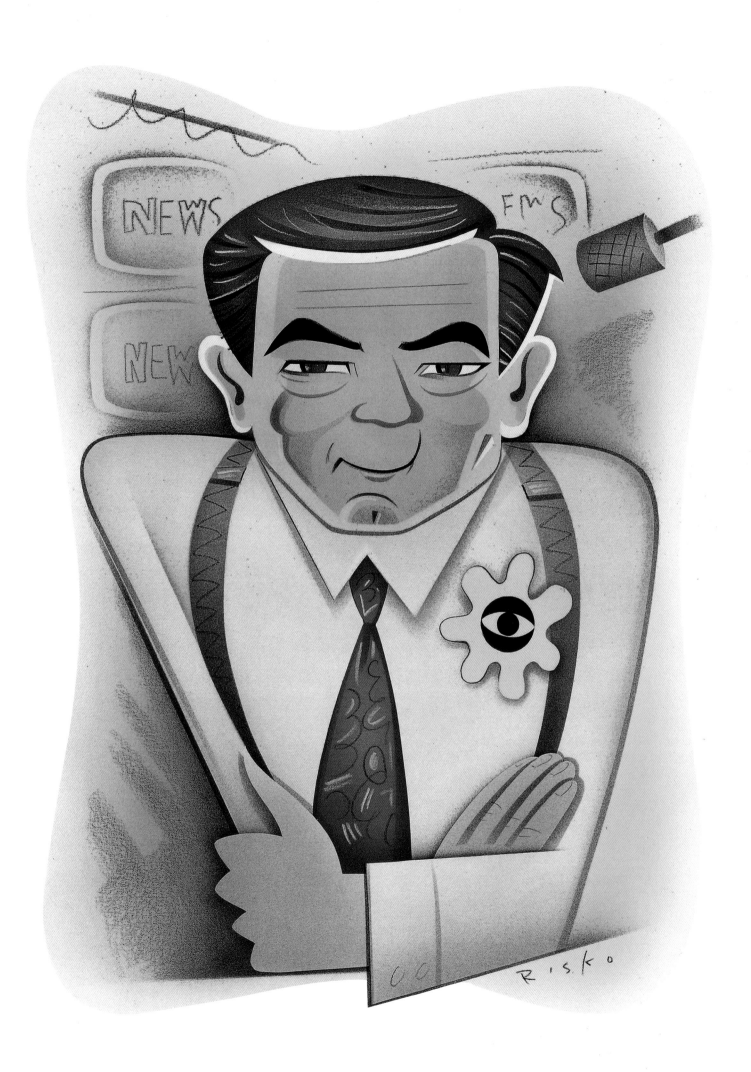

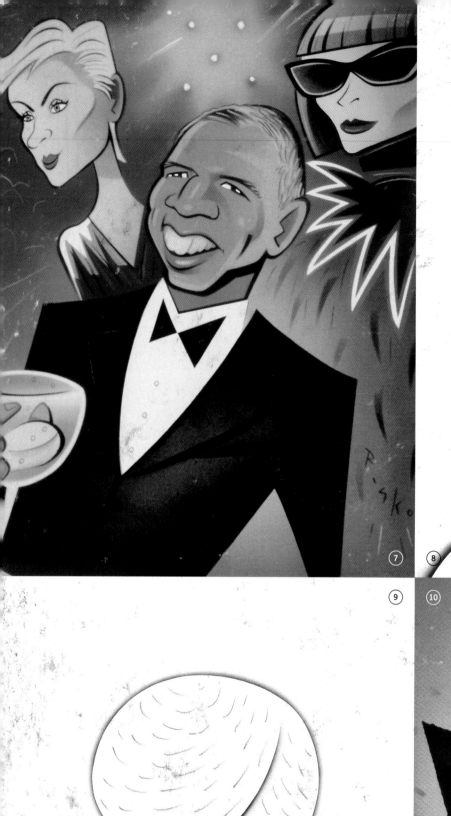

⑦

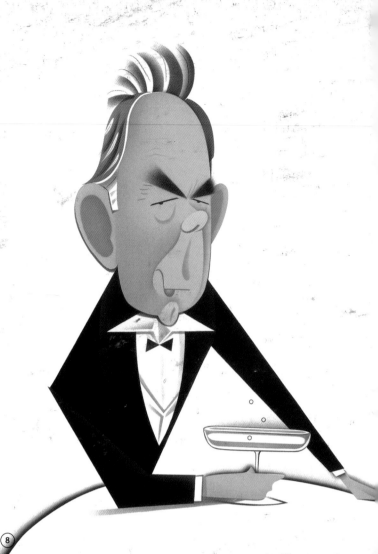

⑧

⑨

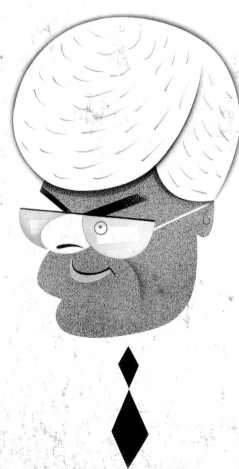

⑩

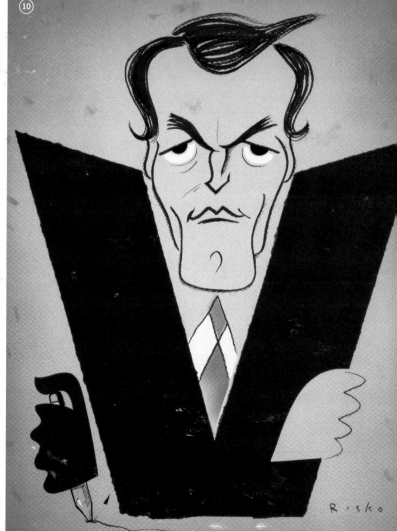

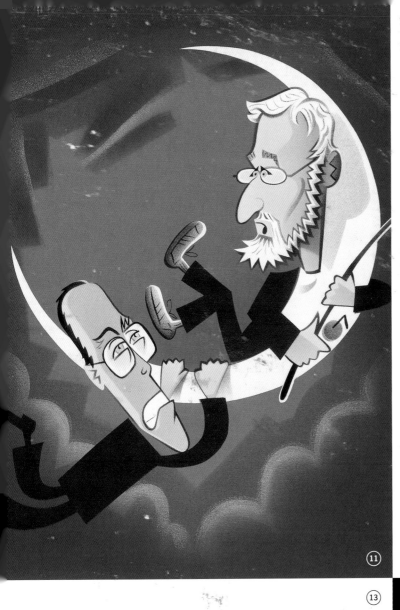

⑪

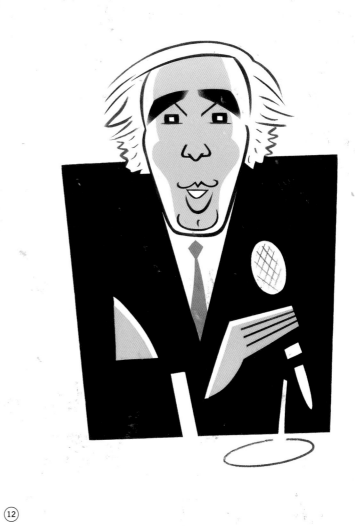

⑫

⑬

⑭

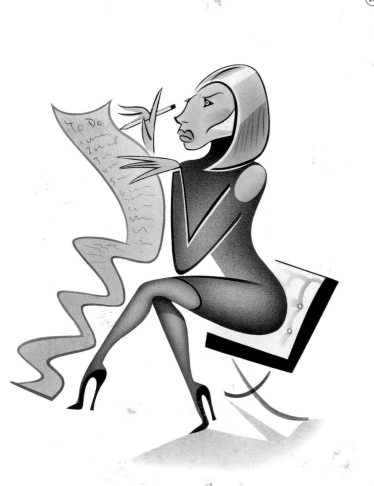

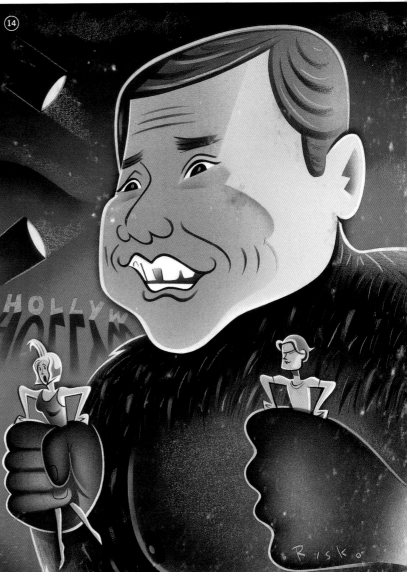

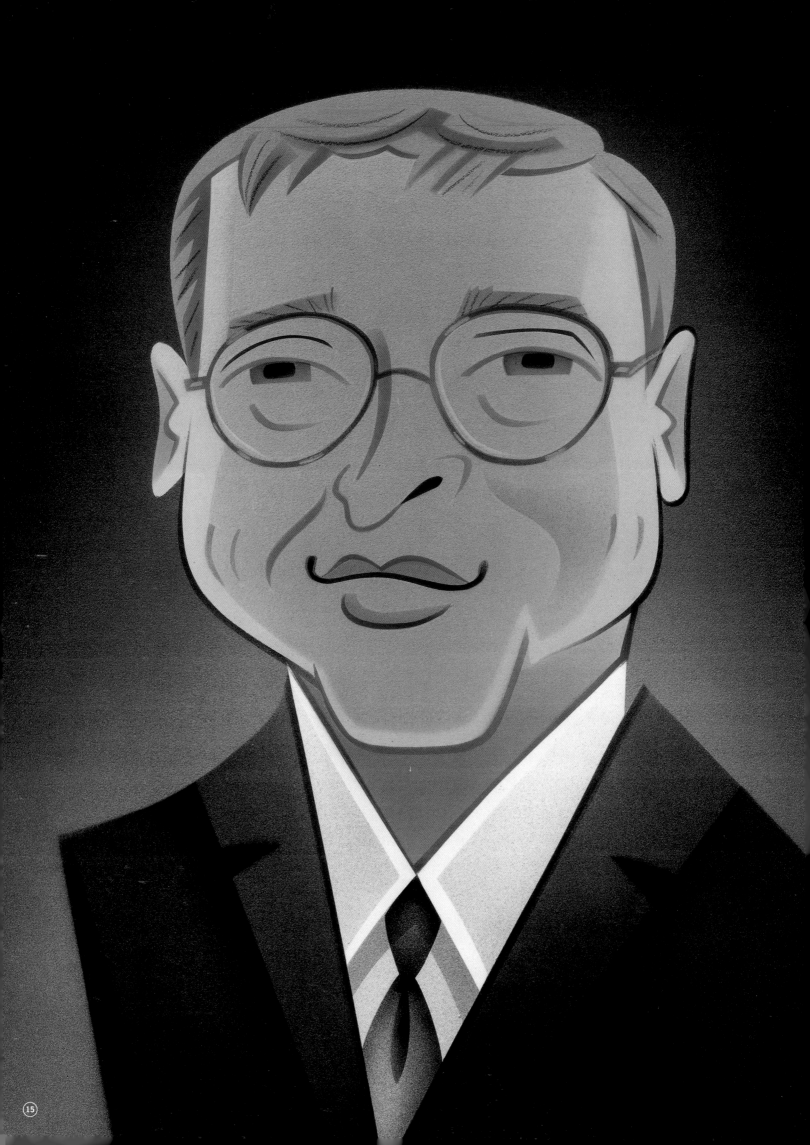

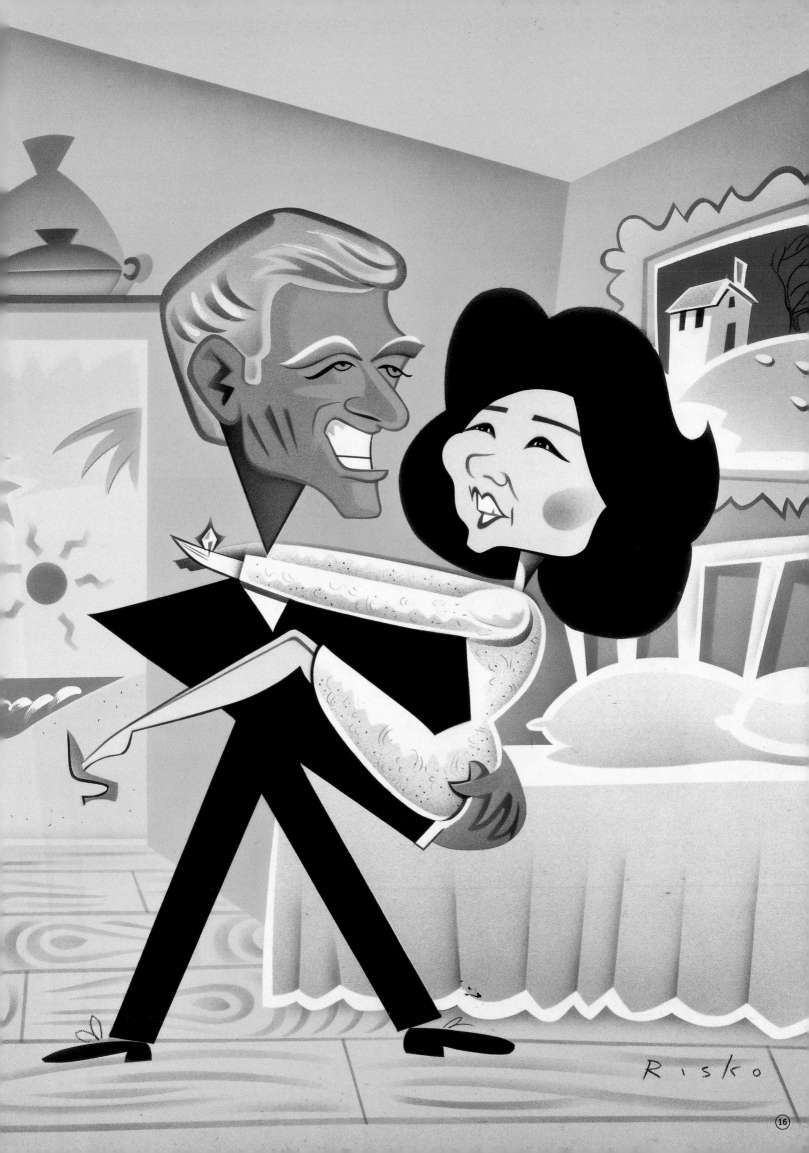

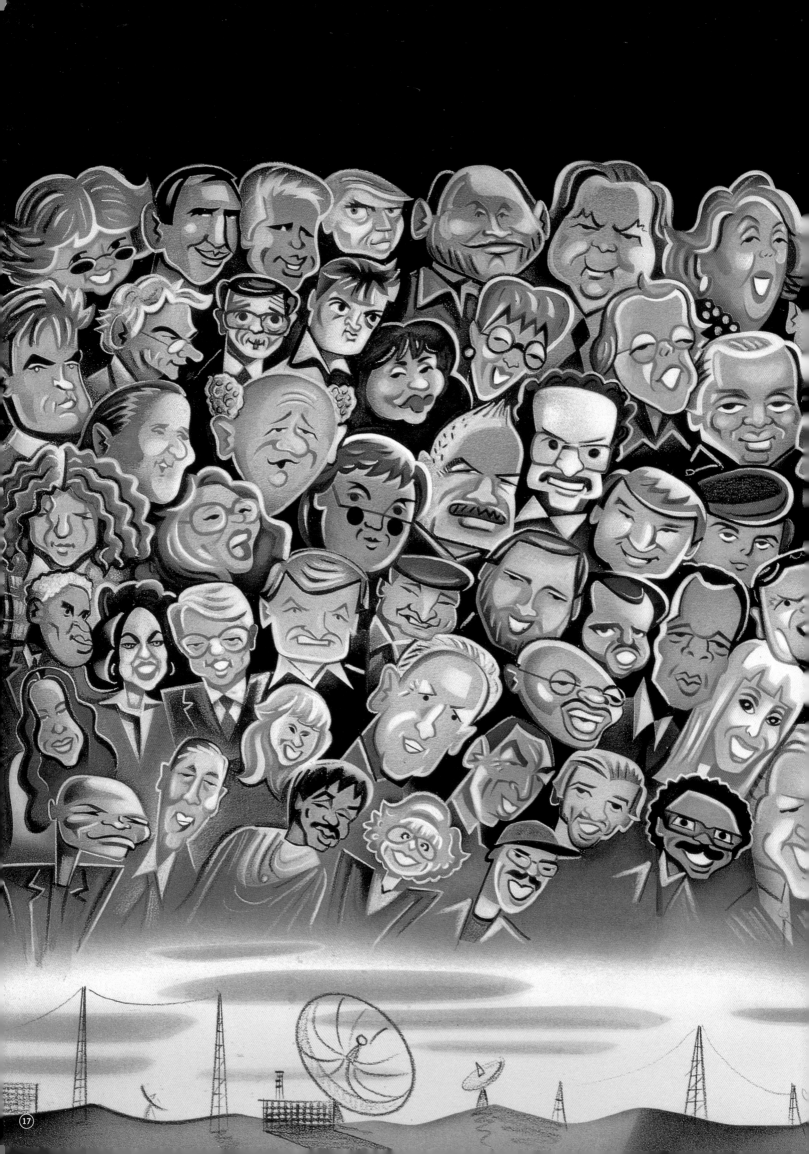

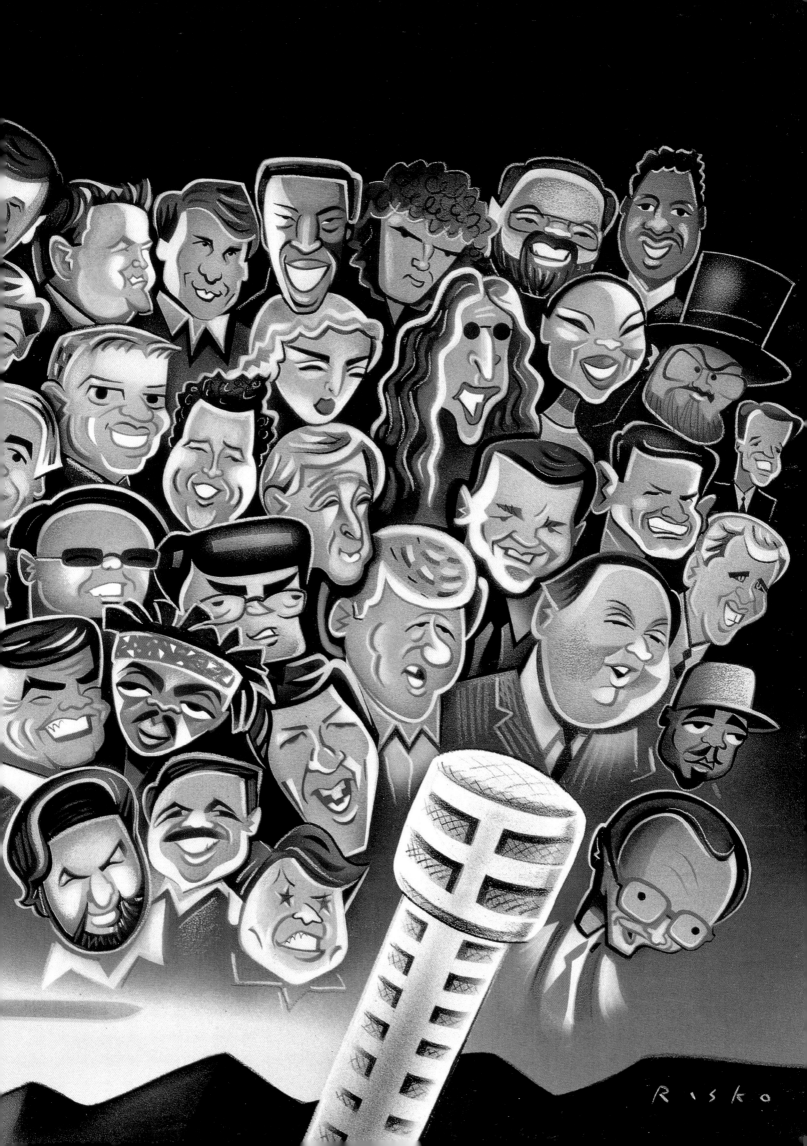

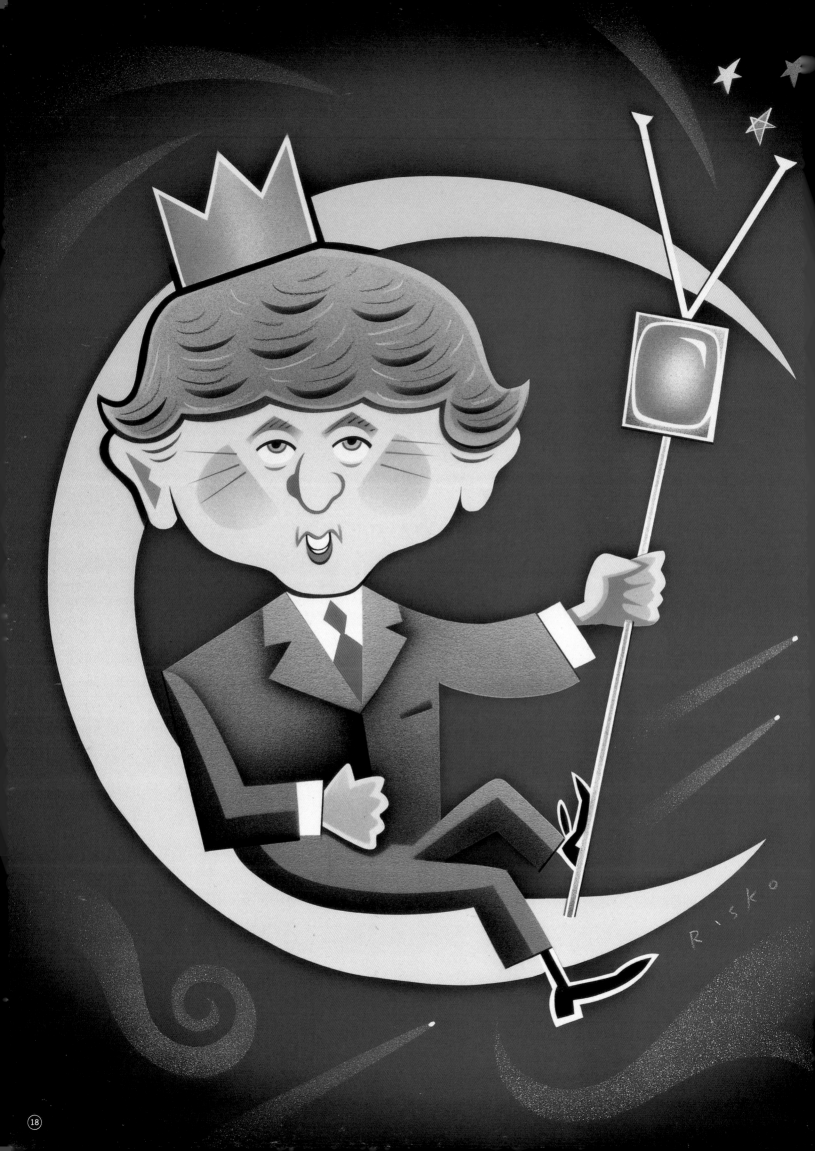

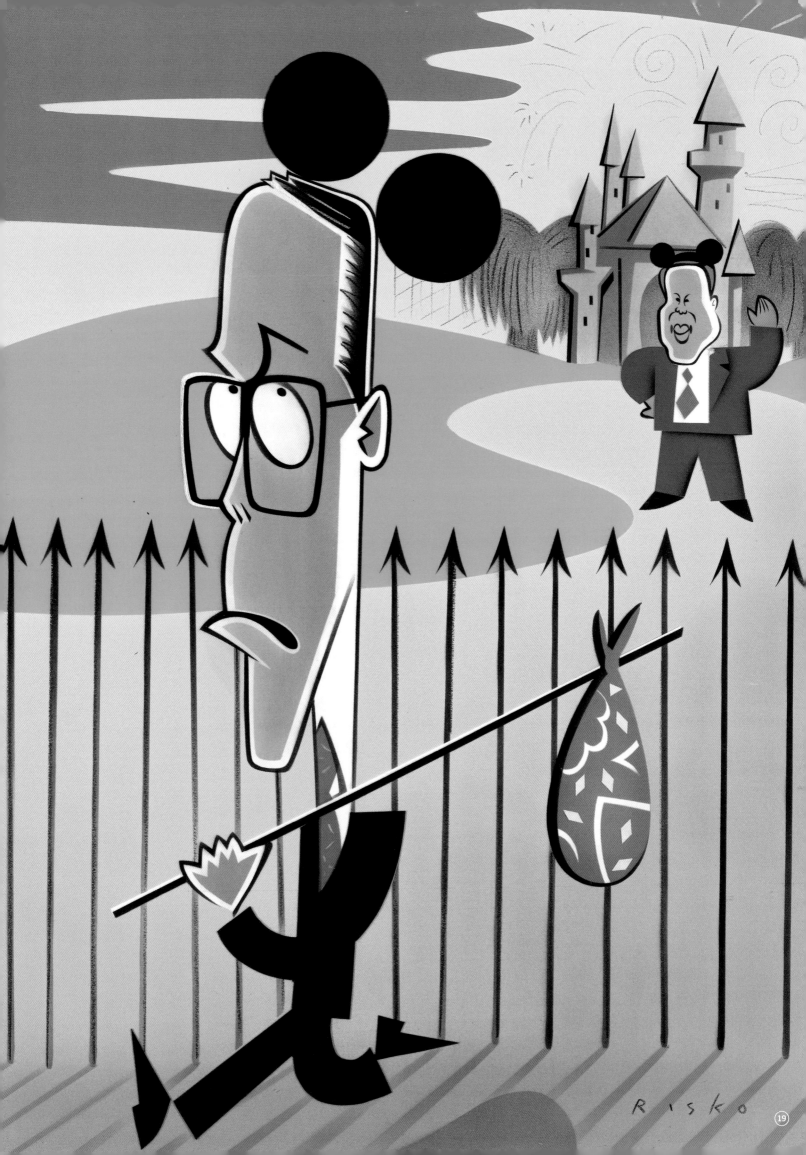

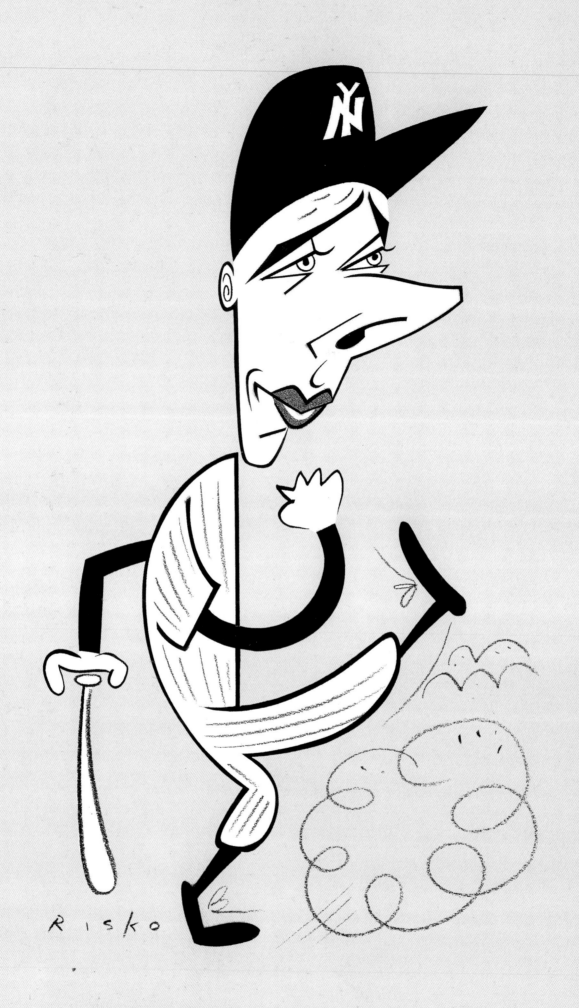

Was Joe DiMaggio more famous
for the Summer of '41 or his marriage to Marilyn Monroe?
We know it wasn't his Mr. Coffee commercials.

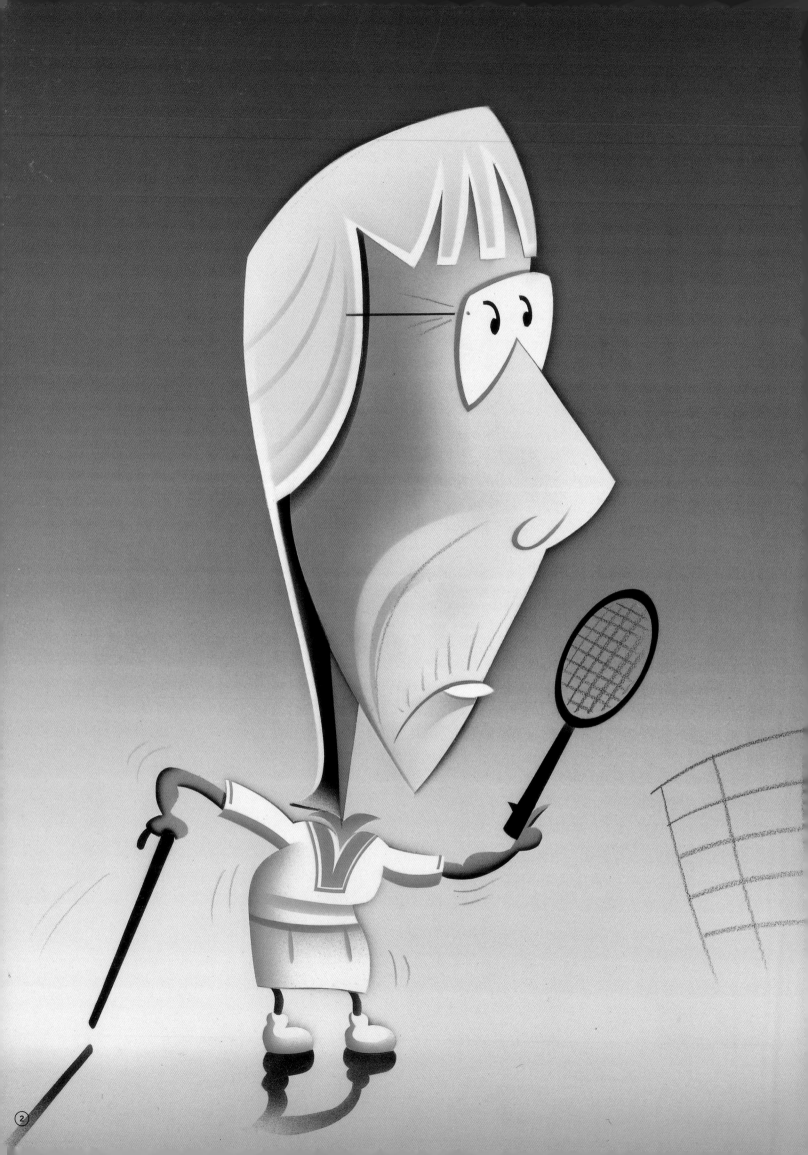

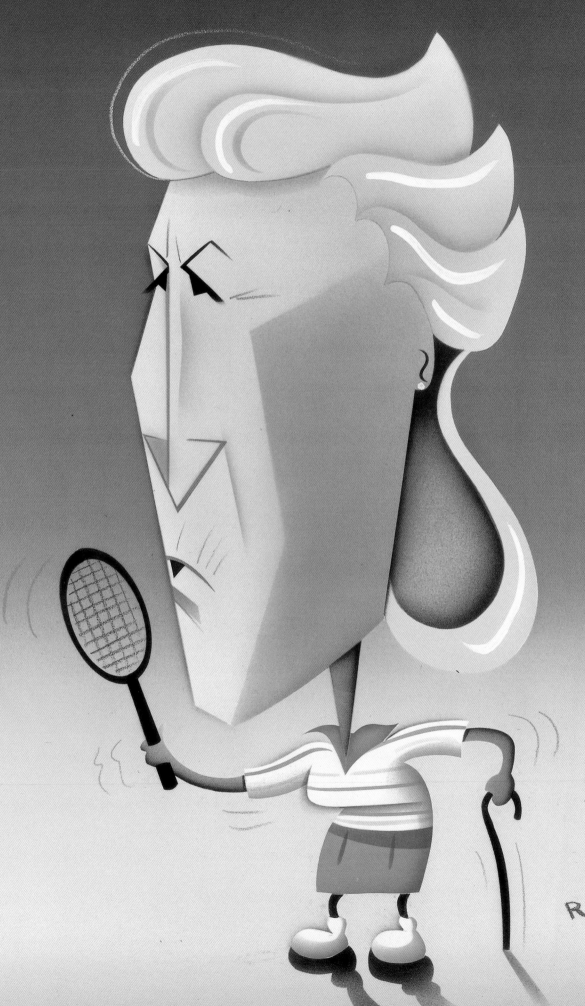

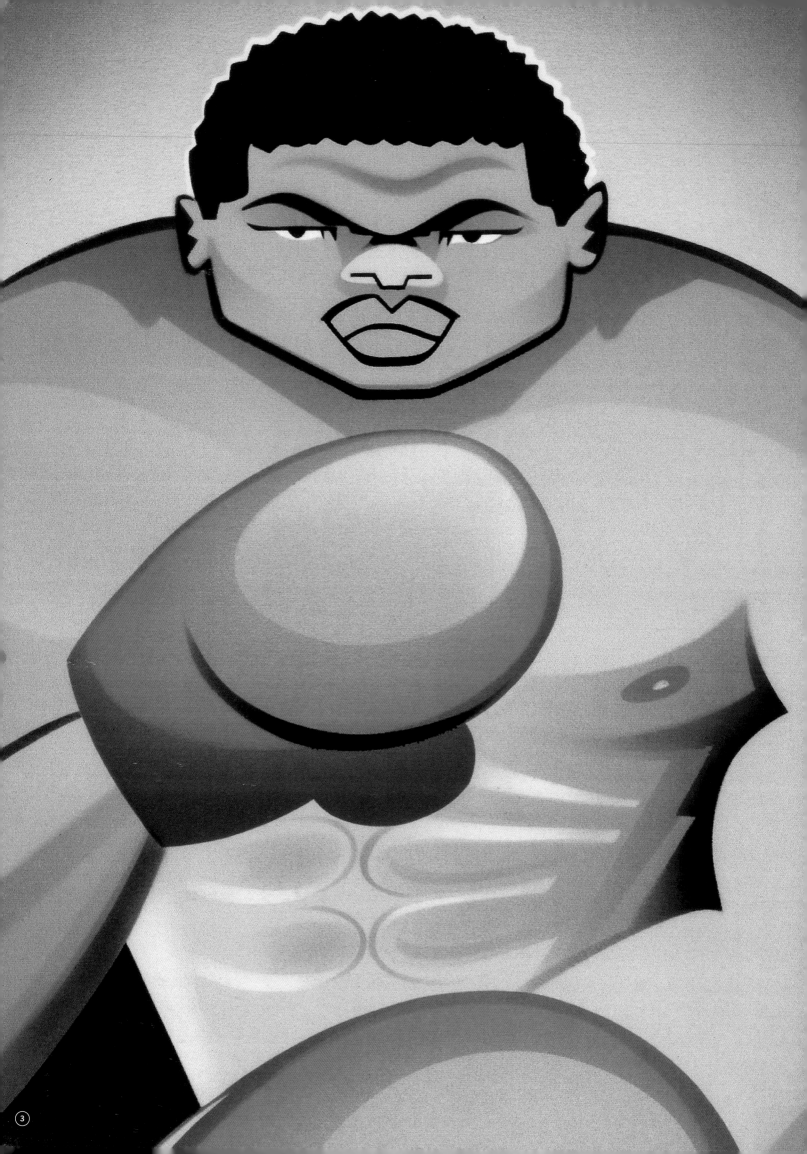

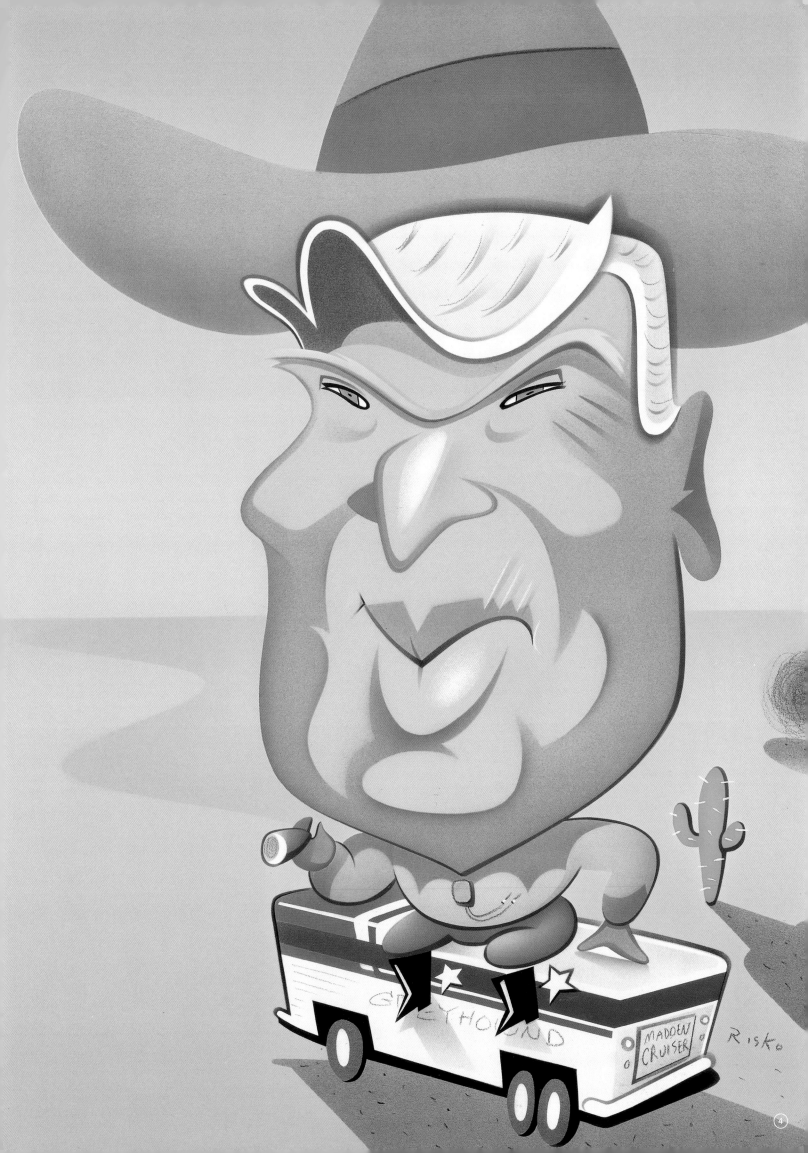

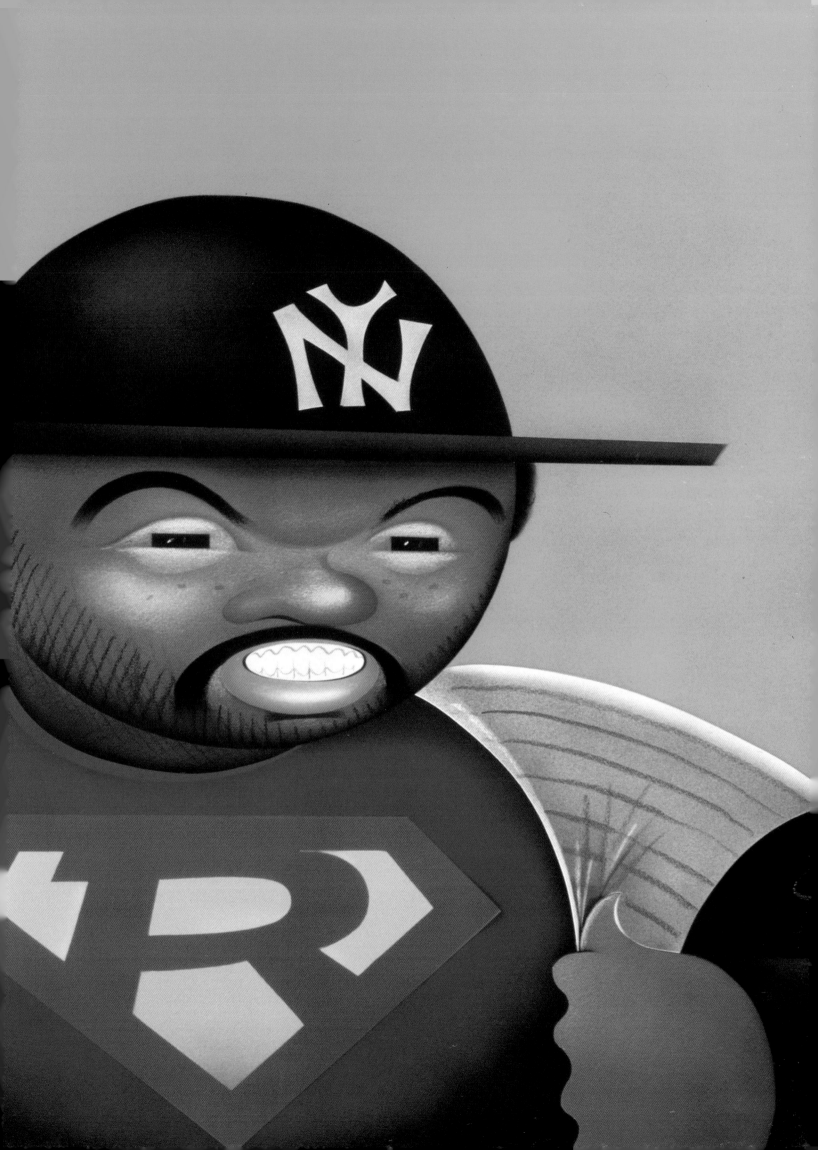

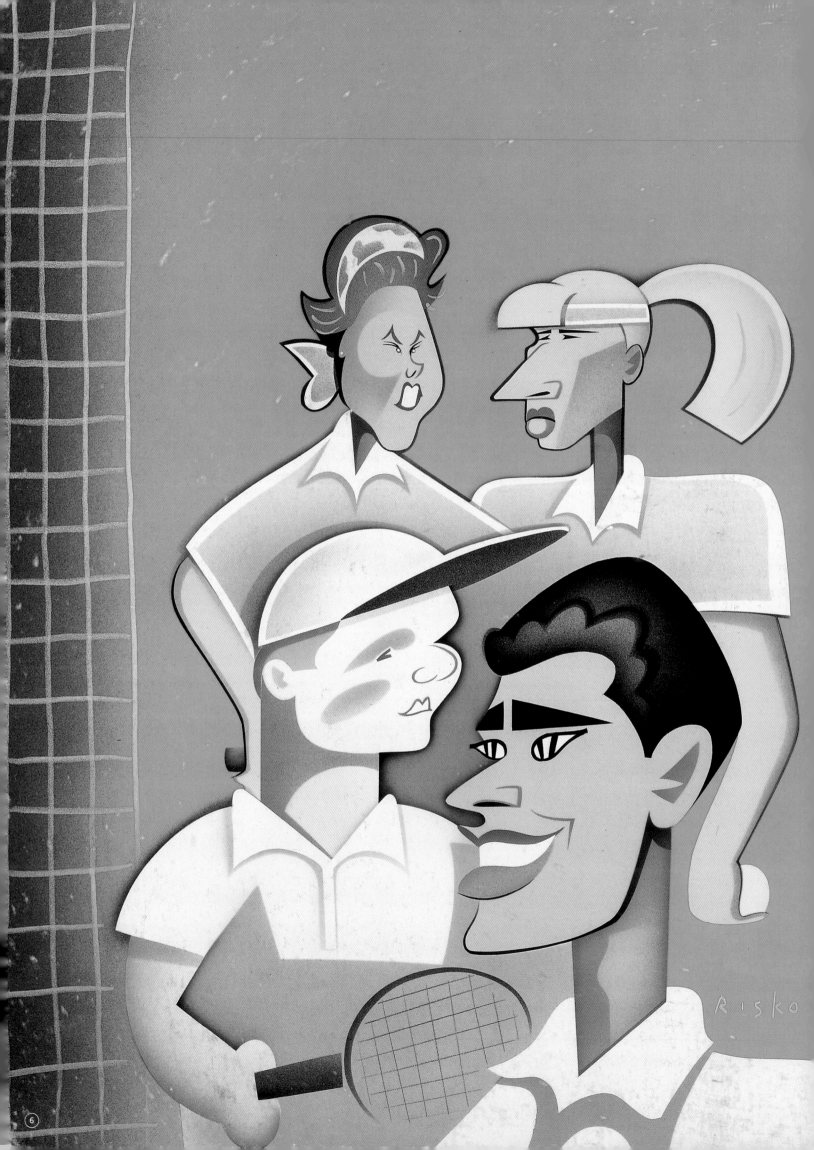

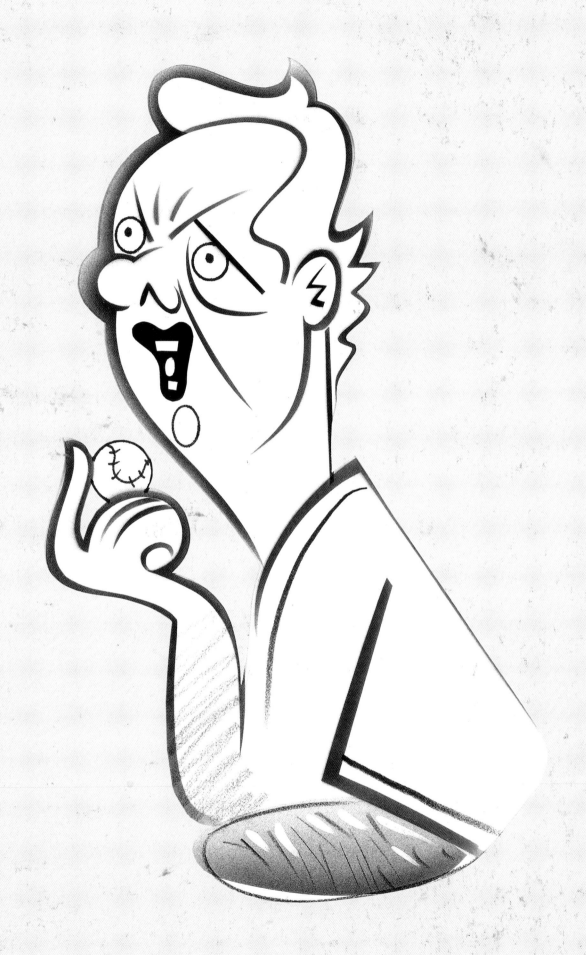

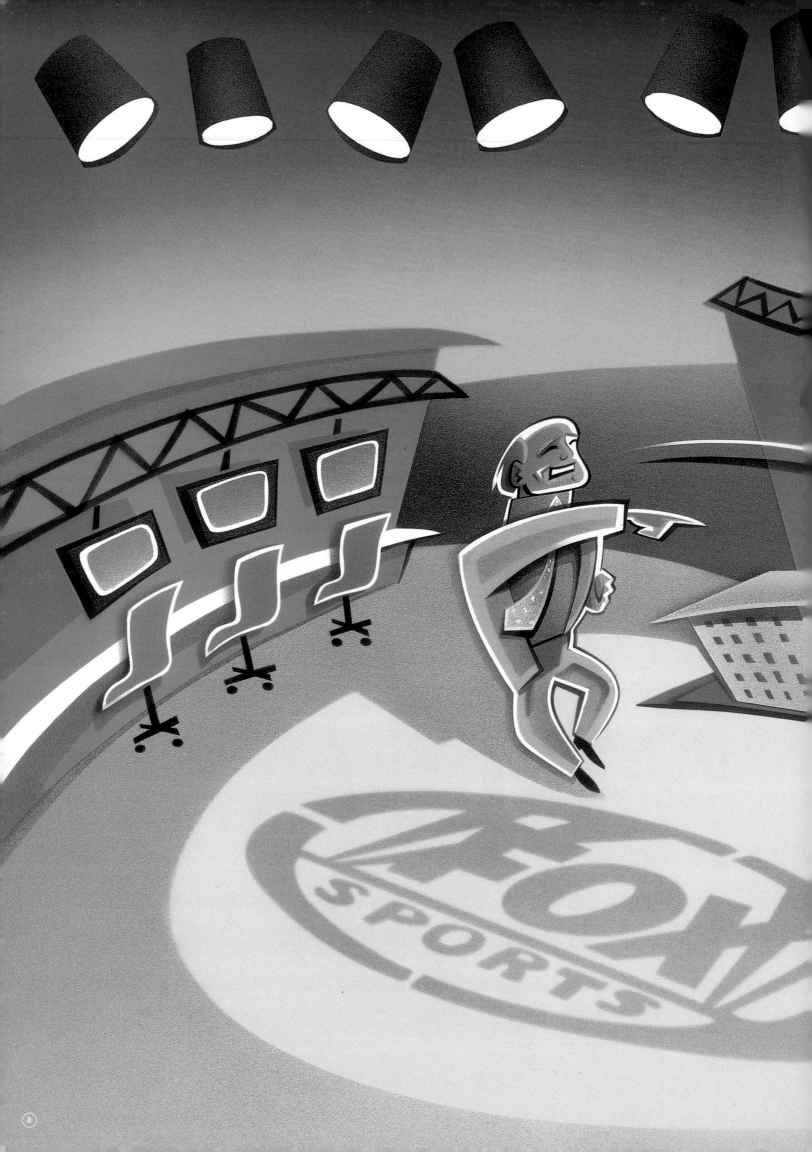

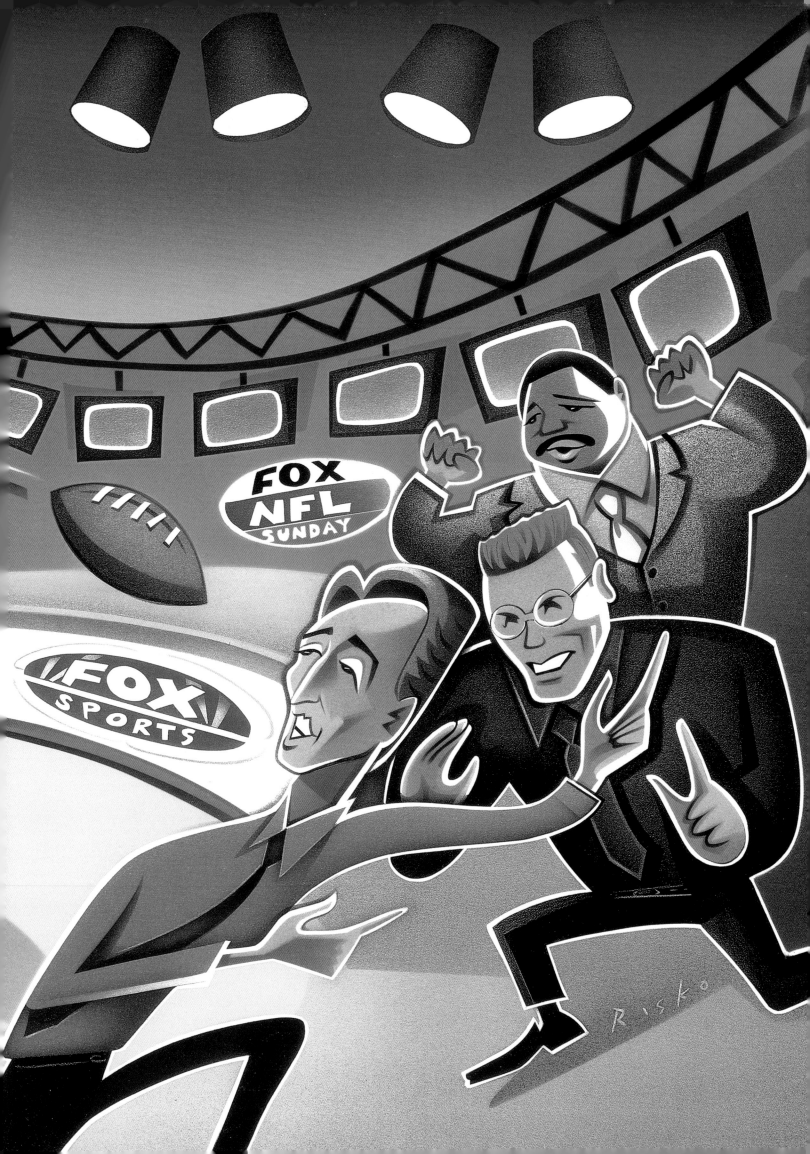

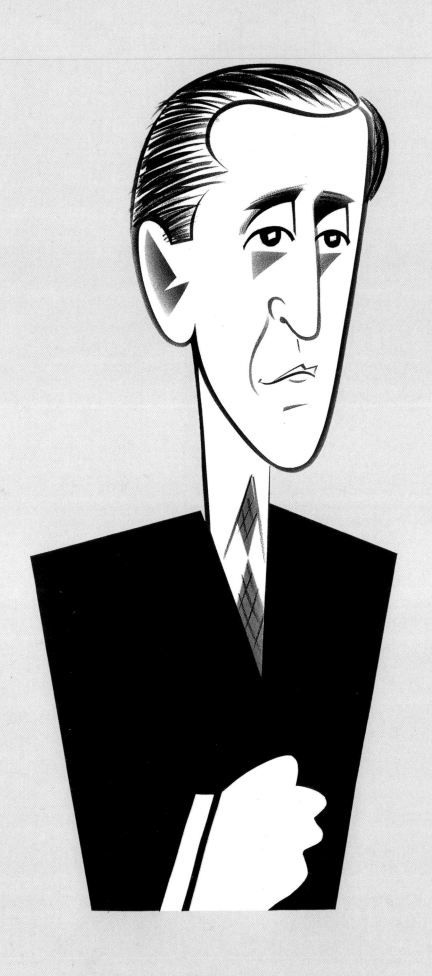

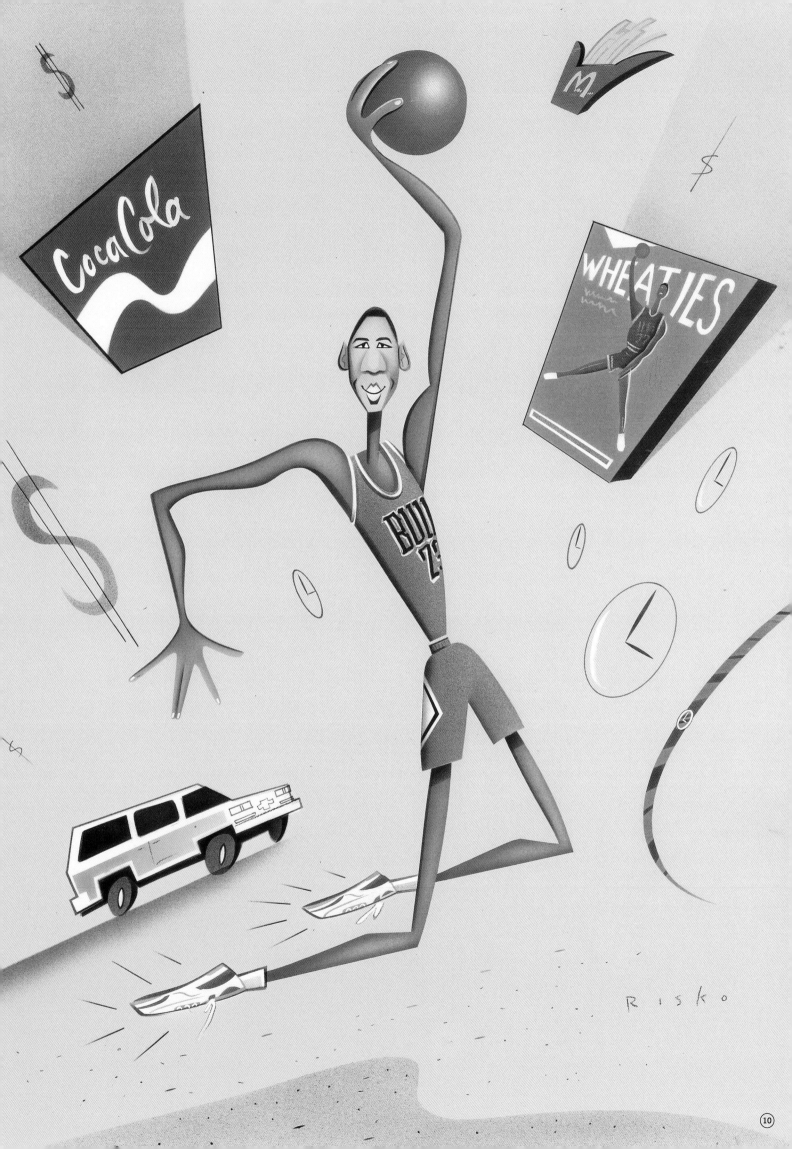

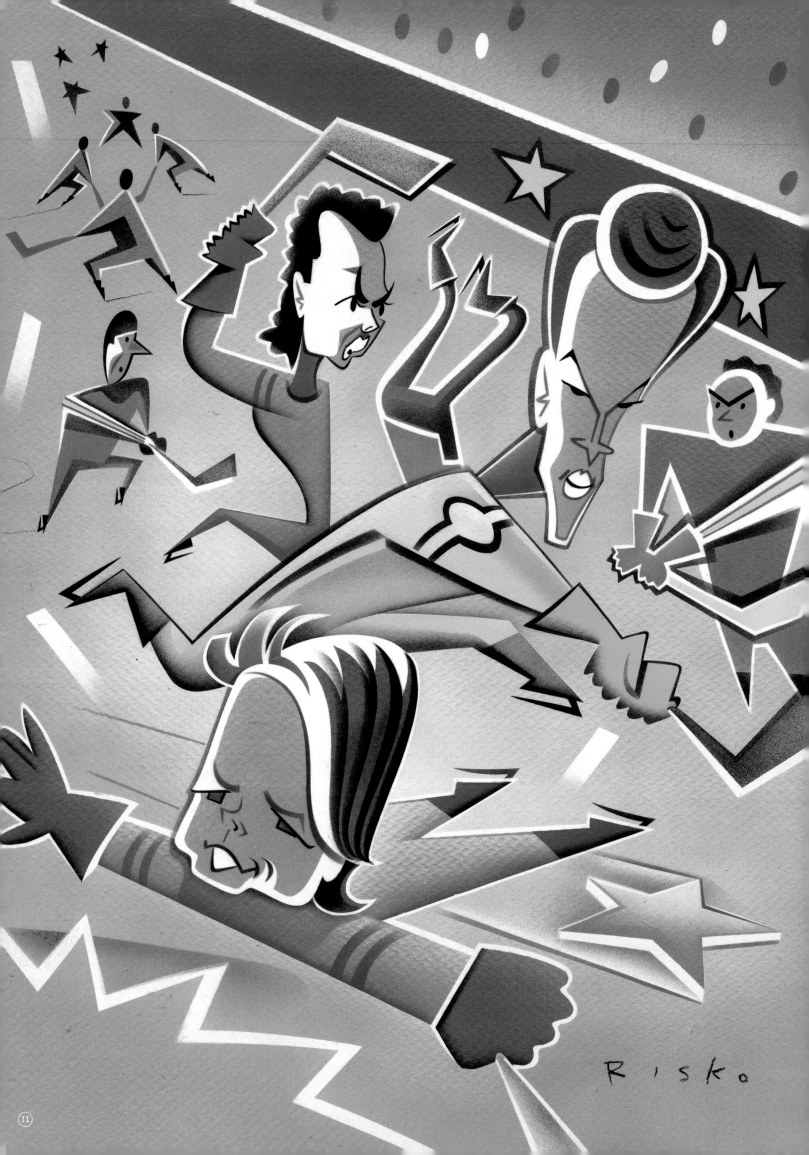

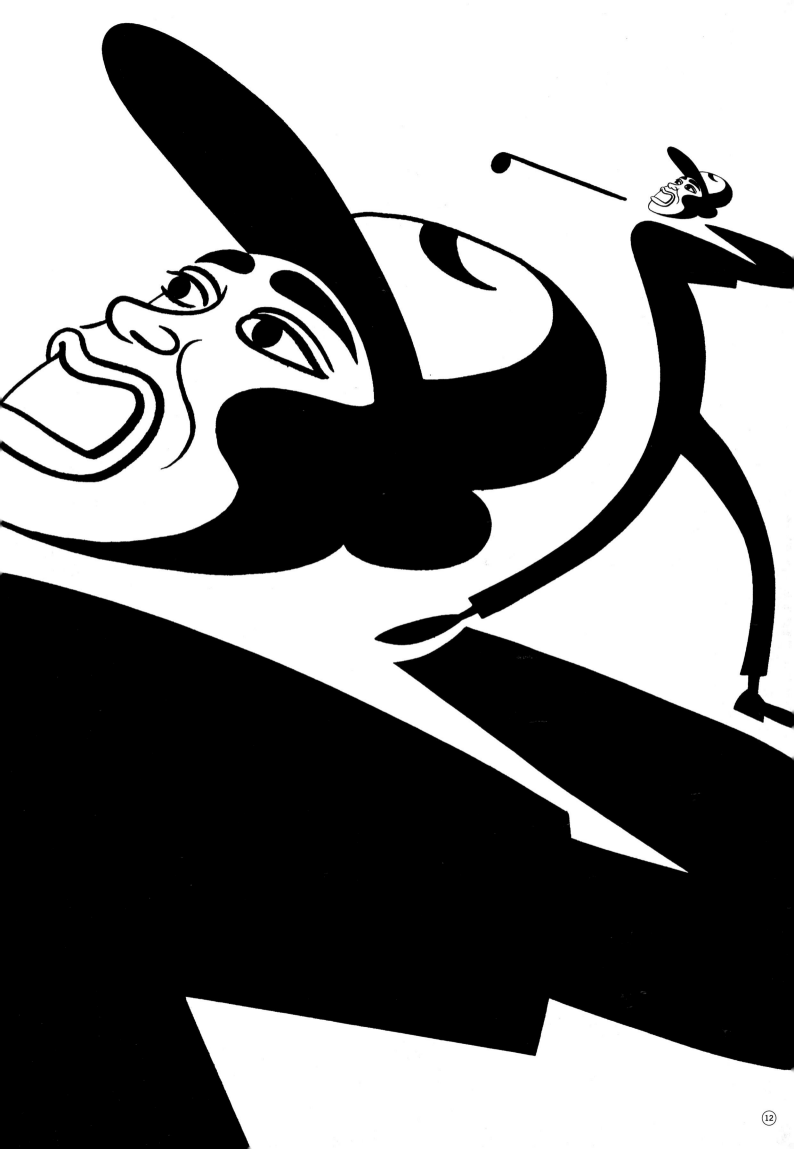

She has that kind of
Heavenly Mother aura that you could either
love or fear depending on her mood.

① Angela Lansbury

② Tommy and Twiggy

③ Buddy Hackett

④ Jackie Mason

⑤ Beauty and the Beast

⑥ Dame Edna/Barry Humphries

⑦ Victor/Victoria

⑧ Siegfried and Roy

⑨ Cole Porter

⑩ Johnny Mercer

⑪ On the Town

⑫ Bob Fosse

⑬ Jule Styne

⑭ Liza and Chita

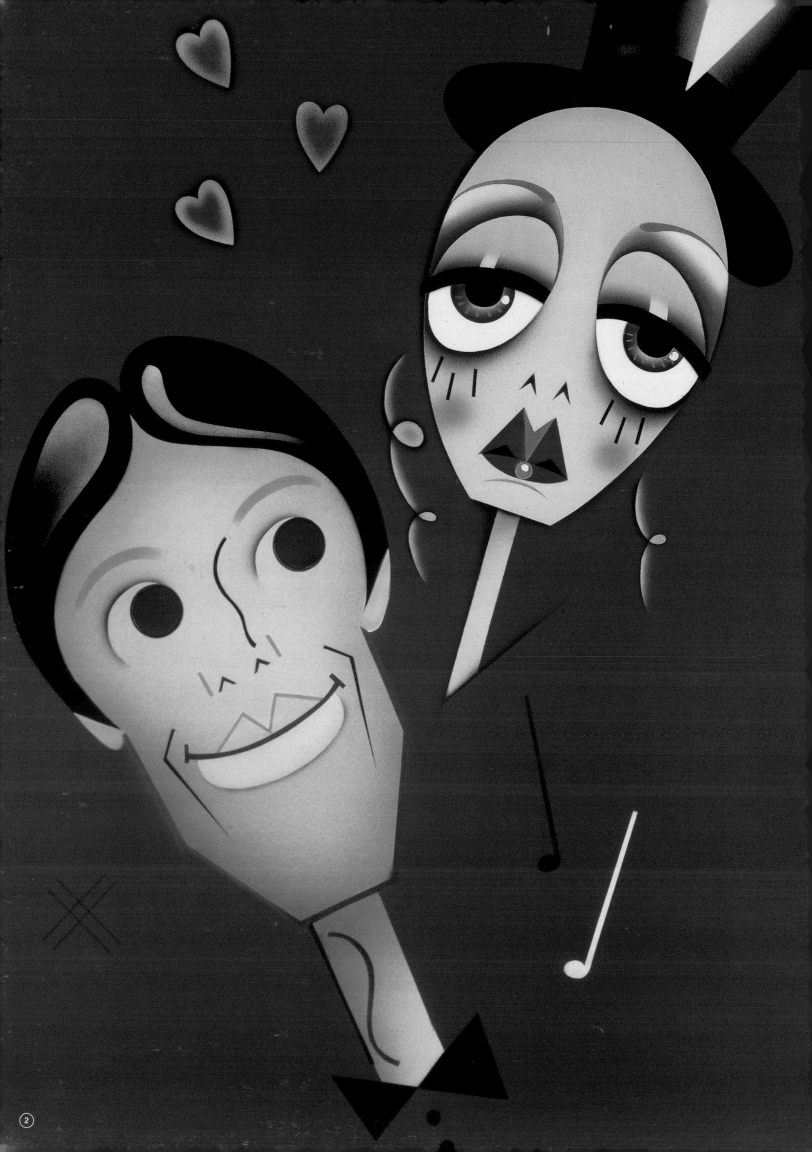

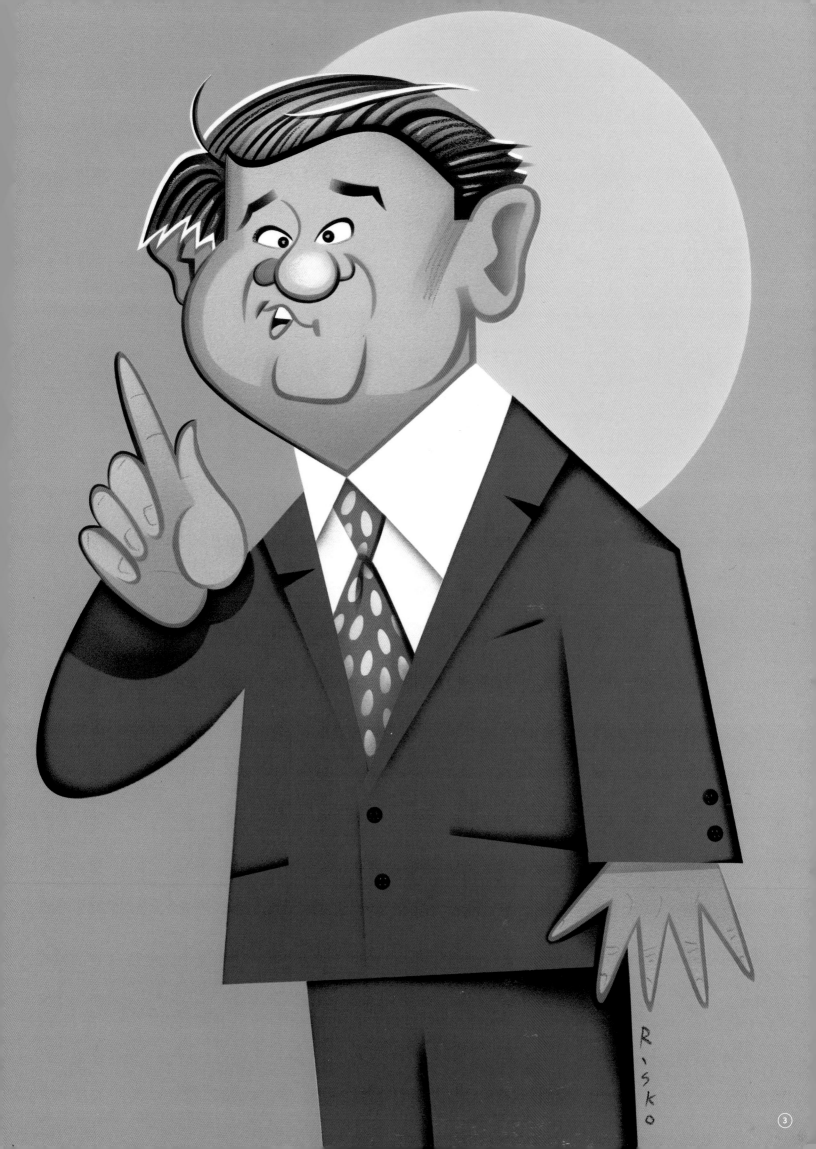

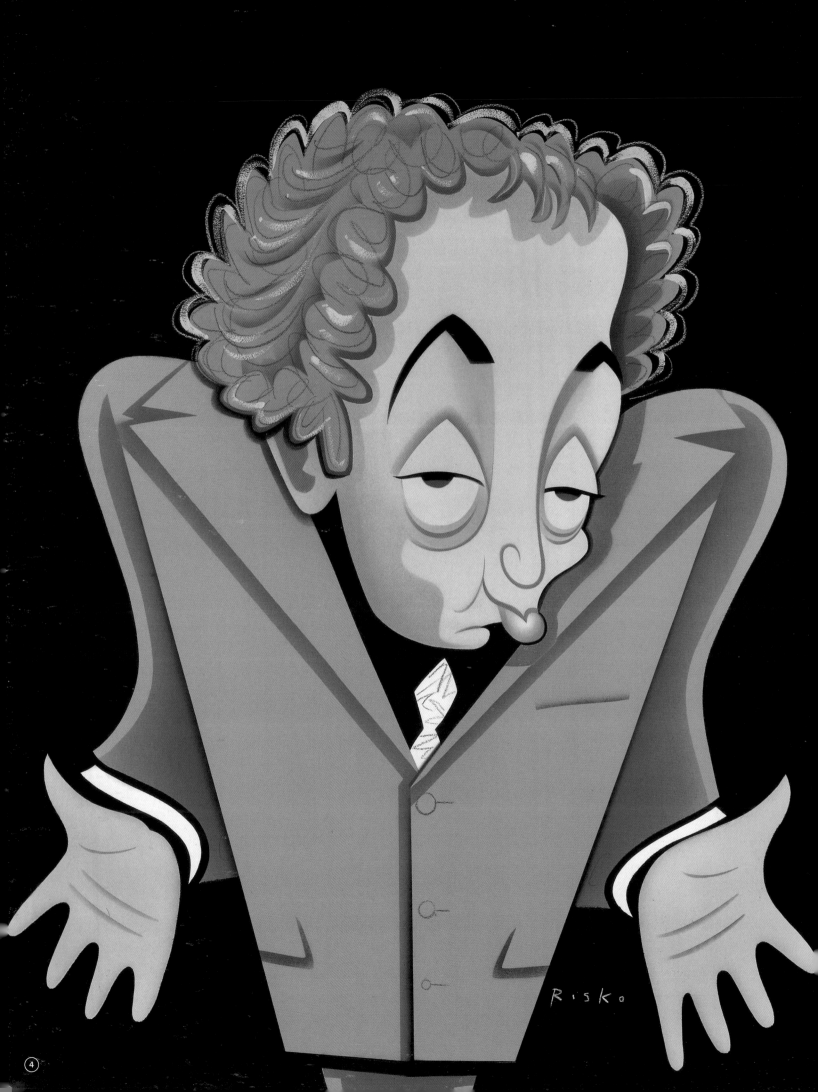

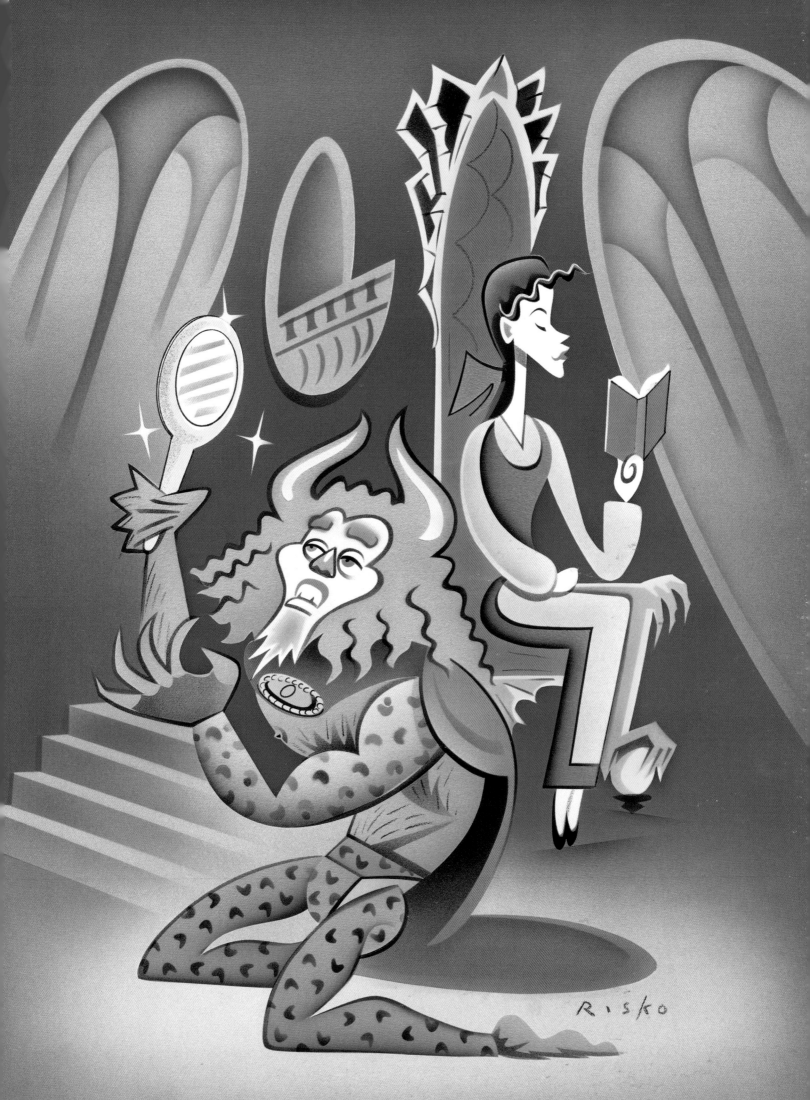

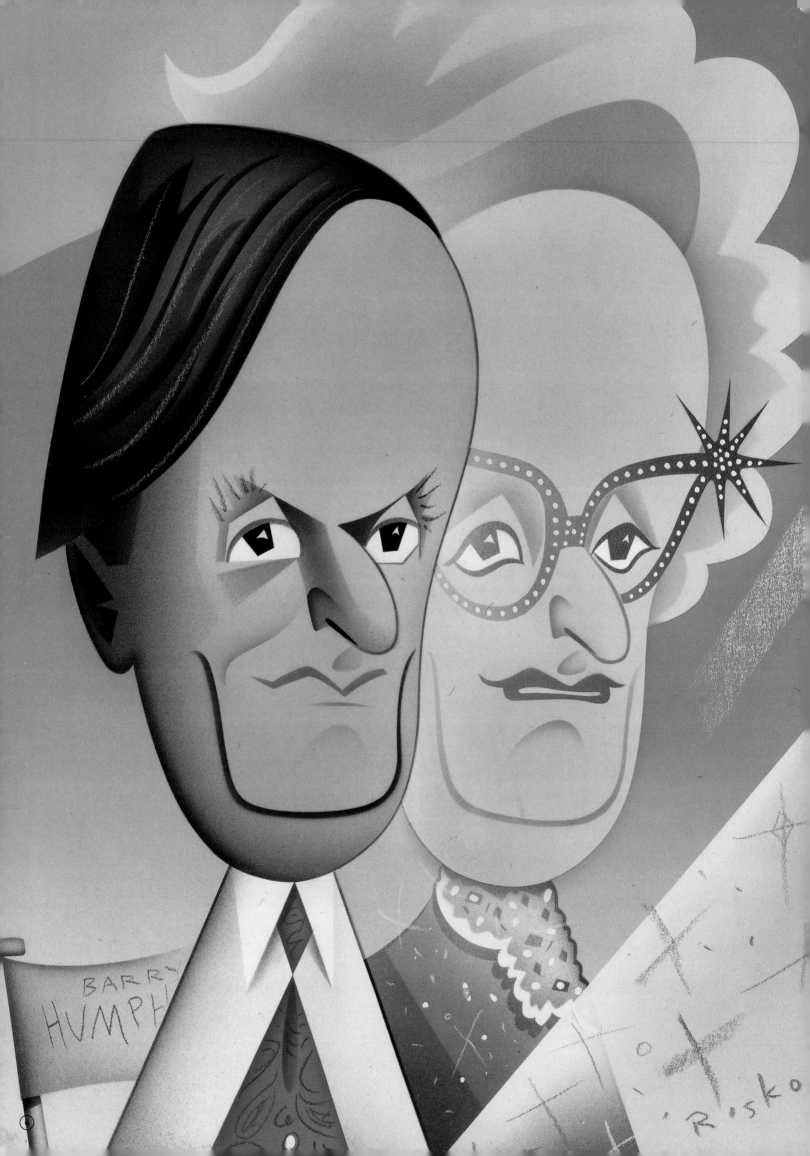

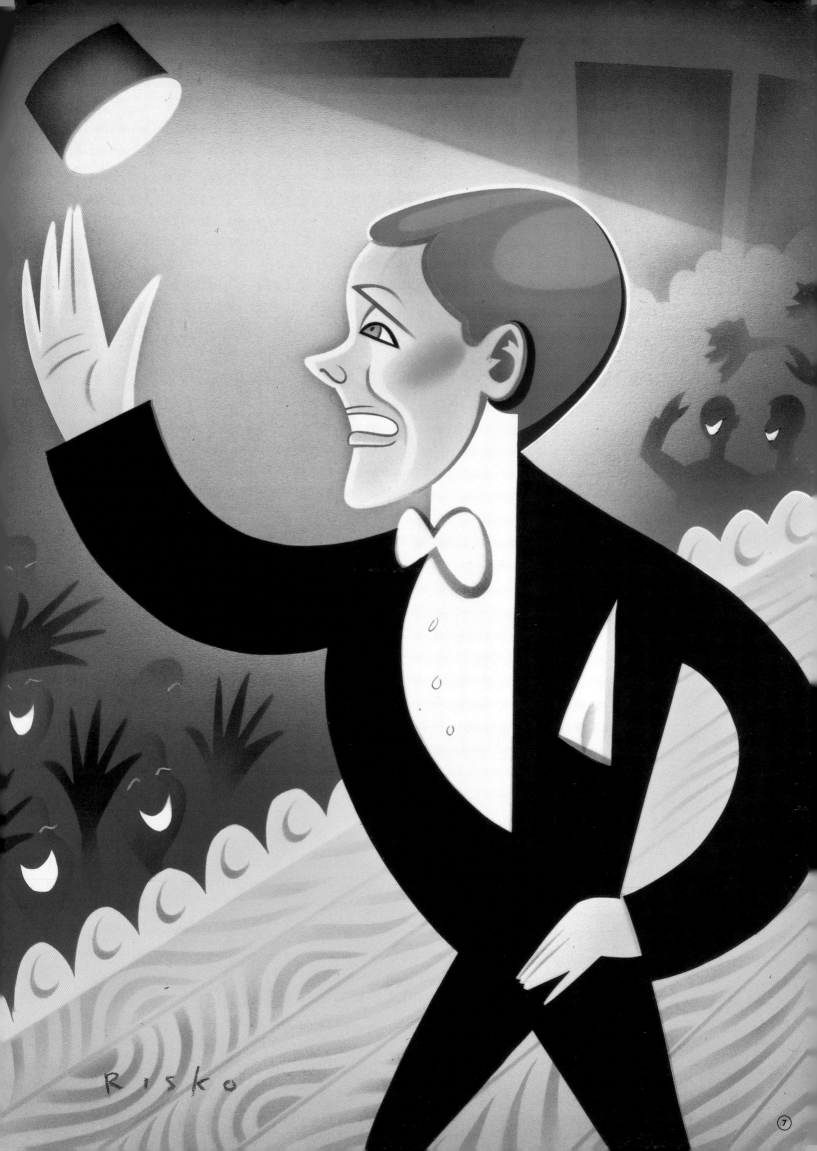

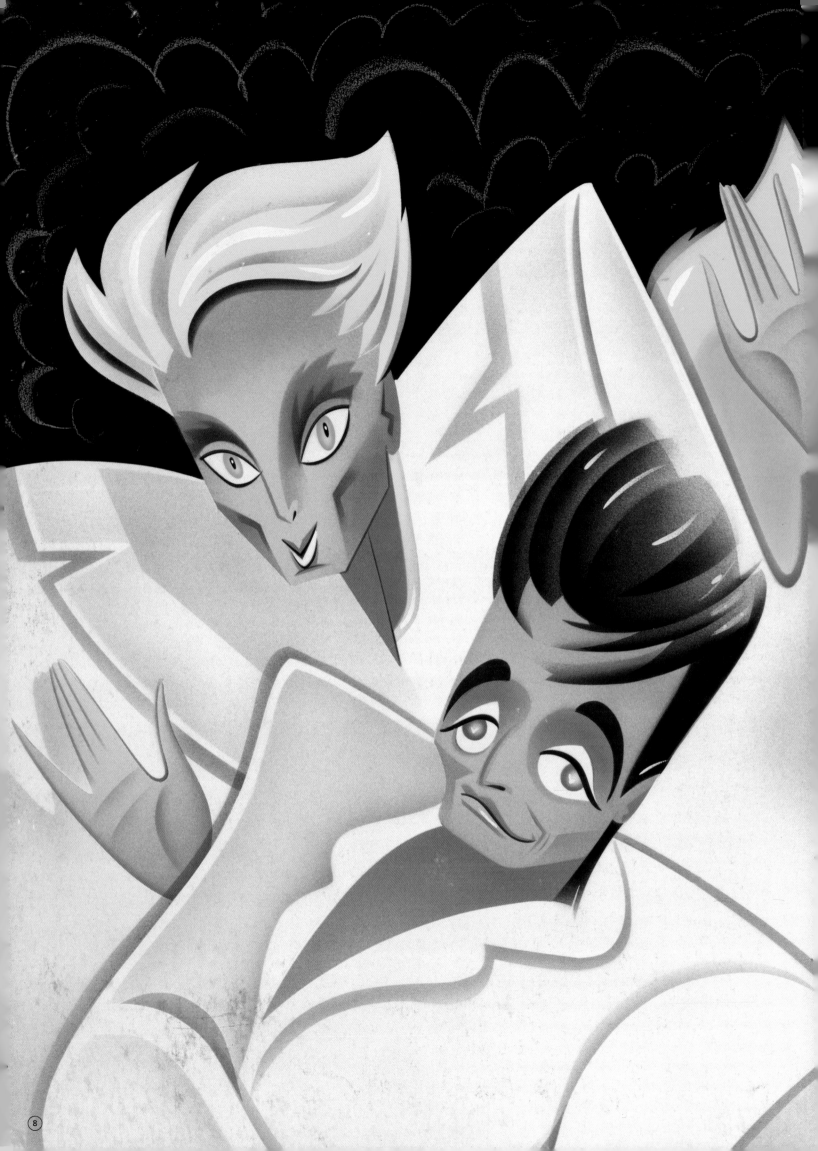

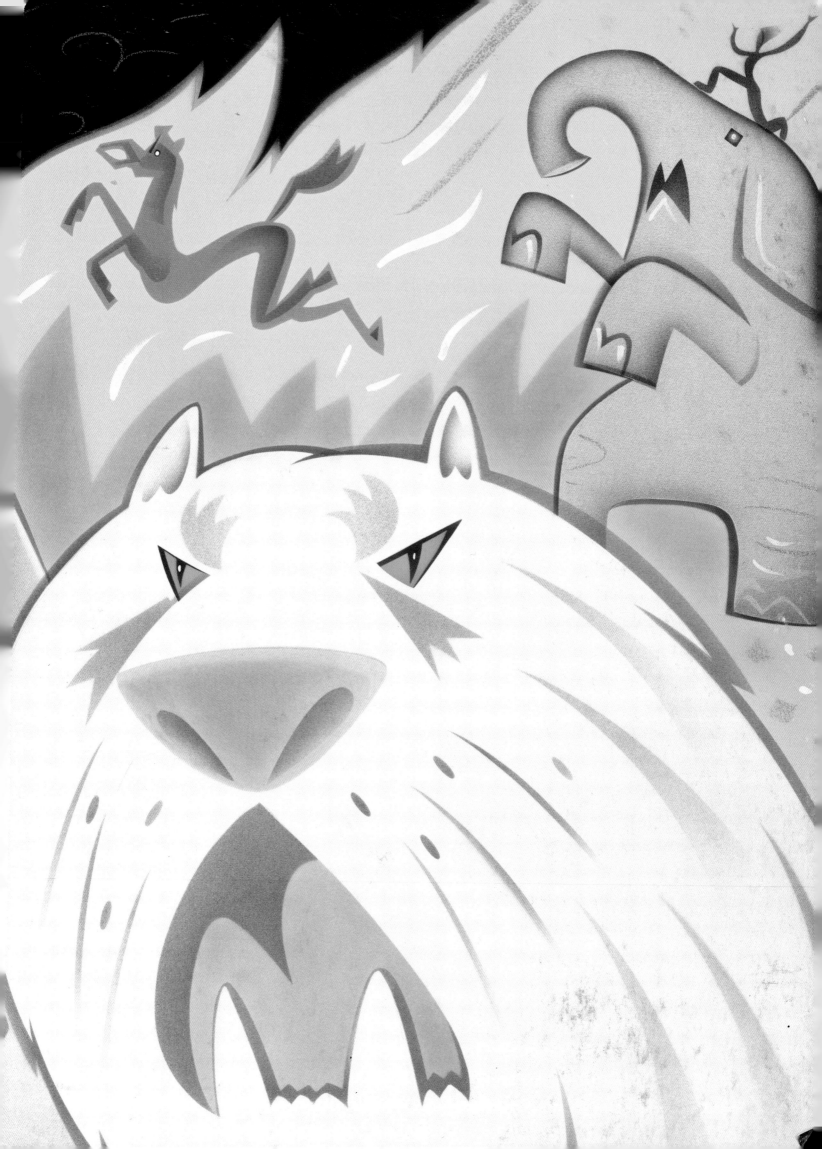

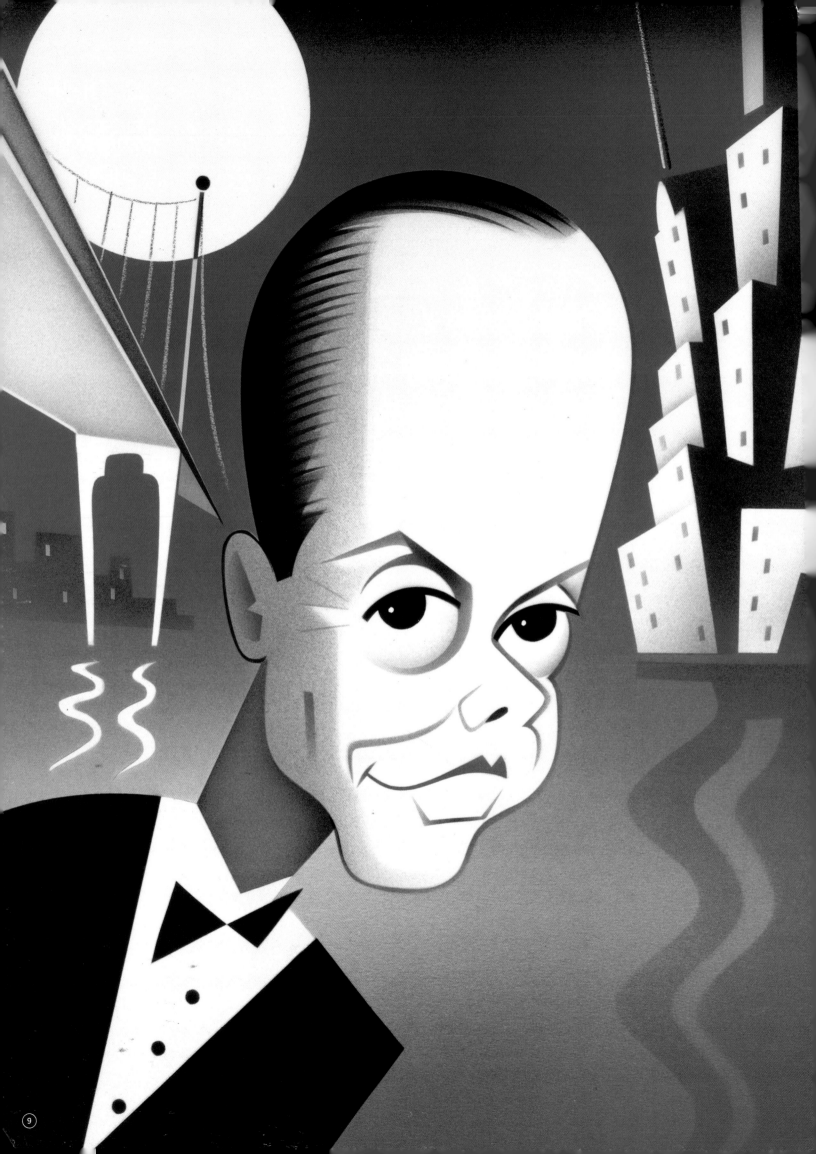

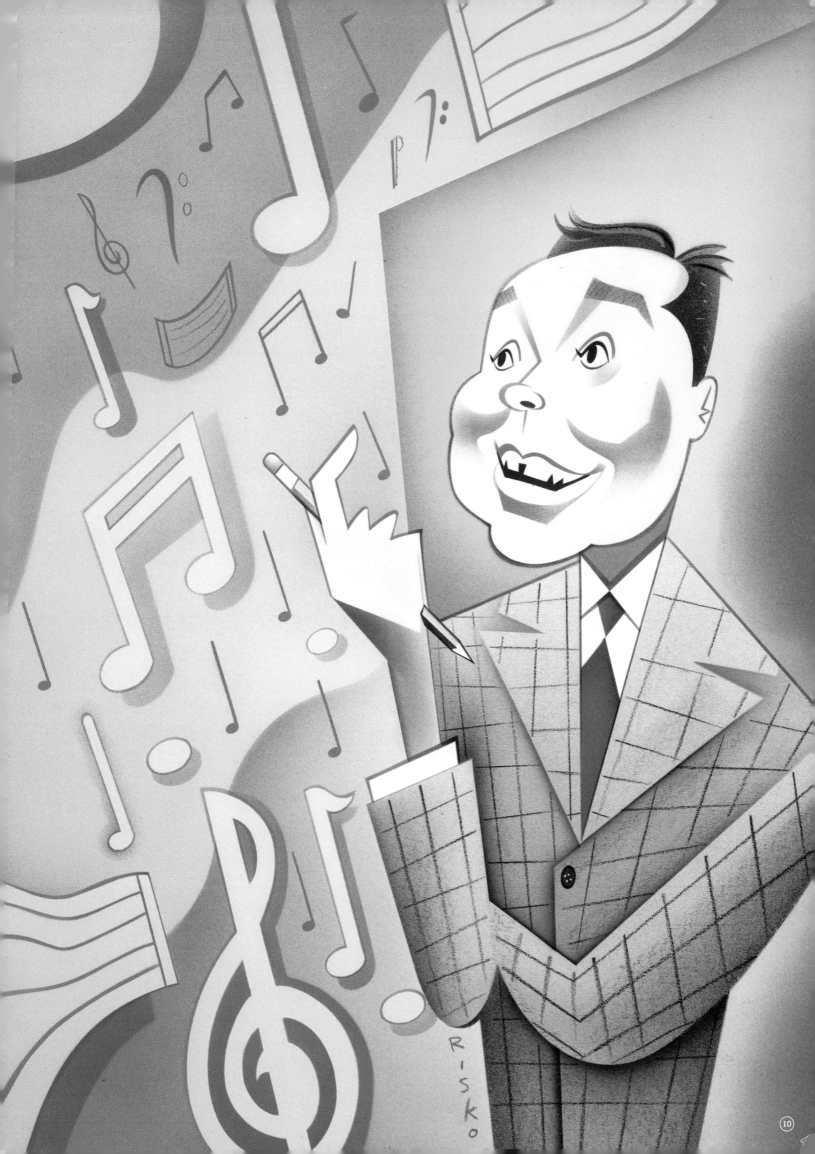

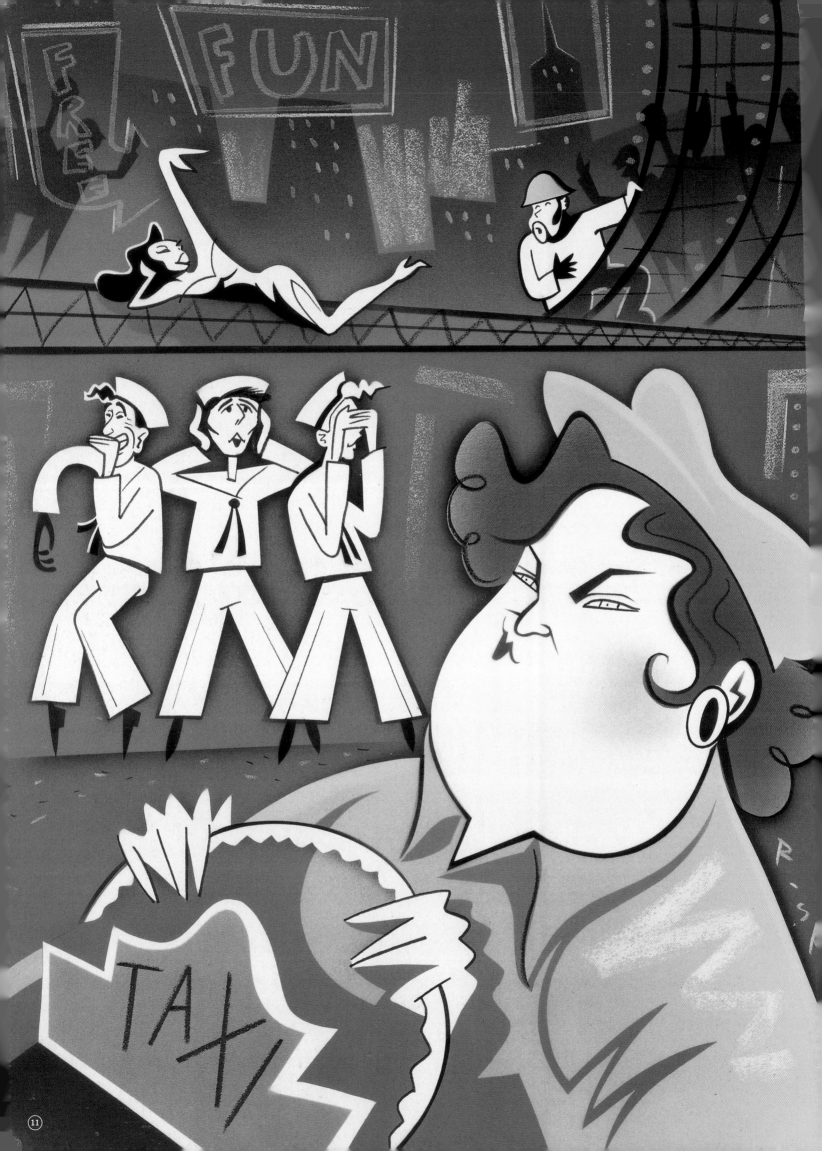

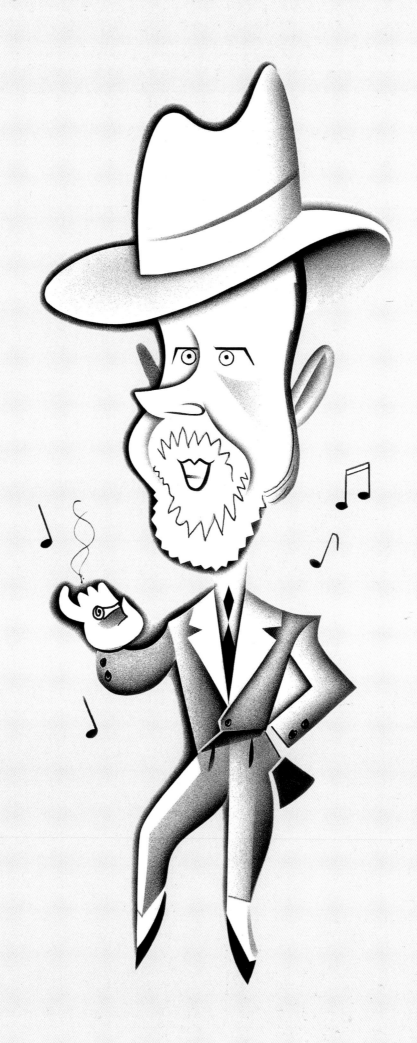

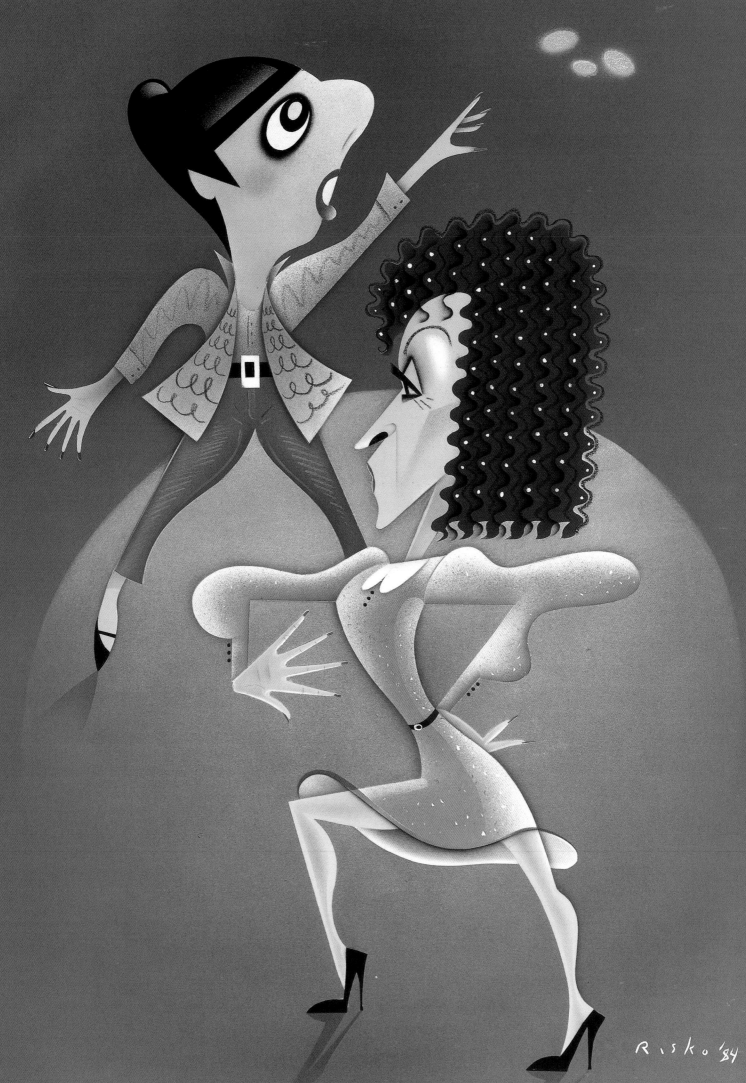

Risko '84

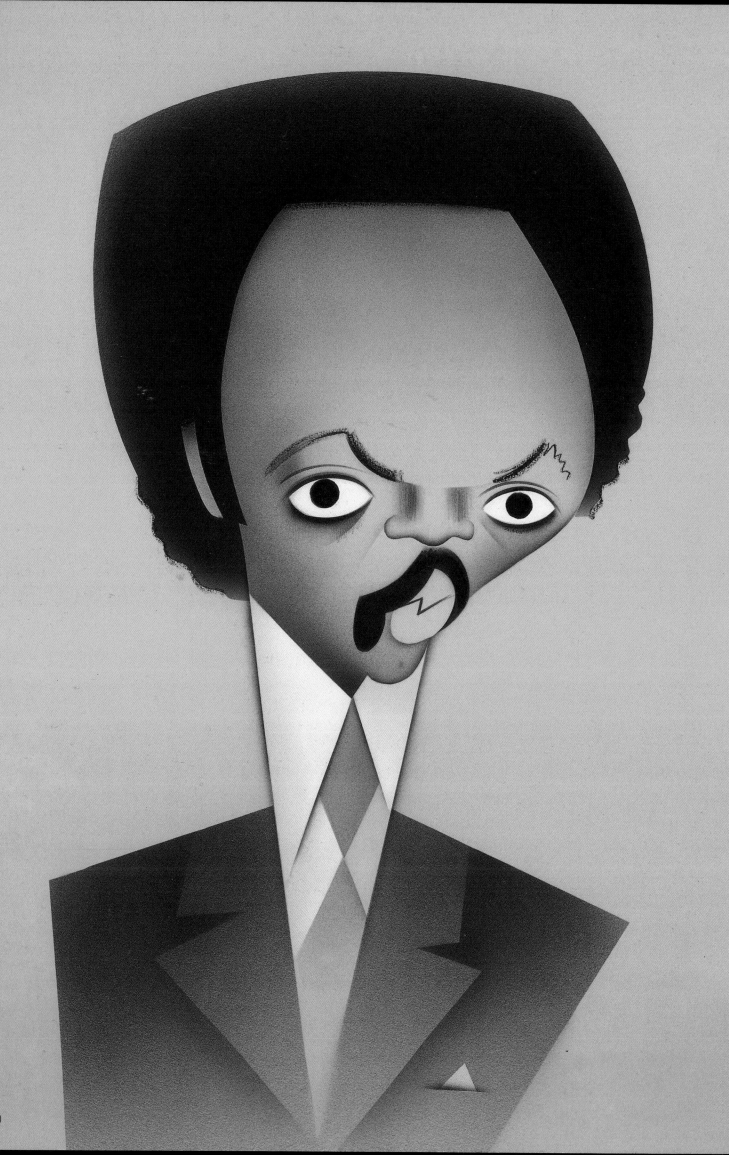

As far as Jacksons go I think
Jesse is a much better performer than Michael.

politics

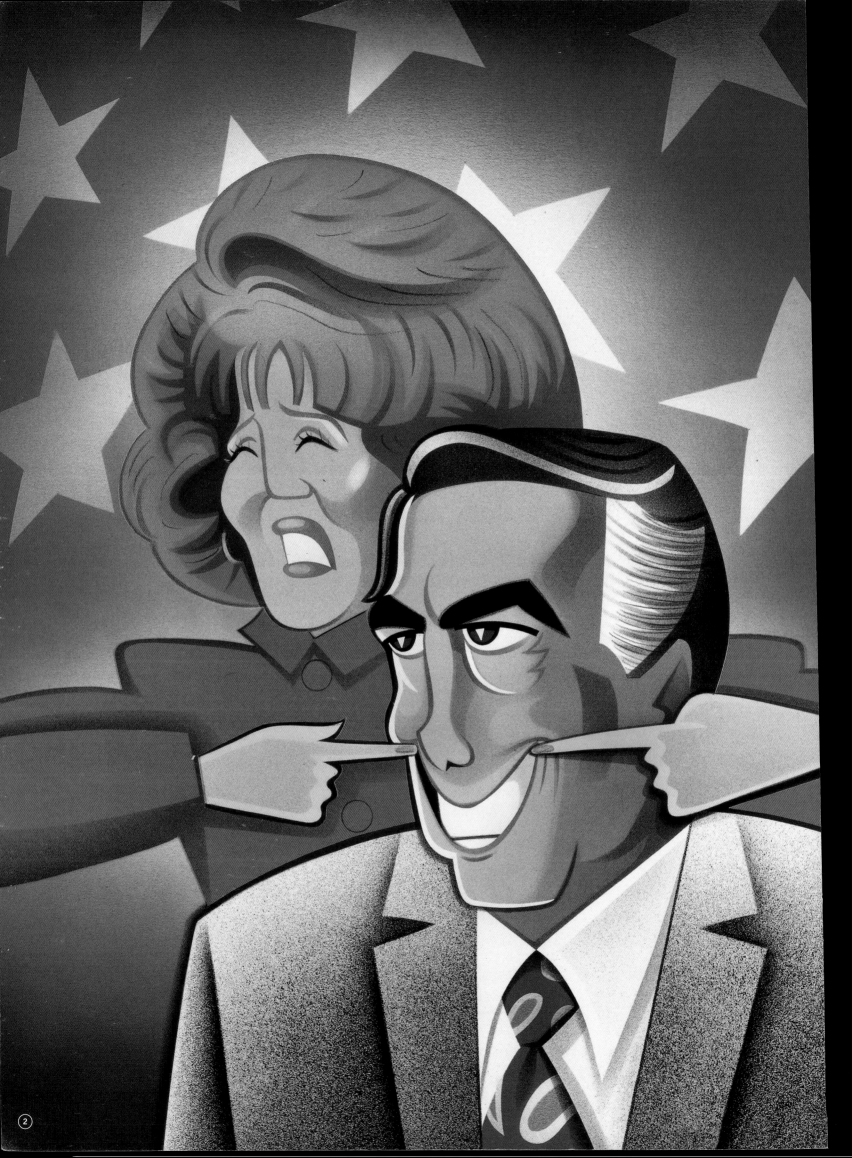

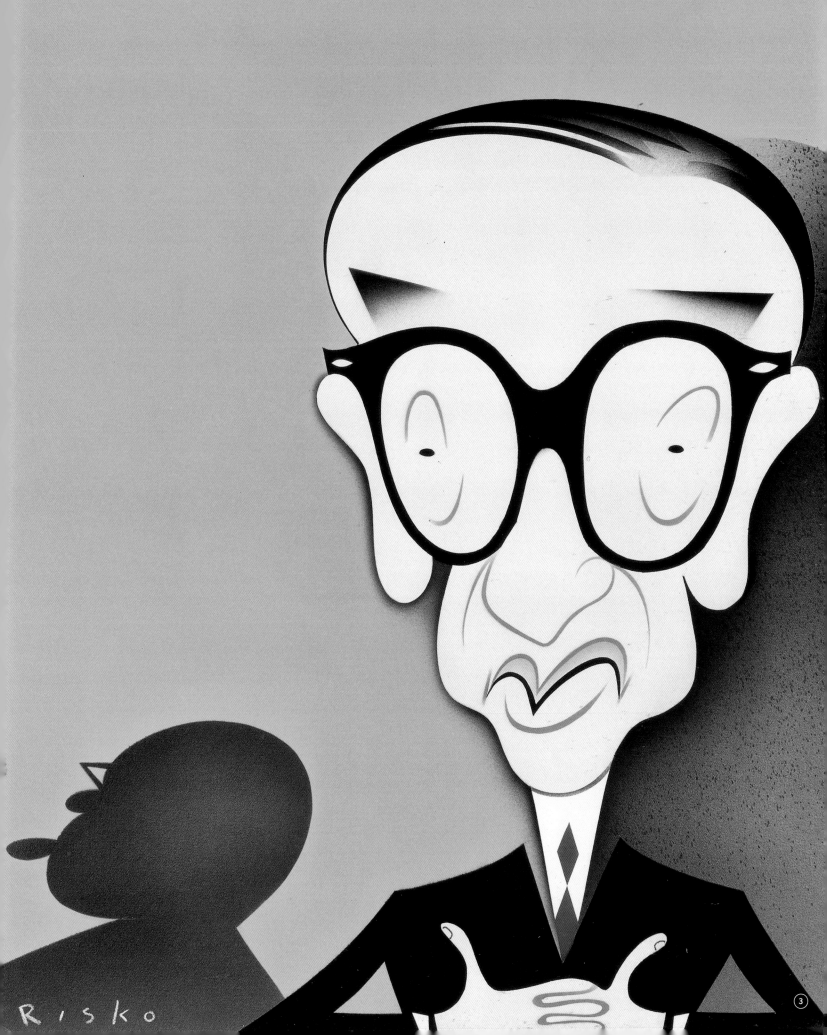

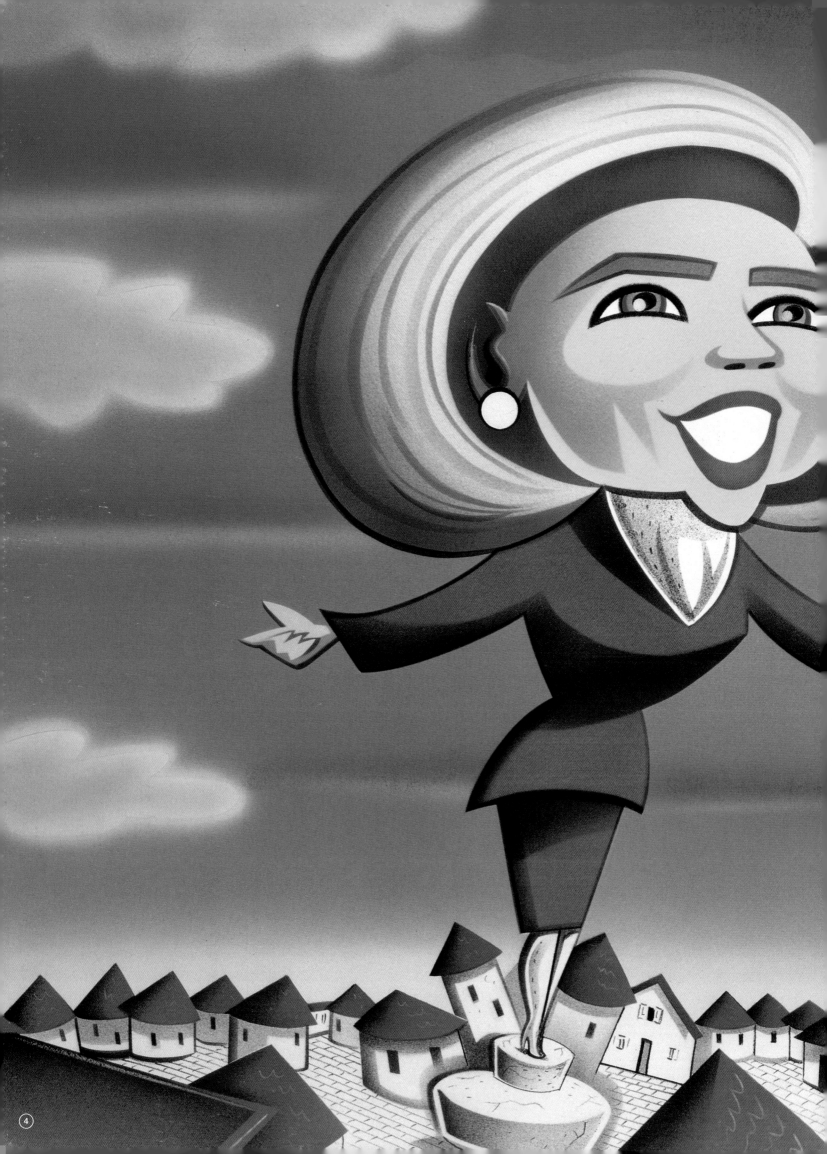

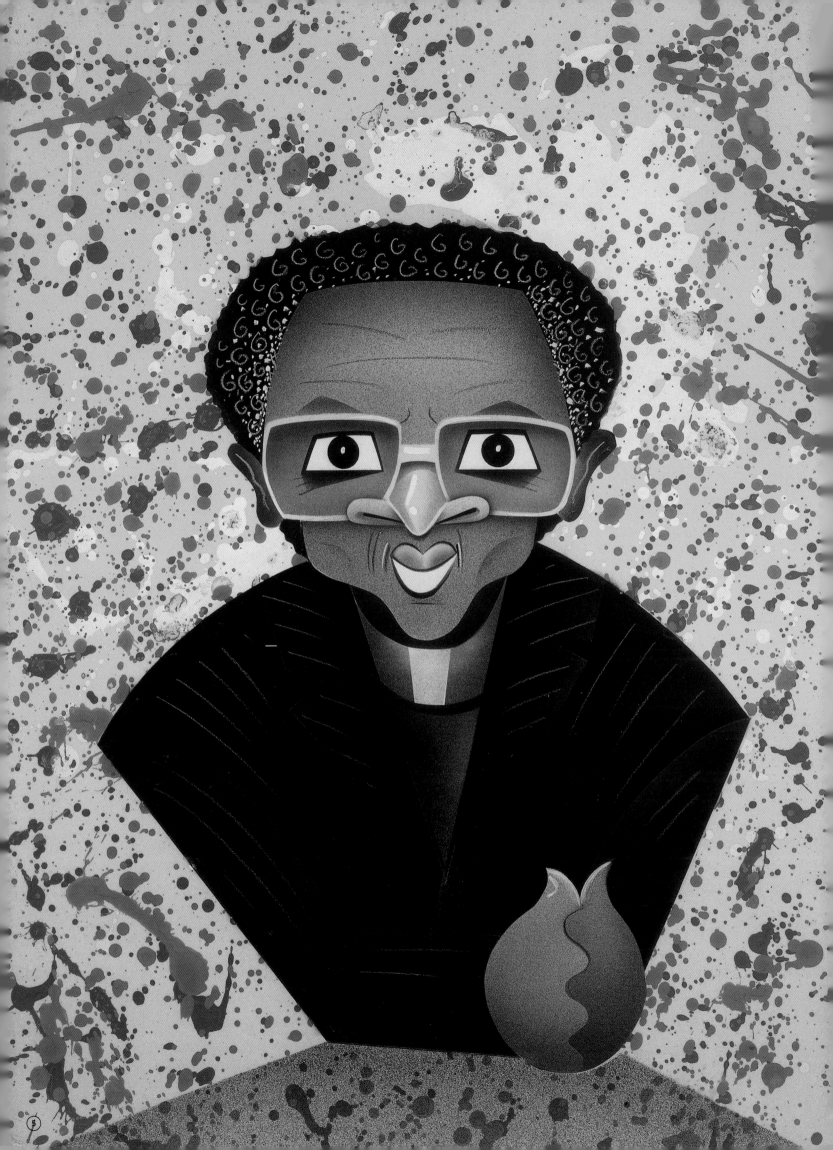

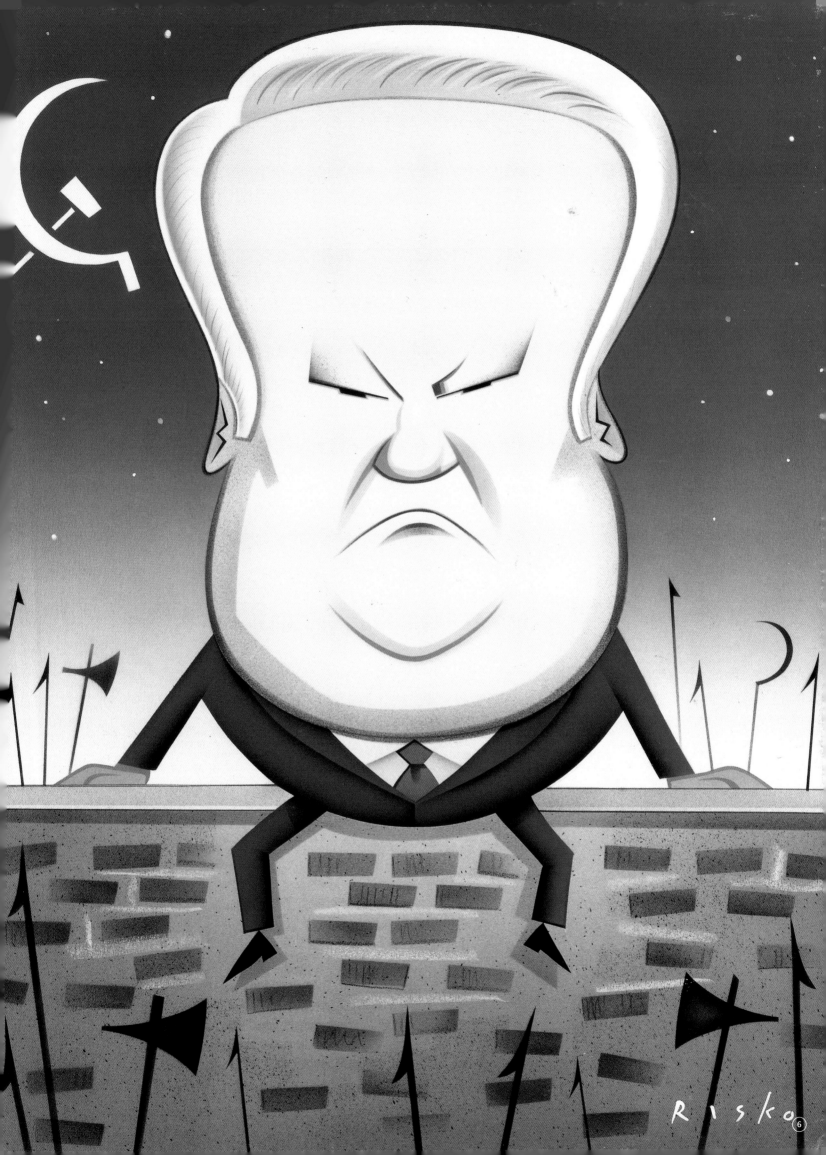

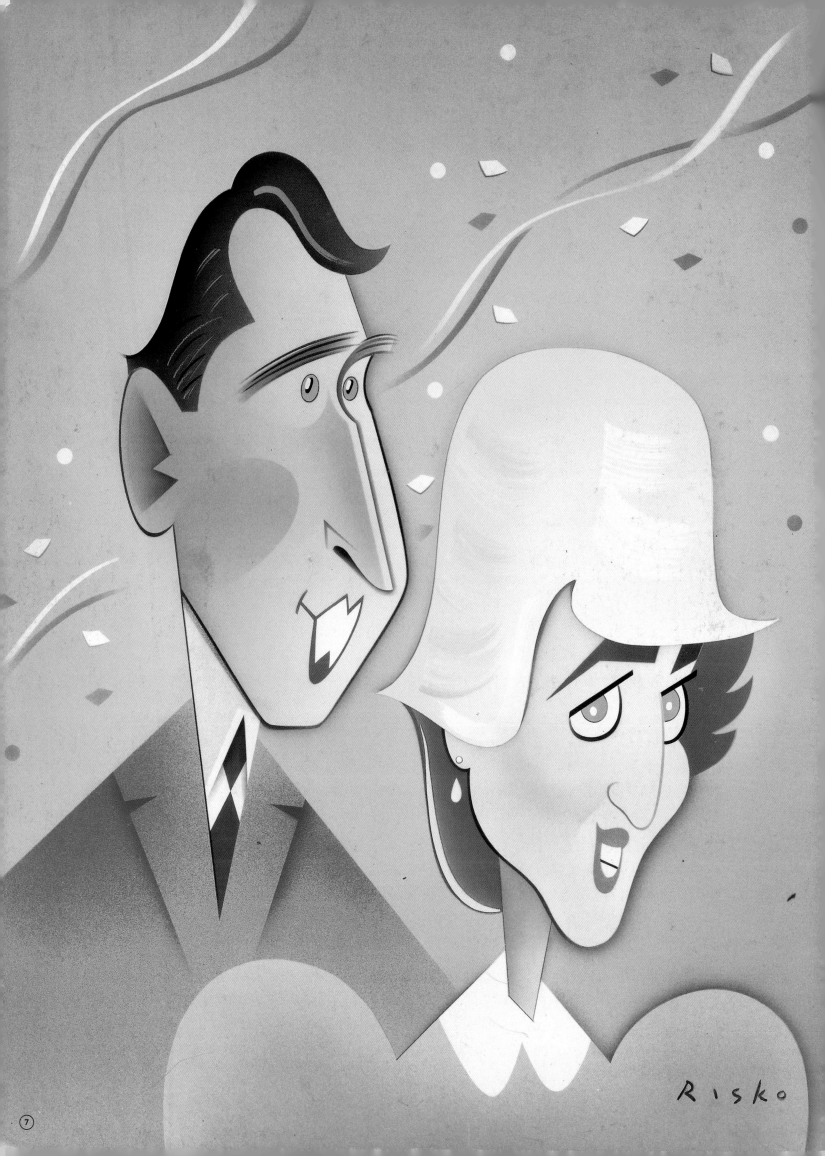

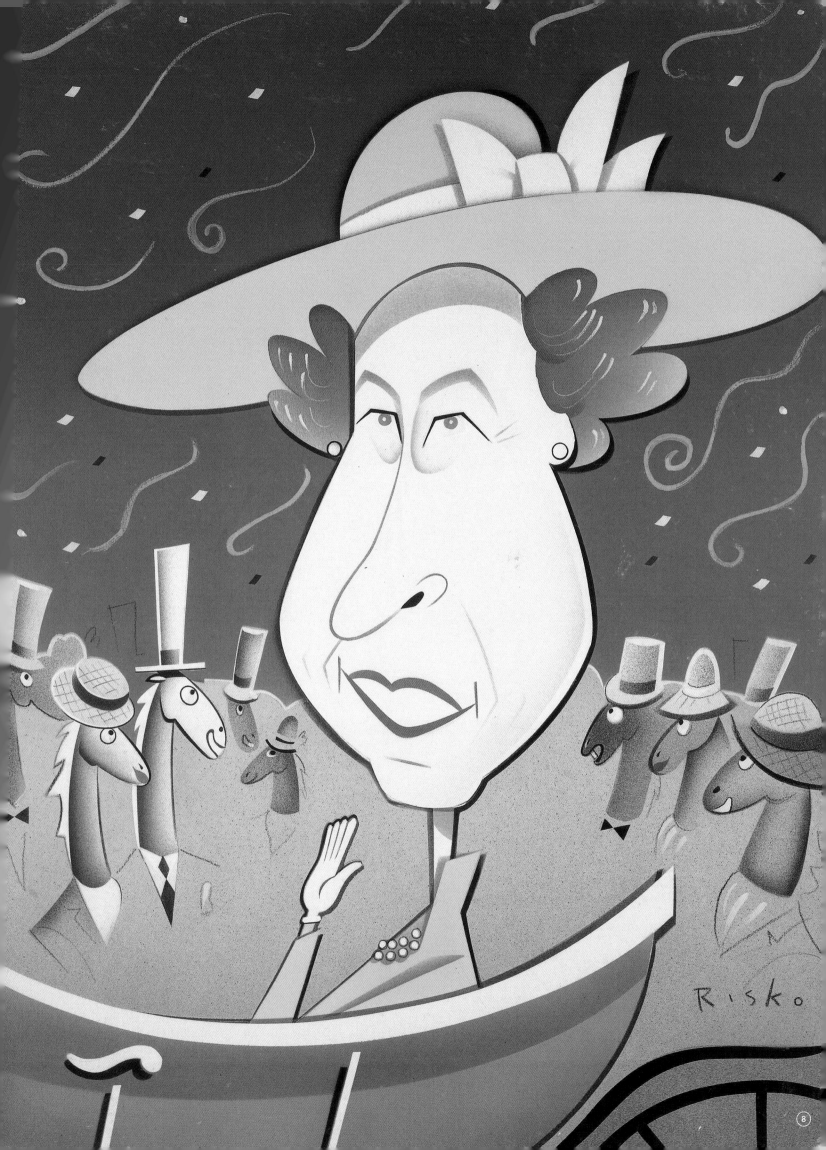

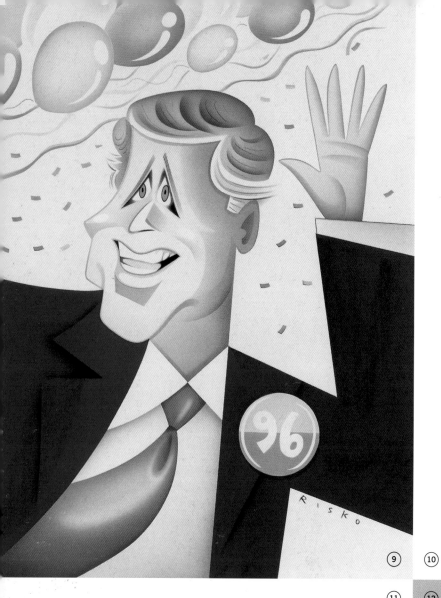

⑨

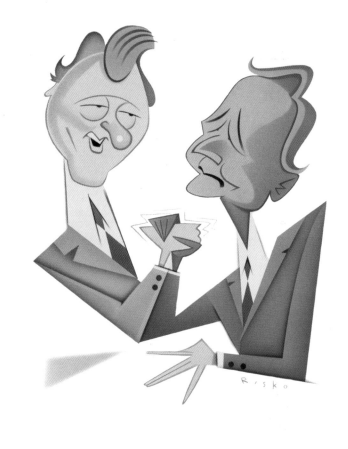

⑩

⑪ ⑫

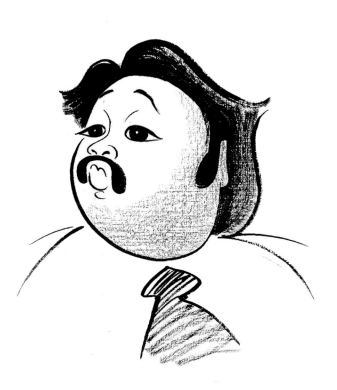

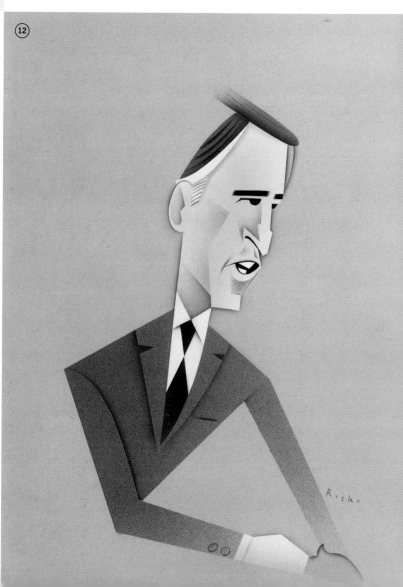

⑬

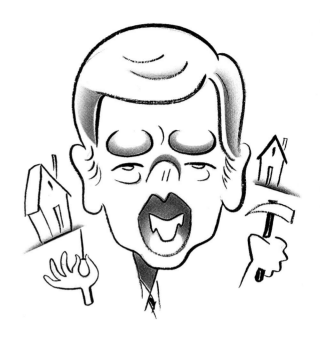

⑭

⑮

⑯

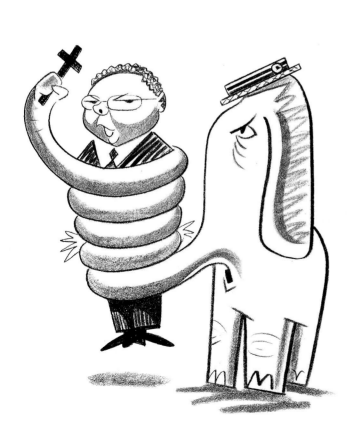

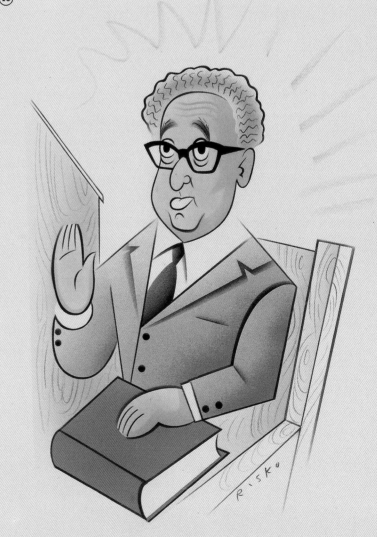

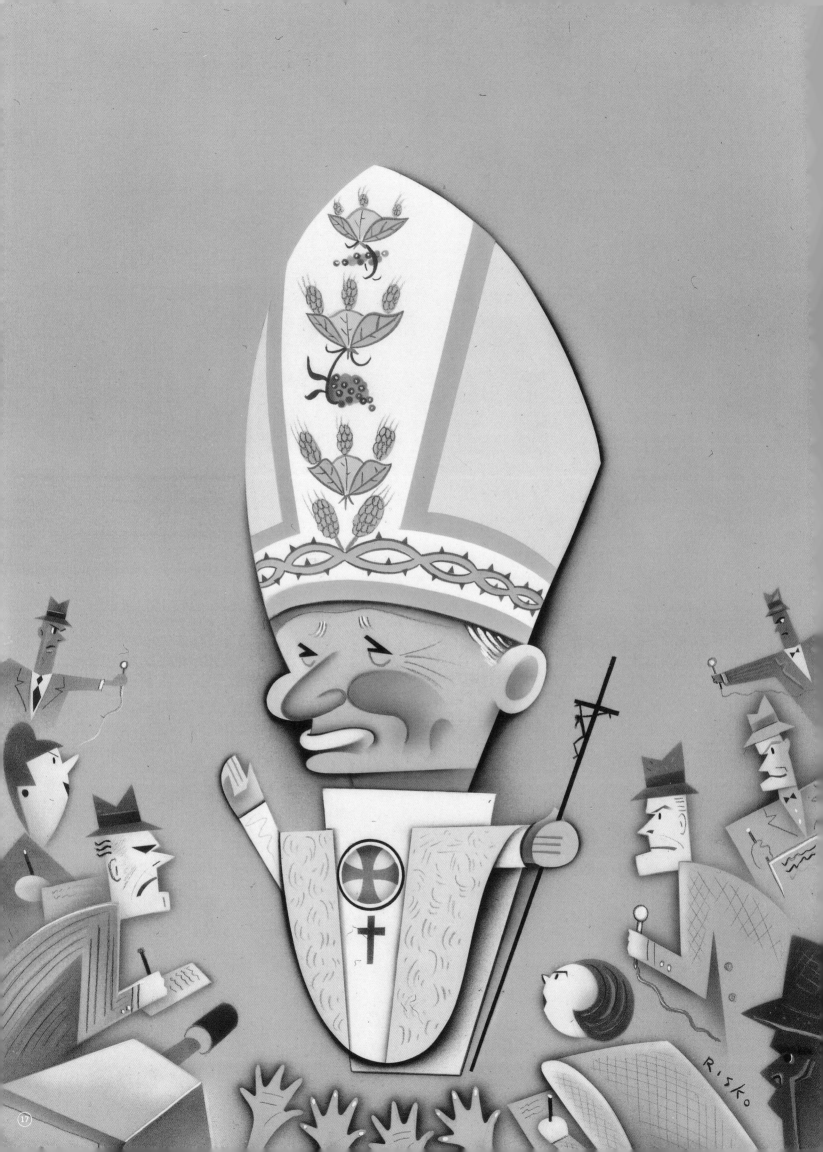

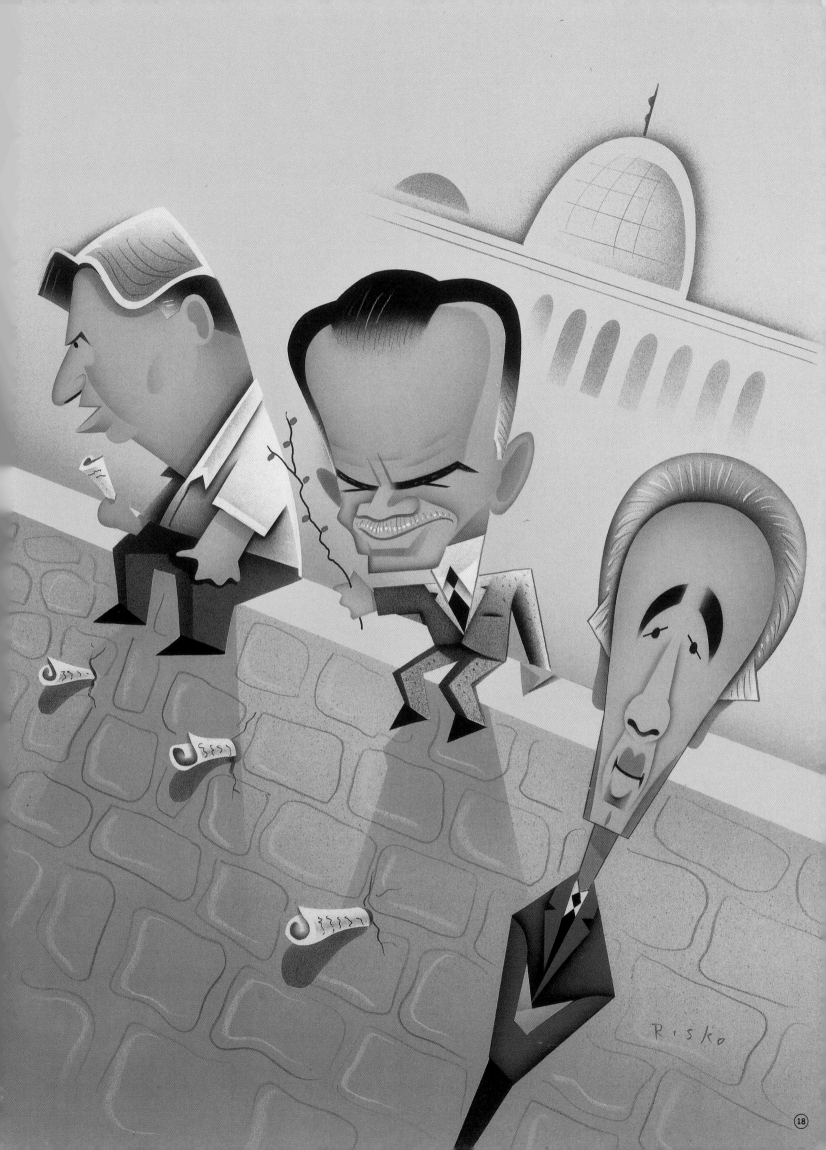

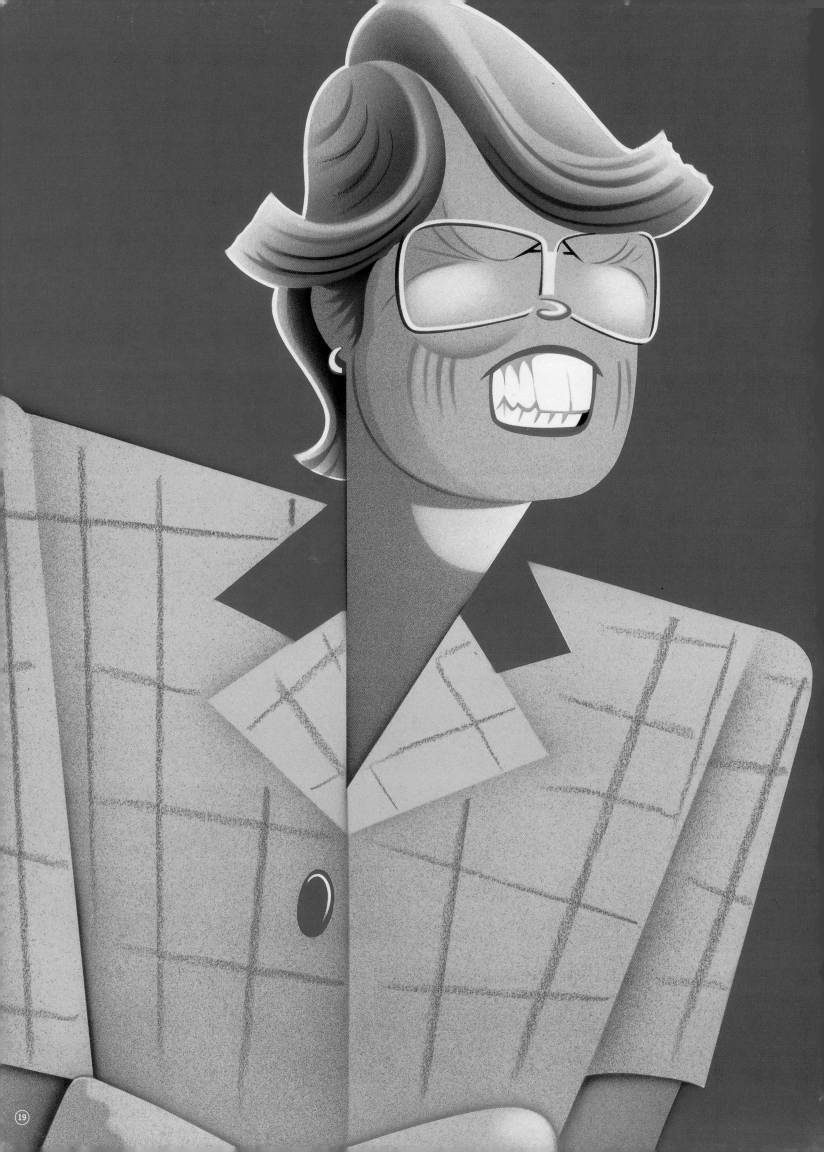

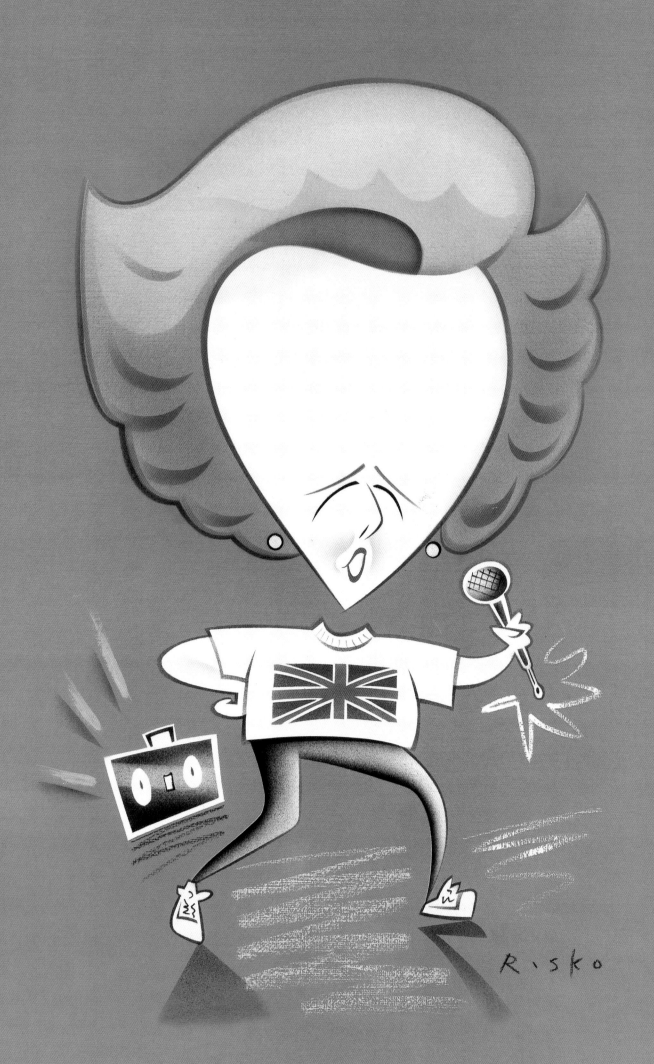

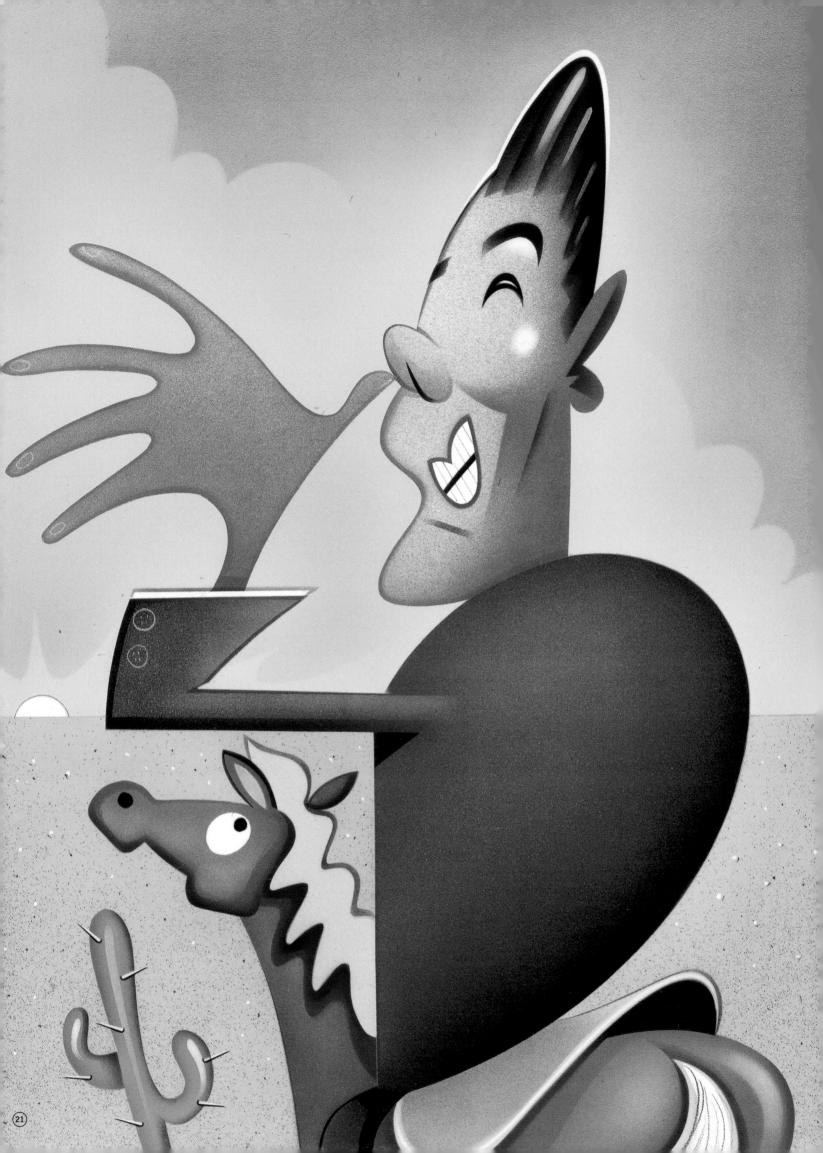

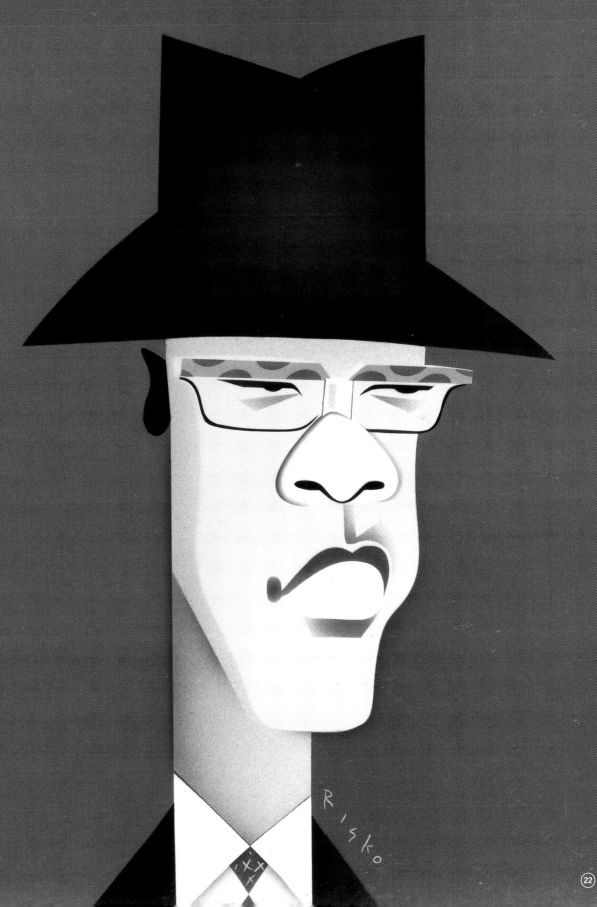

RISKO: THE MAN
AN INTERVIEW WITH ROBERT RISKO
Kevin Sessums

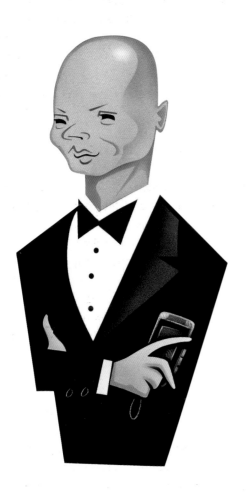

Kevin Sessums is a contributing editor of *Vanity Fair* and the former executive editor of *Interview*.

Back in the late 1980s when I was executive editor of Andy Warhol's *Interview* magazine, I'd see Robert Risko from time to time when he would bring in one of his distinctive caricatures for an upcoming issue. I'd always hurry out to the art department to take a look at his work—especially on those days (and there are many in the magazine business) when I was in need of a smile. Later, when I was Fanfair editor of *Vanity Fair* in the early 1990s and his work began to appear in that magazine also, our paths began to cross more and more. By that point, Robert himself could bring a smile to my face. Like *a* Risko, *the* Risko is keenly witty, colorful, and effortlessly cool.

KS: Are you an artist?
RR: Oh, God . . . well . . . of course.

KS: Is it an insult if someone refers to you as a caricaturist?
RR: I do draw caricatures. But an artist is someone who crafts things and creates something out of nothing. That's what I do for a living.

KS: Are you an artist or a journalist?
RR: I am an artist. I create—whether it comes from my imagination or I'm asked to do something by a magazine editor or it's a commissioned portrait.

KS: Are you easily convinced by an editor to change a piece of work? Does that get your artist's dander up?
RR: Magazine deadlines are very tight most of the time. When I first started doing this back in my early twenties for *Interview* magazine, they wouldn't even ask to see a sketch. They would give me a subject and say: Just do it. Go draw Angela Lansbury. They'd maybe give me a week, but I'd stay up all night long throwing things away trying to come up with something spontaneous that was, as far as I was concerned, a piece of Cubist art. When I started working for *Vanity Fair* it was more like: Well, we have an idea but we have to see a sketch first. In those early days, I wasn't making a living off my art. I was doing photo retouching on the side. So I asked myself: If I can do this with a photo—feel that the work is better if it's retouched—then why can't I look at the editorial process as a bit of retouching? Or another example: If I think that actors and singers and performers are better when they are able to take direction, then why can't I take it too? Because of the constraints of a magazine deadline it's valuable to have an opinion that you trust, whether it's the editor's or the art director's, in order to help you correct things that you're maybe too close to see. In the early days of *Vanity Fair* in the 1920s and 1930s, artists like Covarrubias and Garretto usually had about three months to

develop an idea for a caricature. I wish it could still be that way, but I have to respond to the culture we live in today, which is based on very tight deadlines and an insatiable appetite that the media has. If I really disagree with a suggestion, then I'll fight. But some of the time the ideas get stronger with a good editor's input.

KS: What medium do you use for the original work?
RR: My final originals are in gouache on rag board. Essentially, they are tempera or watercolors . . . a little bit finer than that. I use an airbrush, which I've used since the 1970s when I first moved to New York when airbrushing was the popular thing before there were computers. I was dissed because I used an airbrush. People said I wasn't an artist because I had a tool. An airbrush is like a miniature spray gun about the size of a dentist's drill. The way I work consists of sketching my idea up to the point where it's as finished as it can be with a black pencil. I use that drawing as a template to create stencils. I then use the stencils to lay in the basic shapes with an airbrush. In that transference, I still try to be as loose as possible with the medium. I see what I do almost like a musician learning a piece of music. A violinist, for example. You have rehearsed and played every single note over and over and over again. So by the time I get to doing the finished piece on the illustration board, it's very spontaneous. I try not to spend a lot of time . . . laboring. Many illustrators do labor and render. I don't like to do that.

KS: What verb best describes your work process?
RR: Hmmmm . . . I like to just . . . place it. I've rehearsed the drawing so much that by the final step I like to simplify it—like a fantastic piece of modern minimalist furniture. It's a Barcelona chair. It's designed. It's thought out. It's simple.

KS: Do you work from photographs or videos or the impression a subject has made in your memory?
RR: When I'm given a subject that I've never done before, I ask for as many photographs as possible. We're living in a world where people are no longer famous for fifteen minutes. It's down to fifteen seconds. If I had my own photo files, I'd need a warehouse to keep them all. I do like to see videos or films with the subject in them. I like to see people moving around. I could have been a really good courtroom sketch artist.

KS: What is your take on fame? Are you celebrating your subjects or satirizing them?
RR: Well, I guess both, which goes into making them iconic. But what I'm really trying to do is impersonate them. When I was younger, I was more grand. I had a bigger ego. I thought I really

knew these people and could really find out what they were all about. Finally, though, it's about this: people who are famous have telegenic features and become logos of themselves.

KS: Warhol had this theory that all movie stars literally had big heads.
RR: They do. Their features have to be really large and able to reflect light like a piece of sculpture.

KS: How did you get your start at Interview?
RR: I grew up just outside Pittsburgh so Warhol was a role model who proved that a kid from a steel town could get out into the world and make it as an artist. I was born in 1956 and the early 1960s was a democratic era. There were many rags-to-riches stories. There was Diana Ross from the ghetto. Barbra Streisand from Brooklyn. Warhol from Pittsburgh. All that was required was that you had enough talent and had a look. Black-and-white television back then was so fabulous and graphic. I went to school at Kent State but left after a year. I thought I was wasting my time. What would I do after four years with a fine-arts degree? It finally boils down to your portfolio. I'd had the ability to draw caricatures since I was really young. If I was afraid of my first-grade teacher, I would draw her and then I wouldn't feel threatened by her. A person who's mentally disturbed and doesn't have an outlet creates psychosis in his head. But artists draw their fears so they won't be afraid of them.

KS: That's all very interesting, Robert. But how did you get to Interview *magazine?*
RR: I wanted to be a painter, but I was always good at drawing people. I always got more attention for drawing my caricatures. After I left Kent State, I moved to Provincetown where I drew caricatures on the street for five dollars apiece. That was 1975 and 1976. There was a cartoonist there, Bobby London, who said, "You know, you're really good. You should move to New York and do this. You could be the next Hirschfeld." Meanwhile, up in Provincetown I began to read *Interview* magazine, which I thought was just so chic. I'd sit there looking at all these faces in *Interview* back then—like Monique Van Vooren—and think that they were living, glamorous caricatures. So I began to think about how I could get into *Interview* and maybe do a page every month. I moved to New York and tried to get in—quite literally— but couldn't get past the front desk. I was so scared. It was like: How do you get to see the Wizard? I used to schlepp this little business card around that had a little caricature of Diana Ross on it. It looked like she was made out of metal. That was my thing back then—to make everybody look like they were made out of

metal. My father worked in a machine shop and he used to get these catalogs filled with pictures of airbrushed machines. I thought that was so cool. Anyway, in 1978 my brother, Larry, and I took a day trip to Fire Island Pines. We were sitting on the dock waiting for the ferry to go back and there was a sign that said that Andy Warhol was going to be signing issues of *Interview* that day. I told my brother, "You know what—everybody always says that they see Andy Warhol walking down the street or at the White Horse Tavern or somewhere and I've never seen him. Let's stay. I want to see what he looks like." They did a little setup on the dock. Halston was there with him. And Bob Colacello. It was all very low-key and no big deal. You know those Pines boys— nothing impresses them. But I was wide-eyed. There was Warhol! In the sunlight! I was like: "I'm going up to him. I want to work for his magazine. I'm going to ask him." I had my little Diana Ross business card. When I got up to him in line he asked me in that nasal voice of his who he should sign the magazine to. I said, "Robert. Robert Risko." Then I said, "I've always wanted to work for your magazine. Do you know who this is?" I pulled out my Diana Ross card and showed it to him. "Oh, that's Diana Ross," he said in that emotionless way of his. "It looks just like her." I went ahead and asked him right there: "Do you think I could work for your magazine?" "Oh, sure," he said. "Just talk to Bob. Just arrange it with Bob." When I walked out, I told Bob that Andy said I should work for the magazine, that I could start doing carica- tures. Bob said, "Great. Just call on Monday." So I called on Monday.

KS: How much did they pay you?
RR: Maybe $150 a drawing. I can't really remember. Andy was always so cheap. He was like: "You should be doing this for free. This is going to make you." And in those days it did. Even Robert Mapplethorpe, whose work is worth a fortune now, worked for nothing.

KS: Didn't you bring the first dummy copy of Vanity Fair *down to the* Interview *offices to show Andy?*
RR: I was basically doing one page for *Interview* every three months. Everybody else considered my work avant-garde. I'd show my book around and everybody would go, "No, no, no . . . you're too *Interview*, you're not mainstream." On my twenty-fifth birthday I thought I'd better start making a living. I was willing to give up illustration. The ironic thing was that at the same time the *Vanity Fair* resurrection was in the works with Bea Feitler as the art direc- tor. She called me in to use a Diana Ross that she had seen in my portfolio. I'd first presented it to Andy—that particular Diana Ross portrait—to see if he wanted to run it in *Interview*. He thought it

was "cute" but he wanted to use a photograph of her to run with an upcoming interview. Anyway Bea saw it and thought it was fab- ulous. She thought it was like the old *Vanity Fair* but also quite modern. She used it in that prototype. So I probably brought the prototype down to the *Interview* offices just to show Andy and rub his nose in it a little bit. I said, "Well, here it is. Here's Diana in *Vanity Fair*'s prototype. Looking beautiful! It's on shiny paper! Not on newsprint!" Actually that caused my one mention in the *Warhol Diaries*. He said that they had to get Risko to do a cover for *Interview* because Condé Nast is starting *Vanity Fair* again and they're trying to steal all our artists. Suddenly Andy wanted to claim me. So I got commissioned to do my first *Interview* cover. It was Dolly Parton.

KS: Soon after that Vanity Fair *claimed you instead?*
RR: Bea died. She was sick even when she was putting the proto- type together. And I was so looking forward to working with her and at *Vanity Fair*. After she died, I thought, Well, fate is against me and it's not going to happen. Except for that afternoon on Fire Island with Andy, I've never been very pushy about my work. I'm bad at selling myself. I just like to work and when the work appears that's the best advertisement for myself. I still don't have an agent. After Bea died I thought I'd better get a real nine-to-five job. So irony of all ironies, I answered a generic ad and got hired as a black-and-white photo retoucher at Condé Nast. I was on the third floor and *Vanity Fair* was on the fourth. Like me, *Vanity Fair* was struggling. People were getting fired left and right. Everyone thought it was going to fold. I thought, You know what? I'm glad I'm not involved in all that craziness. Finally Ruth Ansel and Charlie Churchward were brought over from the *New York Times Magazine* as the art directors. This is obviously before David Harris, who's the art director now. That's when my first *Interview* cover came out. When Charlie found out that I was working on the floor beneath him, he called me in and started using me in a regu- lar way. Once I started working for *Vanity Fair*, I started getting calls from all over the place. It's odd. My work really didn't change, but suddenly I wasn't the avant-garde *Interview* artist any- more. I was a mainstream illustrator. I took as much work as I could. From age twenty-five to thirty I was really prolific. I even kept my full-time job there on the third floor of Condé Nast for a year and a half until I couldn't take the schedule anymore. I'd work on my art all night long and work all day. I was living off coffee and reruns of Mary Tyler Moore at three in the morning.

KS: Have you ever done a portrait of Mary?
RR: No, but I'd love to. There are a lot of people I'd love to draw. Some just strangers walking down the street. They don't have to be famous.

KS: *Are any of the famous people ever upset by your interpretation of them?*

RR: I've never heard about it if they are. One of the bad things about what I do is that you never get to see people's reactions to what you do. It's not like you're in showbiz. You don't have an audience out there applauding for you. You do it in private and people see it in their homes. You never really know if people love it or hate it. That's frustrating.

KS: *How has the advent of computer technology influenced your work?*

RR: I still think that the nuance of likeness comes from hand to paper. There's a distortion on the computer screen. I do use the computer more and more for transmitting sketches over e-mail. That kind of thing is fabulous. But if I am developing a likeness, I could never do it on the computer. I basically have to feel it. You have to feel curves and subtleties like the distance between a person's eyes. It has to be done by hand.

KS: *Did you practice your signature growing up? It's quite distinctive and graphic.*

RR: I didn't. I guess it's sort of evolved. I always thought that my work was so smooth and so textureless that I wanted to show that there was a human stamp on this.

KS: *But you only sign your surname, so there had to have been a bit of one-name-diva thought put into it.*

RR: Growing up in my small town outside Pittsburgh I was always called Risko. Everybody always called me that. Nobody used my first name. It's Czech. My grandfather came over on a boat. The name is really Rjaszko.

KS: *Sounds like an artist for the old* Vanity Fair. *When did the association with the* New Yorker *happen? Were you surprised when they asked you to contribute your work there?*

RR: No, I was surprised that they hadn't asked me before! I was surprised that they didn't ask me when I was twenty! The first thing I did for them was a Bill Cosby caricature. I think Bob Gottlieb was the editor then, and it was Chris Curry who gave me the assignment. Once the editors there got over the fear of my style being more hard-edged than they were used to, our association could then work. When Tina Brown arrived, she wanted me to do a cover for them. My first was during the Clinton-Bush election campaign in 1992. It was Bill and Hillary showing up at the White House's front door as trick-or-treaters.

KS: *Do you feel in competition with other . . . well, what word would you prefer?*

RR: Other illustrators? Other artists? Other caricaturists? Other people who work at the *New Yorker*? I'm more in competition with myself. You can't try and do what other people do.

KS: *Do you think you've now reached the heights of your profession?*

RR: No. No. No. Absolutely not.

KS: *Then why do you have this book coming out?*

RR: To show what I've been able to do so far. I can't imagine ever stopping doing what I do.

KS: *Do you ever get bored with it? Do you ever think, I cannot draw another damn famous person?*

RR: I do think that sometimes, but then I go ahead and do it again and become even more obsessive and compulsive about getting it right. I spend more time conceptualizing now than sketching. There were times when I was a little kid—say in the summer—that I wouldn't draw at all. I would play. Then at the end of the summer I'd start drawing again and I'd be just as good or better. It was as if I'd been drawing that whole time. As a matter of fact, I really do feel that if I stopped now and picked up a pencil again in ten years that I'd be better. It's really strange. It's about how you see things as you get older. In the end, it's all about perception.

ACKNOWLEDGMENTS AND CREDITS

I'd like to give special thanks to God and his creations. I try to capture them in my work.

This book is dedicated to the memory of David E. Goldberg, my guardian angel. Without his support and encouragement there would be no Risko.

I want to give a special acknowledgment to the people who have worked on this project: Graydon Carter, who is a king; Kevin Sessums, who is a duke; Andrea Monfried, who is a princess; and Michael Bierut, Brett Traylor, and David Harbarger at Pentagram, who are knights.

I also want to thank the following people for being a part of my life at one time or another: Mom, Dad, Cheryl, Judy, Larry, Tracey, Geoff, Robert, Ralph, John, Cherie, Dominick, Jeffrey, Josie, Michael, Lou, Claire, Jeff, Rodney, John, Blake, Billy, Jacques, Elaine, Michael, Val, Kevin, Aggie, Joe, Greg, Wayne, Punch, Chris, Beth, Bethany, Jane, Sun, Josh, Georgia, Jean, Mitch, Ruth, Anna, Chris, Owen, Matt, David, Françoise, Anne, Lee, Caryn, Fred, Gail, Jann, Derek, Raul, Jill, Geraldine, Bob, John, Michael, Joe, Keith, Ellene, Robert, Stacie, Erin, Rina, Sue, Helene, Walter, Rudy, Arthur, Linda, Tom, Ames, Peter, Kerig, Marcia, Martha, Ben, Geena, Nora, Marty, Peter, Valerie, Ronda, Diana, Richard, John, Rod, Lynn, David, Simon, Steven, Tony, Bradley, Ingrid, Francesca, Marc, Gail, Bob, Glen, Andrew, Dorothy, Janet, Gianfranco, Susan, Steve, Robert, Bob, Bobby, Fran, Fern, Brooke, Teri, Nick, Helen, George, Robert, Anya, Elena, Frans, Robert, Briony, Louise, Suzy, Richey, Bonnie, Dick, Jan, Barry, David, John, Judy, Kevin, Tom, Chel, Bobo, Fabrizio, Alfredo, Alan, Zoe, Cynthia, Irene, Lorraine, Eric, Mike, Adam, Gregory, Michael, Randy, Tonya, Eleanor, Elliot and everyone at St. Paul's, Michael, Mitch, Dede, Margy, Stan, Tim, Bill, Anthony, Randall, J.S., Philip, Dan, Naomi, Lisa, Paul, Brian, Steven, Louis, Tony, Sharon, François, Francisco, Geoffrey, David, Nicholas, Andrea, Mark, Tom, Dave, Chris, Jim, Joe, Ben, Julia, Michael, Flo, Leo, James, Barbara and the girls, Melek, Ruby, Steve, Bill, Sable, Everett, Lynn, Holly, Robbin, Robin, Terry, Alton, Bob, Dick, Barbara, Victor, and Lorna. I'd also like to thank the following angels: Andy, Bea, David, Frank, Gary, Judith, Mark, Michael, Robert E.D., Robert H., Robert R., Trisha, and Willi, plus Willi-boy, Baron, Sam, and Alex.

I am grateful to the companies who have been nice enough to hire me: *A Magazine, After Dark, Ambassador, American Film, American Heritage, Amica,* Atlantic Monthly Press, *Attache,* Avon, *Boston, Brides, Business Week, California Business,* Capitol,

CBO, CBS, CFDA, *Chicago Tribune, Christopher Street, City Nyt,* CNBC, CNP, *Daily News, Dial,* Disney, Doubleday, Rod Dyer Group, *Elle, En Route, Entertainment Weekly, Esquire, Fame 2, Family Life, Forbes, Forbes ASAP,* FOX, *Fox Skybox, GQ, Harvard Business Review, High Times, Home PC, Hot Tickets, Institutional Investor, In Style, Interiors, Interocity, Interview, Intrig,* Jutta Klein, Kaminsky Brothers, *L.A. Business, L.A. Style,* Lexus, *Literary Cavalcade, London Sunday Times, Los Angeles Magazine, Los Angeles Times,* Macy's, *Mandate, Männer Vogue,* McGraw Hill, *Men's Health, Mike, Minneapolis–St. Paul Star Tribune, Mirabella, Moviegoer,* Nappi Eliran & Murphy, Neiman Marcus, *New Republic, Newsweek, New Woman, New York Magazine, New Yorker, New York Times, New York Woman,* Ogilvy & Mather, *Out, PC World, The Peak,* Pentagram, *Playboy, Poz, Psychology Today, QW,* Random House, Rizzoli, *Rolling Stone, Saturday Night,* Saturday Night Live, *Scholastic, Seventeen,* Showtime, *Sports Illustrated, Sports Travel, Spy, Tatler, Tennis,* 1330 Corp., *Time, Total TV, TV Guide, US Magazine, Vanity Fair, VarBusiness, Vogue, Vogue* (British edition), *Vogue España, Vogue Homme,* and *Working Woman.*

Salutations to Tina Brown, Brad Benedict, Charlie Churchward, and the inimitable David Harris. Special thanks to Dino at Color by Pergament. My memory isn't what it used to be, so thanks as well to those I may have left out.

—R.R.

The author and the publisher would like to thank the following magazines and organizations, which originally published the illustrations in this book. Any omissions will be corrected in subsequent editions.

Television: David Letterman, *US Magazine,* 1991; Joan Collins, 1988 (unpublished); Johnny Carson, *Total TV,* 1991; Roseanne, 1992 (unpublished); Calista Flockhart, *Entertainment Weekly,* 1999; Vanna White, *Psychology Today,* 1988; Will Smith, *Entertainment Weekly,* 1997; Bob Newhart, Showtime, 1992; Seinfeld Gang, *Entertainment Weekly,* 1992; Merv Griffin, *Vanity Fair,* 1990; Alistair Cooke, *Vanity Fair,* 1992; Fran Drescher, 1998 (unpublished); Welcome Back Kotter, Nick at Night, 1995; Lucille Ball, *In Style,* 1986; Larry Hagman, *Interview,* 1984; Sarah Michelle Gellar, *Rolling Stone,* 1999; Julia Child, *Vanity Fair,* 1983; The Honeymooners, *Vanity Fair,* 1985; Bob Hope, *California Business,* 1991; Bill Cosby, Playboy Jazz Festival, 1992; Oprah, *Time,* 1998; Rosie O'Donnell, 1997 (unpublished); Wayne's World, *Scholastic,* 1992; Gilda Radner, *Mirabella,* 1989

Style: Joan Rivers, 1330 Corp., 1992; Cindy Crawford, *Forbes,* 1999; Fashion Show, 1993 (unpublished); Calvin and Kelly Klein, *Vanity Fair,* 1986; Brooke Shields, 1989 (unpublished); Puff Daddy, *Entertainment Weekly,* 1998; Claudia Schiffer, 1998 (unpublished); Sophia Loren, *GQ,* 1994; Giorgio Armani, *Vogue,* 1996; Madonna, *Entertainment Weekly,* 1994; Diane Keaton, *Vogue,* 1984; Vogue Party, *Vogue* (British edition), 1992; Jackie Onassis, *New Woman,* 1996; Ralph Lauren, *Mirabella,* 1992; Liza Minnelli, *Interview,* 2000; Warhol and Friends, *Vanity Fair,* 1990; David Bowie, *Vanity Fair,* 1998; Sandra Bernhard, *Vogue* (British edition), 1994

Music: Barbra Streisand, *US Magazine,* 1991; Dolly Parton, *Vanity Fair,* 1987; Stevie Wonder, *New Yorker,* 1995; Al Jarreau, Playboy Jazz Festival, 1992; Cher, *Hot Tickets,* 1999; Elvis Presley, *Rolling Stone,* 1987; Bobby Short, *Vanity Fair,* 1986; Bob Dylan, *Entertainment Weekly,* 1994; George Michael, *Rolling Stone,* 1988; Aretha and Ahmet, *Vanity Fair,* 1987; Garth Brooks, *US Magazine,* 1991; Prince, *Vanity Fair,* 1993; Cyndi Lauper, *Playboy,* 1985, reproduced by special permission of *Playboy* magazine, copyright © 1985 by Playboy; Little Richard, *Interview,* 1985; Roy Orbison, *Vanity Fair,* 1989; On Tour, *Vanity Fair,* 1999; Mick Jagger, *Interview,* 1985; The Eurythmics, *Interview,* 1999; Michael Jackson, 1986 (unpublished); Dionne Warwick, Desert Inn, 1996; Chuck Berry, 1996 (unpublished); Bruce Springsteen, *Rolling Stone,* 1987; Ray Charles, 1996 (unpublished); Women of Music, *Vanity Fair,* 1999

Thinkers: Sigmund Freud, *Vanity Fair,* 1984; Carrie Fisher, *US Magazine,* 1990; Norman Lear, *Vogue,* 1991; Gore Vidal, *New York Magazine,* 1984; Paglia, Steinem, Friedan, *Vanity Fair,* 1999; Tom Wolfe, *Rolling Stone,* 1996; Jacqueline Susann, *New Yorker,* 1995; Stephen King, *Entertainment Weekly,* 1996; Fran Lebowitz, *Mirabella,* 1992; Dominick Dunne, *Vanity Fair,* 1999; Gail Sheehy, *Vanity Fair,* 1995; Artists and Writers, *Vogue,* 1991; Kurt Vonnegut, *Literary Cavalcade,* 1986; Truman Capote, *In Style,* 1985

Film: Bette Midler, *Vanity Fair,* 1998; Jack Nicholson, 1984 (unpublished); Christian Slater, *US Magazine,* 1991; Cathérine Deneuve, *New Woman,* 1982; E.T., *Moviegoer,* 1981; Lily Tomlin, *Vanity Fair,* 1984; Titanic, *Attache,* 1998; Sir Laurence Olivier, *Vanity Fair,* 1984; Macaulay Culkin, *Time,* 1991; Jim Carrey, *Vanity Fair,* 1994; Michael Caine, *Vogue* (British edition), 1992; Julia Roberts, *Working Woman,* 1999; John Travolta, *Hot Tickets,* 1999; Babe, *Interview,* 1998; Private Lives, *Vanity Fair,* 1983; Marilyn Monroe, *Time,* 1992; Edward Scissorhands, *Rolling*

Art Center College

Stone, 1991; Ron Howard, *Vanity Fair,* 1995; De Niro and Thurman, *New Yorker,* 1993; Grease, *Entertainment Weekly,* 1996; Mrs. Doubtfire, *New Yorker,* 1993; Out Cold, Rod Dyer Group, 1991; Sylvester Stallone, *Spy,* 1991; Boogie Nights, *New Yorker,* 1997; Spike Lee, *Rolling Stone,* 1991; Mike Nichols, *New York Magazine,* 1984; Hollywood Beach, *Vanity Fair,* 1995; Paul Newman, *Vanity Fair,* 1998; Goldie Hawn, *Interview,* 1984

Scandals: J. Edgar Hoover, *Vanity Fair,* 1993; Imelda Marcos, *Interview,* 1983; Whitewater, 1997 (unpublished); Burt and Loni, *Time,* 1993; Fergie and Diana, *Elle,* 1993; Mike Tyson and Robin Givens, *Vogue,* 1988; Woody Allen, *Fame 2,* 1983; Warren Beatty, *Esquire,* 1990; Pee-Wee Herman, *Interview,* 1986; Michael Jordan, *Time,* 1992; Donald and Marla, *Time,* 1992; William Shawn, *Vanity Fair,* 1998; Gold Diggers, *Rolling Stone,* 1988; Oliver North, *Vanity Fair,* 1994; Liz and Larry, *Time,* 1997; Alec, Kim, and Mickey, *Entertainment Weekly,* 1991; O.J., Cochran, Dunne, *Vanity Fair,* 1995; Leona Helmsley, 1994 (unpublished); Ellen DeGeneres, *Time,* 1996; O'Donnell and Cruise, *Entertainment Weekly,* 1997

Media: Martha Stewart, *Business Week,* 2000; Larry King, *Vanity Fair,* 1998; Siskel and Ebert, 1987 (unpublished); The Anchorwomen, *Vanity Fair,* 1994; Sam Donaldson, *Time,* 1989; Dan Rather, *Vanity Fair,* 1996; Tina, Si, and Anna, *Entertainment Weekly,* 1996; Robin Leach, *Playboy,* 1986, reproduced by special permission of *Playboy* magazine, copyright © 1986 by Playboy; Phil Donahue, *Daily News,* 1981; Charlie Rose, 1993 (unpublished); Katzenberg and Spielberg, *Vanity Fair,* 1998; Tom Snyder, *Elle,* 1996; Barbra Streisand, *Entertainment Weekly,* 1994; Mike Ovitz, *Los Angeles Magazine,* 1999; Bill Gates, *Vanity Fair,* 1998; Maury and Connie, *New Woman,* 1993; Radio Days, *Vanity Fair,* 1996; Ted Koppel, *Vanity Fair,* 1994; Katzenberg and Eisner, *Vanity Fair,* 1994

Sports: Joe DiMaggio, *Sports Illustrated,* 1986; Martina and Chris, *Tennis,* 1989; Riddick Bowe, Desert Inn, 1996; John Madden, *Sports Travel,* 1989; Reggie Jackson, *Playboy,* 1984, reproduced by special permission of *Playboy* magazine, copyright © 1984 by Playboy; Seles, Graf, Courier, Sampras, 1994 (unpublished); Tommy Lasorda, *Vanity Fair,* 1993; FOX Sports Crew, *Fox Skybox,* 1999; Pat Riley, *Vanity Fair,* 1993; Michael Jordan, *GQ,* 1989; Canadians on Ice, *En Route,* 1991; Tiger Woods, *Vanity Fair,* 1997

Theater: Angela Lansbury, *Interview,* 1981; Tommy and Twiggy, *Interview,* 1983; Buddy Hackett, Desert Inn, 1995; Jackie Mason,

HBO, 1989; Beauty and the Beast, *New Yorker,* 1994; Dame Edna/Barry Humphries, *Vogue* (British edition), 1991; Victor/Victoria, *New Yorker,* 1997; Siegfried and Roy, 1990 (unpublished); Cole Porter, Capitol, 1994; Johnny Mercer, Capitol, 1994; On the Town, *New Yorker,* 1998; Bob Fosse, *Vanity Fair,* 1986; Jule Styne, *Dial,* 1987; Liza and Chita, *Vanity Fair,* 1984

Politics: Jesse Jackson, *Interview,* 1984; The Doles, *Vanity Fair,* 1996; Alan Greenspan, *Institutional Investor,* 1986; Hillary Clinton, *Time,* 1998; Desmond Tutu, *Interview,* 1985; Boris Yeltsin, *Vanity Fair,* 1993; Charles and Diana, *The Peak,* 1990; Queen Elizabeth, *Vanity Fair,* 1987; Dan Quayle, *Vanity Fair,* 1992; Clinton v. Bush, *Vogue,* 1992; Al Sharpton, *Spy,* 1989; Jerry Brown, *L.A. Style,* 1982; Nancy Reagan, 1990 (unpublished); Jimmy Carter, *Spy,* 1989; Colin Powell, *New Yorker,* 1995; Henry Kissinger, *Time,* 1989; Pope John Paul II, *Saturday Night,* 1986; Peres, Shamir, Kollek, *Interview,* 1986; Janet Reno, *Elle,* 1993; Margaret Thatcher, *Time,* 1992; Ronald Reagan, *New York Woman,* 1992; Malcolm X, *New Republic,* 1992

First published in the United States of America in 2000 by
The Monacelli Press, Inc.
10 East 92nd Street, New York, New York 10128.

Copyright © 2000 by The Monacelli Press, Inc.
Illustrations copyright © 2000 by Robert Risko

Library of Congress Cataloging-in-Publication Data
Risko, Robert.
The Risko book / introduction by Graydon Carter ; interview by Kevin Sessums.
p. cm.
ISBN 1-58093-072-7
1. Celebrities—Caricatures and cartoons—Catalogs. 2. American wit and humor, Pictorial—Catalogs. I. Sessums, Kevin. II. Title.
NC1429.R543 A4 2000
741.5'973—dc21 00-033959

Printed and bound in Singapore
Designed by Pentagram